SINCE WHEN

Other Works by Bill Berkson
from Coffee House Press

Expect Delays

Portrait and Dream

SINCE WHEN

A MEMOIR IN PIECES

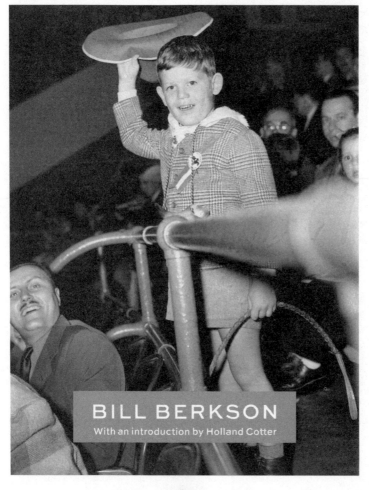

BILL BERKSON

With an introduction by Holland Cotter

COFFEE HOUSE PRESS

Minneapolis

2018

Coffee House Press books are available to the trade through our primary distributor, Consortium Book Sales & Distribution, cbsd.com or (800) 283-3572. For personal orders, catalogues, or other information, write to info@coffeehousepress.org.

Coffee House Press is a nonprofit literary publishing house. Support from private foundations, corporate giving programs, government programs, and generous individuals helps make the publication of our books possible. We gratefully acknowledge their support in detail in the back of this book.

LIBRARY OF CONGRESS CATALOGING-IN-PUBLICATION DATA

Names: Berkson, Bill, author. | Cotter, Holland, 1947- author of introduction.
Title: Since when : a memoir in pieces / Bill Berkson ; introduction by Holland Cotter.
Description: Minneapolis : Coffee House Press, 2018.
Identifiers: LCCN 2018017148 | ISBN 9781566895293 (trade pbk.)
Subjects: LCSH: Berkson, Bill. | Berkson, Bill—Friends and associates. |
 Poets, American—20th century—Biography. | Art critics—United States—
 Biography. | Art museum curators—United States—Biography.
Classification: LCC PS3552.E7248 Z46 2018 | DDC 811/.54 [B] —dc23
LC record available at https://lccn.loc.gov/2018017148

PRINTED IN CANADA

25 24 23 22 21 20 19 18 1 2 3 4 5 6 7 8

Contents

Scenes and Routines *137*

Introduction

I've been reading and loving Bill Berkson's poetry since I was a student in the 1960s. But as an art critic by trade, I've been most consistently drawn to his writing about art. More than drawn to. Every time I read his reviews in magazines in the 1980s and '90s, I felt I was taking a Berkson correspondence course on the fine art of art writing. I read him for instruction in how to develop a style that was clear but beyond utilitarian, individual but not self-aggrandizing. I read him no matter who or what he was writing about, just to experience his language and thinking—his spirit.

Actually, "art reviews" wasn't exactly the genre Berkson worked in. As he himself said, he wasn't interested in producing standard-formula like-this-hate-that evaluation. He was interested in art he deeply and specifically loved, and in getting that love across. To read him on an artist he treasured was to travel through a body of work, or an entire career, with an enthralled and erudite guide. He took us on a rapt grand tour of late de Kooning paintings. He persuaded us to linger over Albert York's silvery pastorals, one by tiny one. He brought Franz Kline, that soulful sweetheart, out of the sober history book and back into the all-night party of life.

His 1985 *Art in America* piece on the West Coast painter Wayne Thiebaud was a syntactical intoxication, Marianne Moore poetry in prose:

> Northern light is nice but difficult, and not always clear. It is any-
> thing but "relentless." It lopes, jounces, jags, spreads (at its brightest like
> aluminum foil), and is often befogged when not rained out.
> "The flowers have fallen, the fruits have all been torn down." In the
> world of things, isn't *scattered* synonymous with *structure*? If things do
> possess us, what do they require? Just breathing space, perhaps, or, as
> Thiebaud has suggested, "an independent repose."

In 1993, in the same magazine, Berkson organized and led, in print, a Piero della Francesca pilgrimage. Over the centuries, countless art lovers have driven and walked a narrow route through Tuscany and central Italy in search of the elusive Renaissance painter. (I did in the late 1980s.) But Berkson's account, titled "What Piero Knew," was a whole other trip, a passion play in prose, with its guide a central actor.

It started in Arezzo Cathedral with *The Legend of the True Cross* frescoes; moved on to Piero's hometown, Borgo Sansepolcro, where his *Resurrection* is kept; went from there to nearby Monterchi and the *Madonna del Parto* (housed

in a cemetery chapel on my 1980s visit, in a museum in the 1990s); and finally arrived in Urbino, where we lingered over the inscrutable *Flagellation*.

And there was our guide talking all the way, about Piero's virtually fact-less biography, and about his shifting afterlife in art history: first lost to view, as if in an unmarked grave, then revealed, transfigured as the concluding synthesizer of a painting tradition. Yet from Berkson we got still another, extra-academic Piero: an over-there solitary, painting away in his own room, with his own thoughts and one bright lamp, the light of which has, in recent centuries, attracted other solitaries—Cézanne was one, Morandi another—not to mention hordes of devotees like me.

To this Piero, Berkson gave us privileged access through language, by pulling us up close to the surviving paintings, to "a huge Pierian inventory of cracklings and abrasions, cracked boards and worm-hole hollowings; scalings off, oxidizings (greens gone to brown or black)."

If Piero "brings us to the particular beauties of the fresco medium," Berkson brings to us the particular beauties of writing about art in the wide and focused view, from a historical and personal perspective. And very few writers write with the same voice and esprit—without gear-shifting, or stiffness—across genres. We find no forced conclusions; no flaneurial snarkiness; no please-look-at-me. We get generous adult ideas delivered by an ego willing to receive and transmit, rather than grab and impose, expressed in word-perfect language poised between journalism, belletrism, and something else. That being, what? Poetry.

—*Holland Cotter, 2018*

Acknowledgments

My husband, Bill Berkson, would often say, "I have to get back to my memoir," which he had been working on for several years. A more pressing deadline would interrupt the memoir writing, but he would always return to it. When he died suddenly on June 16, 2016, he left behind this all-but-completed manuscript and was in the process of editing it with Coffee House Press. I am grateful to Chris Fischbach, publisher of Coffee House Press, associate editor Lizzie Davis, and production editor Carla Valadez for working with me and Bill's son, Moses Berkson, to put the finishing touches on this memoir. Mac McGinnes and Nina Lewallen Hufford helped me with final edits, and Moses worked from Bill's notes to organize the photographic images. I also wish to thank Holland Cotter for his wonderful introduction. I know Bill would have been pleased.

—*Constance Lewallen, 2018*

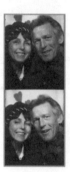

Connie and
Bill, 1994

SINCE WHEN

What's the worst thing you've ever done?
When I was about nine, I shot a bird with a BB gun, but just to prove what a saint I became that instant, I went over and picked up the bird and propped it on a branch. The miracle was that after a couple of minutes the bird flew away.

SINCE WHEN

Bill's birth record, 1939

The writing of history is a method of getting rid of it.
—GOETHE

At least two coincidences attended my birth on August 30, 1939, in Doctors Hospital, New York, near the East River on the Manhattan side. One was that Brigid Berlin, known in her syringe-toting days as a featured player at Andy Warhol's Factory as "Brigid Polk," was born there a few days later. I used to think it was the same day, our mothers having entered the maternity ward together, and as Brigid and I like to picture it, just down the hall, separated-at-birth style. (Thirty years later, when I packed up to leave New York for California, she documented that ceremony at length with her Polaroid.) Brigid's father was president of the Hearst Corporation, and thus stood as the immediate superior to my father, who was then general manager of International News Service, Hearst's rival to the Associated Press. The INS motto, imprinted on desk rulers and at the reception desk, was "Get it first, but first get it right."

That day, too, saw the first rumblings of the Second World War. In the room where my mother was preparing to give birth, the radio blared reports of the German army mobilizing near the Polish border. "Shut that thing off!" my mother demanded, to which the nurse replied huffily, "Don't you want to know what's going on in the world?"

My war experiences, so to speak, as I vaguely recall them, involved occasional citywide blackouts and big military parades up Fifth Avenue, accompanied by soaring trills and grave thumps of patriotic marching-band music. I loved the parades but in the long run was more impressed by the pungent smell of fresh newsprint at the candy stand by the elevators in the lobby of the Oliver Cromwell on Seventy-Second Street near Central Park West, where we lived for four years before moving across town to a similarly tall apartment building on Eighty-Seventh and Fifth. I came to know that same pulpy sensation, mixed with teletype, printer's ink, and tobacco smoke, in the hallways and huge, open pressrooms of the Daily Mirror Building on West Forty-Fifth where my father had his office. About the war, though, there were mainly the trophies my father accumulated from various INS correspondents—a Nazi dagger and dress sword and an ornate Ethiopian shield presumably garnered in the course of Mussolini's doing battle with the Lion of Judah, Haile Selassie. Then again, I recall how, in the aftermath, aged seven or eight, I found in our library, and went back to again and again, two books of photographs, one of Mathew Brady's images of the Civil War and the other, entitled *It Can't Happen Here,* documenting Nazi death camps and other atrocities widely publicized in the postwar years. Such were my first views of dead people, at whatever absurd remove, yet etched in consciousness permanently as only photography can claim to do.

My war was the "cold" one, the war that came next, that was in the air from my seventh year onward and never completely dispelled. Threats of an atomic-bomb attack provoked absurd drills of hunkering under school desks or filing out into the hall to hunch against marble walls on marble floors, as if any such maneuvers would save us. The general apprehension was such that the sound of an airplane flying low into LaGuardia or Idlewild signified imminent death by fireball. One civil defense training film screened for students from first grade up showed an American city being bombed—fireball, light flash, shock wave, and, in a cut to the suburbs, the fallout: a man in a hunting cap making last-minute preparations, gathering canned goods for the family bomb shelter, rain dripping off the open garage door; the emergency-radio voice cautions, "Fallout may materialize in the form of light rain, which is highly radioactive!" As the man draws back in horror from the raindrops, so do we. Poison rain, a novel concept, the imprint of which transfixes all further weathers.

Such terrors notwithstanding, the prime visual, and so idyllic, fact of my childhood was Central Park, stretching in view from the front rooms eleven floors up at 1060 Fifth. The lowermost part was visible, too, through the wide window of the office next to the Sherry-Netherland where my mother orchestrated her fashion-publicity business, facing Saint-Gaudens's statue of General Sherman and his victory angel and to the left of that, the Plaza Hotel. The park meant pony rides in the zoo—first in a little cart, then mounted on a saddle, firmly supported by the track attendant—and later learning to ride a succession of bikes, roller-skating, and after snowfalls, scooting on a sled down the short slope between the Eighty-Fifth Street transverse and the Metropolitan Museum.

The prospect from our high windows provoked a surge of initial wonder—a democratic vista, if ever there was one, of oblong reservoir, rocks and trees and

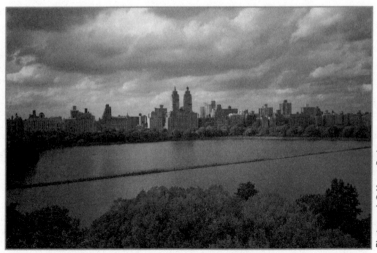

Photograph © Moses Berkson

The view from Bill's childhood home at 1060 Fifth Avenue

meadows, strolling people, pigeons, dogs on leashes (ours were standard poodles, brown and black), car traffic, and the swank faces of ultramodern, brass-tinged ziggurats on the opposite rim, across the park, the numbered streets between them intimating the Hudson way out west in beautiful sooty light. Whatever greenery was spread was ornamental to the big granite outcroppings. Granite is my base element. Through the medieval, transverse underpasses, I rode the cross-town bus to school and spring afternoons walked back solitary or with one or two friends. Then, too, my room down the long hall, at the back of the building, had its own views: a span of ornate rooftops, terraces, and the strangely noble, squat proportions of water towers stretching away; at night the rows of rear windows of neighboring apartments lit up in shades of dull yellow revealed to my busy imagination so many distant bodies in motion, whether "the help" preparing meals or washing up, or the lady of the house in various stages of undress. From one side, in the fifties, I could look down on the Guggenheim Museum being built, Frank Lloyd Wright's greenish oval expanding up and out like a pneumatic toilet seat. The park itself is my idea of heaven. It's where, on a dire winter's day, I scattered my parents' ashes, commingled, from an urn, and where I would want mine put too. (My best hope is to be sprinkled stealthily into the reservoir or, lacking that, the black dirt of the bridle path close by.)

My mother and father, Eleanor Lambert Berkson and Seymour Berkson, had come eagerly to New York from their respective birthplaces: Crawfordsville, Indiana, and the South Side of Chicago. My father's family were Jews who arrived (there is some mystery as to when and in what order) from Lithuania and Odessa. His father, William, was a tailor for an upscale men's clothing store called Kuppenheimer, and his mother, Bertha (née Bloom), taught English to immigrants and wrote poetry for the temple newsletter. Seymour's Chicago was

Bill on the beach, 1941

the mythological one of jazz and gangsters and other mayhem: he was fourteen when his heroes, members of the infamous "Black Sox," threw the World Series and ruined professional baseball for him forever after; the young child-murderers Nathan Leopold and Richard Loeb were fellow undergraduates, and Loeb a fraternity brother, at the University of Chicago; some of his acquaintances were among the men killed by Al Capone's mob in the St. Valentine's Day Massacre. As a young reporter from Chicago, my father went east, then to Paris, and from there to Rome, working as the Hearst bureau chief and watching, as he wrote, "the rise and fall of Mussolini" (the fall signaled by Il Duce's pact with Hitler— he later characterized Mussolini as "a thug"). It was during his Italian stay that he met my mother, who was dispatched by the Whitney Museum to undo what he, Seymour, on Hearst's orders, had accomplished by inserting into the U.S. Pavilion at the Venice Biennale a Polish society painter's portrait of Marion Davies. About the portrait, the Italian authorities, delighted with the uproar (the press had nicknamed the pavilion "la casa Davies"), proved stubborn, but, despite the issue at hand and the fact that they were both then married, the two young Americans found more of an interest in each other. By 1936, they were together in Manhattan.

My mother's father, Henry Clay Lambert, who died before I was born, was an advance man in the Midwest for Ringling Bros. and other circuses. Although his wife, Helen, lived until 1942, I never knew her either. My mother's family

Bill with his parents, en route
to the Caribbean, 1947

was a "pioneer" mix of Scots, Irish, French Huguenot, Dutch, and, rumor had it, Choctaw. There are echoes of such names as Benge, Houghton, Warner, and Craig (my middle name), some branch moving from the Jamestown Colony to South Carolina; St. Louis, Missouri; and Albion, Iowa. Along with a lineage of Irish kings (the Creaghs), my mother liked to speak of our connection, supposedly on my maternal grandmother's side, with Colonel Seth Warner, who led the Vermont regiment alongside Ethan Allen's Green Mountain Boys at the Battle of Bennington, and his wife, Sally, who famously helped by melting down all the silver in the immediate neighborhood for bullets. It turns out, however, that our Seth Warner was a different man entirely and no relation to the Hero of Bennington.

Clay Lambert first developed his skills as a theatrical entrepreneur while living in Deadwood, South Dakota, after hauling Helen and their two infant daughters there from Indiana in 1883. He moved the family to Crawfordsville eight years later and soon left them behind, striking out for New York, where he managed road tours for Maude "Peter Pan" Adams and similar theatrical lights. Eleanor was the youngest of his and Helen's five children by more than twelve years. Her brothers, in their youth, were star athletes. Ward "Piggy" Lambert played professional baseball briefly and has a plaque in the Basketball Hall of Fame commemorating his success as a coach at Purdue. (He introduced the fast-break running style of court play.) Kent Lambert became a dashing and notoriously unruly career army officer who retired with the rank of colonel, having served on the dishonored General George Patton's staff during the 1940s war. His wife, Janet, wrote juvenile novels (*Candy Kane, Star-Spangled Summer*) about young girls riding horses and living in army camps.

Bill at a horse show with his uncle, Kent Lambert, 1942

Bill's mother, Eleanor Lambert,
1930s (*above*) and 1940 (*right*)

Bill's father, Seymour Berkson, 1930s

My mother left Crawfordsville at eighteen with the idea of becoming a sculptor; she got as far as the Art Institute of Chicago and decided that as a sculptor she would never be great, so in her twenties in New York she discovered her talent for promoting greatness in others—first, artists like Isamu Noguchi, Alexander Calder, and Walt Kuhn, and later, and more decisively, the American fashion designers who became prominent when Paris haute couture was cut off in the war years.

By the time I came along, my parents had pretty well achieved their personal versions of the American dream. A gypsy fortune-teller once told my mother, "You will never be rich, but you will always have beautiful things." Essentially right: my mother and father earned good incomes by unflagging work at high-pressure jobs that suited them. (I once estimated that in the late 1950s their combined annual income was equal to Joe DiMaggio's career high in base-ball, $100,000.) They seemed to have promised each other to be never in debt despite always living a little beyond their means. My mother's favorite color was red—red nail polish, red roses, red bindings on her address and appointment books and the family photo album; she wore dress shoes with customized red leather heels that matched the upholstery in a succession of black Buick family convertibles. (For the photo album, she crocheted an image of a blond, winged cherub with a pair of shears tucked in at his waist and embracing what looks to be a tiny goat.) In the postwar years, our house regularly filled with spirited smart-set Manhattanites—parties that mixed people from show business, journalism, and the fashion world. The so-called American Century was still young: to me, its inhabitants were glittery arrivals in our foyer in dark wool topcoats, gentlemen's and ladies' hats, the women draped in fur wraps and stoles. I heard the grown-up talk—such words taking shape as "organza," "taffeta," "Truman,"

Bill with his mother, 1946

"Dewey," "Westbrook Pegler," "Winchell," "Reds." I shook hands politely in a navy-blue suit, hair doused with my father's Bay Rum.

Our family friends included Judy Garland and Vincente Minnelli (and later Judy's second husband, Sid Luft), Jinx Falkenburg and Tex McCrary, Dorothy Kilgallen and Dick Kollmar, Cecil Beaton, Albert and Mary Lasker, Janet Gaynor and Adrian, and Leonora Corbett, famous as Noël Coward's original Blithe Spirit, whom I called "Blondie" but who, when asked what color her hair really was, said "light marmalade." The fashion people were Norman Norell, Pauline Trigère, Adele Simpson, Valentina and George Schlee. There were Norman and Rosita Winston; Cheever and Andrea Cowdin; Paul Gallico, who wrote *The Snow Goose;* and my father's Hearst colleagues Bugs Baer and Bob Considine (special to me because he had written the first biography of Babe Ruth). I remember answering the phone to hear the alarming nasal of Louella Parsons—"Hel-lo, Bil-lee, this is Lou-ella. How are you?"—calling my father from Hollywood with her latest scoop.

I just wanted to kill my pillow or whatever it was. Because both my parents worked every weekday and also traveled a lot, I was cared for by governesses, the longest lasting of whom, Miss T., as I knew her, lived with us for about six years, until I was nine. The T. was short for Turnbull, but she was married at the time to a man whose last name was Nelson. I fantasized—incorrectly, it turns out—that Nelson had been an American pilot shot down in the Pacific. Her daughter, Saundra, lived with us, too, for a while, she and her mother in the spare bedroom next to mine. Although the time was brief and I recall little of it, Saundra and I were as much a brother-and-sister act as either of us would ever have, though not an easy one. A much older cousin

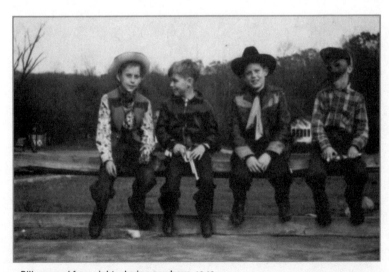

Bill, *second from right,* playing cowboys, 1949

tells me I was a "handful" and often beastly, having developed around age six an occasionally mean, violent streak. Rough play at Cowboys and Indians was one outlet, along with emulating the laughing swordplay of the incomparably beguiling Errol Flynn. Jumping alone about my room, I performed secret shoot-outs and swashbuckling feats; for real-life fights, I had a killer headlock. I can picture the Little Beast now. Saundra, who had her own fears and resentments to contend with—her mother had left her in a convent school for several crucial years—reacted accordingly. She turned away, which left me clambering after her. With my actual half sister, Barbara, my relations were more abstract. Born late in 1934, not long before Seymour and his first wife, the adventurous journalist Jane Eads, separated, she was an infrequent visitor. We were never close, and whenever she did appear during my very young years, she did her best to terrorize me. (I took revenge in my teens by "necking" with the friends she brought along on vacation from Hillsdale College.) Barbara lived with her mother in Washington, D.C., and later in Vermont, where she taught art. After many years

Bill with his friend
Saundra, 1945

of not being in touch, I wrote her, only to have the letter returned with a stamp that read "Addressee Deceased." She had died, as I nearly did some years later, of emphysema.

One night in the mid-sixties, a woman of my parents' generation came up to me in a club and said, "My God, you're alive! I never thought there was room for anyone else in that house, what with their being so involved with each other and their work."

I saw her point. Preoccupied they were in those ways, in their demonstrative affections and shared ambitions, both. Altogether, though, my parents did what they could, their fair-minded, dreamy-hearted best. I was protected and given comfort and worldly advantage with all its endless, and eventually baffling, options. I was loved, and repeatedly told as much. Neither Seymour nor Eleanor was really prepared by past experience—the pass-it-on factor, it might be called—for being a parent to a small child. Eleanor had been conceived on one of her father's infrequent visits home. It fell to her brother, Kent, to assume the role of surrogate father. Her mother seems to have been a complainer with no great initiative or care—in a word (one that was among my mother's favorite put-downs), "feckless." Seymour's father, as I recall, was a sweet, extremely quiet man, but my paternal grandmother, sweet too in her way, was outspoken, a real Jewish mother, so to speak. During their annual summer visits, my father made a point of taking his dad fishing and leaving Grandma to me, an assignment I enjoyed tremendously, including, as it always did, multiple games of canasta peppered with the only family stories anyone would let me in on for many years. My mother called me "Mr. Man," affectionate though a bit vague as to who or what I might actually be. (I was, in fact, a small child.) More awkward, sadly, in retrospect, my father tried all sorts of ways to get next to me. Physically, he could be plainly embarrassing and even hurtful: he liked to tickle and apply a torture called the Dutch rub, with his knuckles on my scalp. Otherwise, there were various disappointments by turns: fishing wasn't really for me (I hated putting worms on the hook and gutting the catch of the day and, except for flounder, sulked at the prospect of eating whatever came of it). I suppose the distance between these two, whose home life I putatively shared, and the lonely kid I was got to me. By late adolescence, I had reasoned my way out of any overt resentment by thinking of my parents as "friends."

I started at Trinity School in the first grade and continued through my sophomore year. Two distinguished Trinity alumni were Humphrey Bogart and Truman Capote, though I don't think either of them was enrolled for more than a year. In a second-grade pageant I was pulled into costume for a tableau vivant of Hans Holbein's portrait of *Edward VI as a Child*; I hated the chubby Edward

and his ill-fitting attire, wanted instead to be Thomas Gainsborough's hand-some *Blue Boy*, so confidently poised against romantic English weather. Another defeat for me was the marriage of the fifth-grade teacher, Mr. McLeod, who had landed with a unit at Omaha Beach on D-day, to the heartthrob brunette first-grade teacher, Miss Johndreau. Around where Trinity sat on West Ninety-First Street, its Beaux-Arts entry behind a black-painted iron fence and backed by the dusty vacant lot that served as our football and baseball practice field, the neigh-borhood was home to Puerto Ricans who, during the forties, formed a new urban underclass. There were gangs, or anyway groups of older Puerto Rican boys, who made getting to and from the bus stop a risky business. Across Ninety-First, in an open window on the third floor of one of the brownstones, a dark, skinny woman in scant attire would show up sometimes and dance, gesturing seduc-tively as we stared in awe from our classrooms. The headmaster, Matthew E. Dann, instructed us to ignore her, that she was deranged. Periodically, someone would file a complaint and the police would cart her away.

School was a perpetual test, with its admixture, balanced or not, of wary affections and outright cruelty. At our fiftieth reunion, Charlie Kapp, the class science whiz, and consequently a mystery to the rowdier types among his peers—including me, it seems, in my beast mode—asked me what sort of writing I was doing, and when I told him poetry, he leaned close and said, squinting through some long-nurtured rage, "I would have thought murder stories." Administrative cruelty, too, was part of the learning process. At the same reunion I saw Bill Scully, who, for most of our grade-school years, formed with Mason Hicks and myself a fairly inseparable neighborhood threesome—"best friends," the phrase that weighed heavily then. As we talked at the reception, sampling one another's life sagas after so many years, he started, "I don't know if you remember that day . . ." "I never forgot it," I shot back instantly. "Good," said Bill. The day we both had in mind began with Bill's being yanked out of the line for morning chapel and told to leave school for lack of tuition payments. Bill's family—his gentlemanly father; kind, delicate mother; and two brothers, John and Tom—had fallen on hard times. For the next three years, until reinstated on an athletic scholarship, he went to PS 6.

Religion was never discussed in our home, but somehow, without instruction or any clear image of what divinity involved, I entered early into a special kind of direct communication with a higher being. In these top-secret meetings I mostly asked for whatever further privilege I could imagine. Some confusion arose when I asked what was the sword-wielding, black figure depicted in a Tibetan thangka hanging above the bar in our library and my father casually told me it was "some kind of God." Surrounded by only monotheisms, I took this to mean the God of

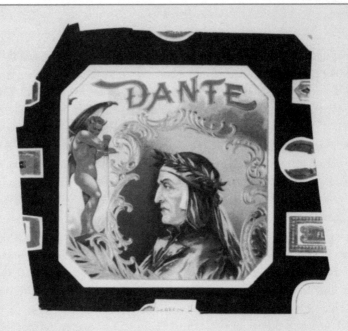

Red Devil

The red devil perched with his sword
a little to the left above the profile of Dante
on the torn square of wrapping paper pinned to the wall
that shows a series of Italian cigar-box labels—
Dante is one of them, as "en Veil" at the tear-edge is another.
Dante wears his customary, slightly pinched, fierce "fuck you"
expression which is not directed at anyone personally, the viewer
but registers inner struggle toward thought and concentration.
The Red Devil was one of a string of Italian restaurants
around Broadway in the theater district circa 1950 where I
used to go for supper with my parents between Sundaymovies.
It was my favorite for spaghetti and meatballs
and within easy walking distance of the best theaters—
The Rialto, Strand, Roxie, Paramount, Capitol and Loew's State.
My father had lived and worked in Rome during the '30s,
he so enjoyed speaking Italian with the jovial hefty waiters,
and I would have Chianti mixed with water like a real Italian kid.
By the door and on the front of the menus was a red devil,
the piquant muted red of spaghetti sauce.
One time as we were leaving the place, getting on our coats,
there was a tall stately brunette standing near us,
adjusting her mink wrap. She was sexy, I was 12, I froze
and gawked. Then I noticed my father looking at her too
with a funny light in his eyes. I don't know which way my
mother was looking, but for a split second my father's look
and mine clicked, and he gave me a very knowing glance.
I felt something slip into place.
It was our first shared joke as men.

Bill Berkson

the orthodox, the one sung about at Trinity in chapel every morning as "our help in ages past / our hope in years to come." This flaming skull stomper didn't look very "onward-Christian-soldier" to me. At about age ten, to my parents' shock, I began attending the Church of the Heavenly Rest, partly because my life then centered on playing basketball on weekends and during holidays in the church basement. I soon became a confirmed Episcopalian. The heady rush of wine-and-wafer communion brought to every Sunday morning a deviant vertigo. Six years later, when I graduated from high school, my parents, respectful of my beliefs (which, unbeknownst to them, had been almost completely dispelled), gave me a lovely Salvador Dalí ink drawing of the Crucifixion.

One Friday night, aged about eleven, I was walking down Madison Avenue with a couple of friends, planning what to do the next day. Whatever activity was effectually proposed, one friend said that if that was the plan it would leave him out, and when asked why, answered matter-of-factly, "Because I'm Jewish." When, at breakfast the next morning, I told my parents of the incident and asked what my friend had meant, my mother abruptly said, "Ask your father. He's Jewish." I looked at them both in amazement. Then again, at our summer home in Port Jefferson, Long Island, I discovered the further mysteries of Irish Catholics—the McAllister tugboat dynasty from Brooklyn—and the Mass, getting tangled up trying to match beautiful, older Ellen McAllister's swift manner of crossing herself (Episcopalians genuflected but didn't cross), and the sinking sensation on hearing Brooke Etzel's mother sternly remind the two of us tender juveniles that Brooke would never marry a boy who wasn't Catholic.

The attempt at formalizing my spiritual bent collapsed after a few years during an equally fuzzy political awakening when I seemed instinctively to see through the official "police action" version of what the Korean War was about and watched every moment of the Army-McCarthy hearings on TV. The sermons delivered during church services by the Reverend John Large were abhorrent falsehoods in the face of what I saw plainly to be the case. Generally speaking, officialdom was rotten. Listening in the dark as Alben Barkley, the incumbent vice president under Truman, spoke at the 1952 Democratic National Convention, I got so choked up I switched on the light and wrote him a letter praising what I took to be his magnanimity and eloquence and within a week got a personalized reply. In late adolescence, I developed the habit of lecturing dinner guests on world events; although my views on these matters were inclined in ways that would horrify most of this audience, I must have been fairly diplomatic in putting them across because my mother would say afterward how impressed everyone had been by my good manners, "and so mature."

It occurs to me now that by limiting the number of books I read as a child I intensified what I retained of them. Except for newspapers, sports magazines,

and comic books, including Classics Illustrated comics, which I continued to buy well into high school, serious reading was for schoolwork almost exclusively. I remember liking *Stuart Little* (especially the part where a ring falls down the bathtub drain) and gazing at the illustrations in *The Wind in the Willows, Treasure Island, Black Beauty,* and *Lorna Doone* but never fully taking on the texts. Mainly I recall the poems assigned for memorizing: Milton's "On His Blindness," Shakespeare's "When, in disgrace with fortune and men's eyes," and the many speeches from his plays. Frank Smith's Latin lessons stuck, and Paul Bolduc's French course helped prepare my ear for French poetry and Jean Gabin movies later. But scholastics generally were a blur. I was interested in sports and dancing and girls. (Earlier—earlier than with most of my friends, it seemed—sex had reared its great and perplexing head.) From the movies, I learned glamorous codes of honor; tantalizing, cathartic revenge; and kissing that sometimes looked, as Edwin Denby would write, "as if love had said forever." (By age eight, I fell in love with the heartless Estella devastatingly embodied by Jean Simmons in *Great Expectations*.) Likewise, in Broadway shows I found (still do) the wonder, even more choked up, at anyone's stepping out and singing and dancing on a public stage. Friday or Saturday nights, often brandishing press passes my father doled out, my friends and I went to the neighborhood RKO, Loews, or Trans-Lux. Long weekend and holiday afternoons were spent in my room listening alone to records. Everything else I studied by osmosis.

Becoming a teenager, I experienced a sudden change of shape and aptitude. From an awkward mass of muscle, excess baby fat, big ears, and somebody's idea of a tough-guy squint, I turned into an agile thirteen-year-old whose features had

Bill with Connie Ullman, Brearley dance, circa 1956

come passably into focus. During summers, I developed strong legs from long bike rides over the hills between Port Jefferson and Setauket or Stony Brook to be with friends. A point of pride that year was getting an A for coordination in gym class.

Never having anticipated anything, I am always astonished when anyone has a plan. After eighth-grade graduation, I walked across the park with my friend Mason Hicks, who told me that he knew exactly what he would do when he finished college—take over his uncle's nylon-stocking business in Knoxville, Tennessee. This struck me as not just exotic but incredible. Later, another close friend, Dick Nye, told me that he would succeed by going on to Harvard Business School and marrying a rich man's daughter. Both did exactly as they predicted, and, as far as I have ever known, it worked out well for them. For my part, between eleven and seventeen I knew only that the world of business was out and I wondered what else, if anything, there was for me. What place for all this energy in life? My juvenile fantasies ran to playing big-league basketball (I was lucky to make the starting five at Trinity) or crooning from a bandstand, a pop singer (I'm an off-pitch monotone). The real-life alternatives, as I conceived them, were "beachcomber" and "soldier of fortune"—even so, the exact meaning of either term was lost on me. I was, as Paul Goodman would say, "growing up absurd." In fact, "grown-ups" almost always seem alien to me; perhaps due to my having been an only child precociously measured against people who, either by age or achievement, were steps ahead of me, I generally assume that I'm the youngest person in the room.

In my admissions interview at Lawrenceville I delivered my one prepared statement, "Mathematics has always been my nemesis!" Apparently, that classy turn of phrase worked well enough because I was admitted the following September. In Dawes House, the dormitory to which I was assigned, I fell in almost immediately with an elite group who made their collective mission getting and reading every book on the Modern Library backlist, the more dangerous the better ("dangerous" meant any sort of sex, spelled out or implied). Aside from the Joseph Conrad novels we were assigned in most English courses (the teachers seemed to value the Polish-born Conrad primarily as a vocabulary builder), we read much of Henry James, Radclyffe Hall, James T. Farrell's Studs Lonigan novels, Samuel Butler, André Gide's *The Counterfeiters* and *Lafcadio's Adventures* (the acte gratuit was hot), *Point Counter Point, The Sun Also Rises,* Jean-Paul Sartre's *Nausea*, and whatever we could get our hands on of D. H. Lawrence and Henry Miller. (Lawrence's *Lady Chatterley's Lover* and almost all of Miller's work, except *The Air-Conditioned Nightmare, Remember to Remember,* and *Big Sur and the Oranges of Hieronymus Bosch,* were banned, inaccessible except when smuggled in from France.) Salinger's books were instant favorites—not

just *The Catcher in the Rye* (which was of course about us, our preppie disaffec-
tions and furtive weekend adventures, and not the Christian allegory our teacher
tried to twist it into) but also the stories of the Glass family, especially "A Perfect
Day for Bananafish." Twenty years later, I set out to reread some of the books we
read then and wondered what we found there, beyond the glamorous fatalism
that seemed to go with the raging uncertainties and melancholy we were intent
on playing out.

It was a dark and stormy night, I was sixteen and pitiful. I went down to the
little office beside the front door of Dawes House and started writing. I had been
composing somewhat lyrical diaries for about two years, and fictitious sports col-
umns before that, but, as fate would have it, this was going to be a poem: "What
has love come to that it is played . . ." I wrote twenty-two lines. Some rhymed,
others not; it looked plausible. "But for a single tender thought / I'd die some-
day." The next day I showed my poem, now typed on an onion-skin sheet, to my
friend Mike Victor, who suggested taking it across the campus to Peter Fichter,
editor of the *Lit*. Fichter said, rather offhandedly it seemed to me, "I'd like to
publish this in the next issue. Do you have any more?" "Yes," I said, reeling. That

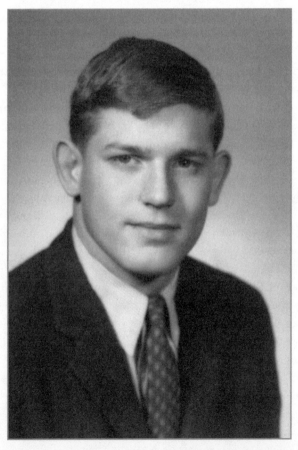

Lawrenceville
yearbook, 1957

I may have become a poet because of a precipitous lie makes for some contrition. I knew nothing of the lives or characters of poets then. I had no particular taste. I went ahead, cutting classes, sitting and breaking a cardinal school rule by smoking in my dormitory room, obsessively typing poems in just about every style and format I happened upon in magazines at the time. I wrote one called "My Father's House" and another called "Threnody in Dust." One teacher, Frank Rouda, who had a good jazz collection and smoked mail-order Picayunes, gave me access to his library: I borrowed books by Henry Green, André Gide's *Journals,* and Gertrude Stein's *Three Lives.* I began writing stories too. John Silver, whose wife Cathy I worked with later at *ARTnews,* read my poems carefully and lent me his thoroughly annotated copy of *Personae* by Ezra Pound, from which I got the idea of poems as narration rather than self-interviews or complaints, which my first ones had been. It must have been reading Pound that soon sent me headlong into T. S. Eliot, whose poems became the sources of most of my ideas, and education (I decided to read every work mentioned in the notes to *The Waste Land,* and then some), for the next year. Besides Eliot, I imitated the "Camera Eye" sections of John Dos Passos's *U.S.A.* trilogy and, like every other teenage modernist, the hyphenated patter of e. e. cummings. In a Princeton bookstore, I instinctively picked up books on Zen Buddhism by R. H. Blyth and D. T. Suzuki, *The Book of Tea* by Kakuzo Okakura, and the latest volume of William Carlos Williams's *Paterson.* In the midst of such absorptions I had a class with Thomas H. Johnson, the great Emily Dickinson scholar, gentle, informative, no ax to grind, but glad to encourage me in my tyro eagerness.

October of my senior year, Russian tanks went into Hungary, and James Michener came to lecture us about the injustice of this act. I was in my last semester at Lawrenceville and in danger of failing chemistry. When I argued that knowing chemistry would be of little use in my life as a writer, my father said, "If you're going to be a writer, you need to know everything." By a stroke of luck, I got the mumps during final examinations week and stayed in the infirmary listening to the deejay William B. Williams play Fats Domino on the bedside radio. The chemistry teacher, Mr. Davis (who had coached me as a half-mile runner the previous spring), visited to say I would pass his course without having to take the exam. Then Mrs. Healy, the headmaster's wife, came and handed me a note transcribing something her husband, Allan, had said at Fifth Form Tea the day before: "That boy has his doubts, but he's going to be somebody." At graduation, I won awards for Best Long Essay and Best Poem (the prizes were Lloyd Frankenberg's *Pleasure Dome,* a book of D. H. Lawrence's essays, and Eliot's *Complete Poems and Plays*). Under my picture in the yearbook appeared a trumped-up, not wholly inaccurate, motto: "Plato or comic books, I'm versatile."

In 1957 I went from prep school to college and from tweeds and khakis to blue jeans and an army fatigue jacket. That year everything moved ahead several paces with a synchronicity that still strikes me as impressive. Although at Brown classroom philosophy was limited to British empiricism ("John Stuart Mill to A. J. Ayer," as the textbook proclaimed) and psychology was behaviorist in the mode of Wolfgang Köhler and B. F. Skinner, there were moments of sweet relief. Gerald Weales glanced around the room on the first day of his course on the nature of tragedy and said, "You may not know it, but you are all existentialists." I knew because I had read *L'Étranger* by Albert Camus in French class at Lawrenceville and Colin Wilson's *The Outsider* that summer while working as fact-checker at *Newsweek*. But I also knew the excitement of finding that a literature of the moment was possible despite what had threatened to be an encirclement of dullness. "First came Patchen, then Ferlinghetti," as Ron Padgett recalls the initial jolts absorbed in different parts of the country by beginners like us, and even those first shocks superseded in quick succession by Allen Ginsberg, Jack Kerouac, Gregory Corso, Robert Creeley, John Ashbery—on down that ever-widening street. The dismal *New Poets of England and America* anthology appeared in 1957, but then so did, as if on cue, *On the Road* and the first four issues of *Evergreen Review*. On the cover of *Evergreen*'s third issue was a photograph of Jackson Pollock, who had died the previous August. Inside, along with pictures of Pollock at work, were stories by Patsy Southgate and Samuel Beckett, essays by Albert Camus and Alain Robbe-Grillet, and poems by Frank O'Hara, William Carlos Williams, and Barbara Guest. In the fifties, like many people, I had heard of Jackson Pollock—the name itself was memorable, and his method of working was notorious. Ed Neilson, a pipe-smoking literary type, sat in his respective dormitory making little paintings by dipping lengths of string in poster paints and then ingeniously dropping them.

Well-meaning and pernicious as stage mothers, most English teachers think it's just too great, if you are writing interestingly as a student, that you are writing at all. David Krause, an expert on Irish theater, was the first professor at Brown to encourage my writing. A review of Eliot's *On Poetry and Poets* published in *Brunonia* earned me permission to sit in on Hyatt Waggoner's graduate seminar on modern poets. S. Foster Damon, author of the concordance of the works of William Blake, was helpful in that, for his prosody course, he assigned simply the forms—the meter of Samuel Taylor Coleridge's "Christabel," dactylic hexameters, villanelles—to be filled by words in any order that fit, just to get the prescribed shape. John Hawkes gave me the first sense of professional conduct by saying one night after his short-story workshop let out, "You and Steve Oberbeck are the writers. You should spend more time together." In class, Hawkes urged his charges, with a slightly demonic grin, to write "out of [their] childhood fears." He had little patience with my Kerouac imitations but liked

my account of a friend's mad strategy for eliminating raccoons from his Florida backyard.

At Brown the people I knew talked about literature, social life, and current events (although events were stirring, we didn't have anything like a mentionable politics yet). Like jazz, contemporary poetry was a small-group topic. If art was mentioned it was something downhill at the Rhode Island School of Design where girl students wore exotic long hair piled up, and shawls, and gave surrealistic formal garden parties. (At one of those, Harry Smith, a Korean War vet and later editor of his own journal, the *Smith,* put the LP version of *Four Saints in Three Acts* on the turntable.) John Willenbecher, then an art history major at Brown, spoke admiringly of Harry Bertoia. What painting I saw coming out of RISD was likewise abstract. In retrospect, it follows that anyone becoming conversant with painting and sculpture at that time might tacitly accept abstraction as natural, art history having been defined pretty much as a connoisseur's chronology of arranging and rearranging significant forms. In the one such introductory course I took, understanding a Georges Braque still life (*Still Life with Red Tablecloth,* as I recognize it now) meant reduplicating and gluing down its pancake shapes in different shades of cutout construction paper. Of the slides paraded during lecture sessions, I remember looking especially hard at Raphael's *The School of Athens* (the traffic control amazed me), Michelangelo's Medici tomb sculptures, a radiant twenties Mondrian, and (just why I can't recall) *Agony* by Arshile Gorky. As with literature, modern art was more approachable, so one discovered the old masters through it, going backwards in time—or, more properly, circling around, since art history occurs not as a forced march, but as a field where acreage is worked as needed. Even so, educating myself from the present or near-present to the past, it took another fifteen years to arrive at a firsthand understanding of painters like the medieval and quattrocento Italians, whom I now see as so vital.

Richard Foreman and the beautiful, delicate Joyce Ann Reed were the stars of the campus theater group, Sock and Buskin. She was Antigone, he played Richard II and the father in *Desire Under the Elms.* Richard was often typecast as an old man. A third actor, the one who went on to serious roles on both stage and screen, was Raymond J. Barry, whom I knew first as the freshman in the room next to mine, a star athlete lifting weights when he wasn't deep in his philosophy texts. Likewise, Alvin Curran was already composing music; we wrote songs, words and music, for a dopey musical about the Boston Tea Party, proposed to us by another student, Jack Rosenblum, whose job it was to write the book, but he never completed it. The next year, Richard Kostelanetz arrived, mysteriously up on everything about criticism. Clark Coolidge, also there (his father chaired the music department), was a close friend of Curran's, but Clark and I never actually met until the late sixties. Another poet was Ken Snyder—intense, pure, laconic,

a Brando-type in style and looks, and mostly interested, as I recall, in D. H. Lawrence. "Don't blame everything on America" was the corrective Ken offered when I showed him my series of poems called "Forty Dead Days"; useful, it probably saved me six months or more of useless ranting. The editor of the newspaper, the *Brown Daily Herald,* was Wallace Terry, who in the later sixties reported from Vietnam for *Time* magazine and the *Washington Post.*

A slightly older student from Detroit, Jim Davidson, passed along Keats's nifty conception of the poet as a "chameleon" with no separate entity of self. Jim introduced me to my first Greenwich Village bar, Julius', a hangout for other gentlemen scholars like himself, most of them hoping to succeed as editors for the big-time publishing houses or copywriters in advertising. Hampered by

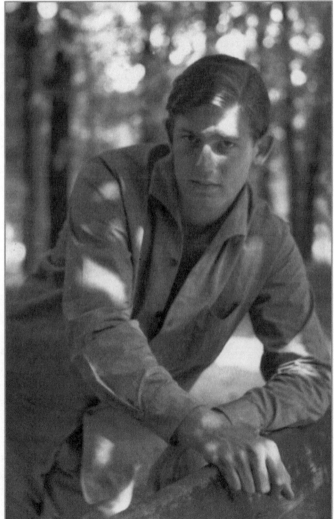

Photograph © the Estate of Peter Fink

Bill in Paris, 1959

a trick knee that worsened when he drank, he was found dead a year later on the tracks of the Broadway-Lafayette subway station. "Fell or was pushed," said the police report. Together with another friend of Jim's, Lynn St. John, I was summoned at dawn to the city morgue to identify the body. Except for a small, red wound on his forehead, he didn't look any different.

During Thanksgiving break in 1958, I visited San Francisco with my parents, ostensibly to secure a summer job on one of the newspapers but really to search out the writers I thought would be there. North Beach was jammed with tour busses. I stood dumbfounded in the Place; asking the bartender if Gregory Corso or Allen Ginsberg might be around, I was given an unexpected clue: "They're all in New York, man!" I had been misled by Jack Kerouac's having transposed the actual events of *The Subterraneans* from Greenwich Village to North Beach. The only San Francisco poet I saw plain that night was pointed out to me after the bars closed: Jack Spicer, shoulders hunched, standing alone in the 2 a.m. fog on the traffic island at Broadway and Columbus.

January 4, 1959, the day my father died, I left Providence and returned—was summoned, is how it felt—to live full-time in New York. I had just entered the apartment I shared with a couple of other undergraduates on Williams Street when the phone rang. My mother, calling from San Francisco in tears, told me he had suffered a heart attack, fatal unlike the one that had struck him a little over a month earlier, just after Thanksgiving. This happened just before the era of transplants and bypasses; in November, all the doctors could do was keep my father from chancing the stress of travel, so he had stayed in San Francisco through the end of the year. He was approaching his fifty-fourth birthday, the publisher of the *New York Journal-American,* a handsome, charming man, serious about his mission as a journalist, otherwise happy on weekends catching flounder, bluefish, and porgies outside the Port Jefferson Harbor breakwater on Long Island Sound. As I came of age, we had our differences. Once, when I expressed my newfound pacifism at the dinner table, he denounced me as "a pigeon for the Reds." Another time, we came to blows over a misunderstanding, and I finished it by hitting him hard, bruising a rib. Our last conversation of any length was on the telephone on Christmas Eve; he greeted me gently from a room in the Mark Hopkins Hotel with his quaint Chicago idiom, "Hello, bub." (We discussed the book I had sent him a few weeks before, Boris Pasternak's *Doctor Zhivago.*) In Providence, as I went down the stairs, seeing one of my apartment mates coming up, I blurted out, "My father has died. I'm going to San Francisco and then New York, and I don't think I'm coming back." For me, my father's memorial service was a numb affair, but I was struck by how many people, in particular friends my own age, turned out that day at Frank Campbell's funeral chapel. Mainly, I was

concerned for my mother and grandmother, both of whom were hit hard, and more immediately than I, by the loss.

Spring semester, 1959: Having quit Brown, my plans included transferring to Columbia, but secretly I wanted to experience firsthand the steam-heated life of poetry and some other, seemingly connected fantasies of an accelerated life. This other New York culture, despite its happening practically in my own back-yard, was far from my original, rather checkerboard bearings on the Upper East Side. It existed for me as occasional nights in MacDougal Street coffeehouses and jazz at the Five Spot (Thelonious Monk opened there a month before my eighteenth birthday), the Half Note, and the Village Gate. For the music at least, I had an ear, but the places were just drab rooms; no context enveloped them or their occupants, except of course the unifying factor of everybody keeping New York time.

In the delay before entering Columbia in the fall term, I decided to take classes at the New School for Social Research. Searching the catalogue, I saw that John Cage, whose name rang some distant bell, was teaching experimen-tal composition in a classroom at the school's Twelfth Street headquarters and, in the woods near his house in Stony Point, a course in mushroom identifica-tion. Pointless now to wonder if I didn't play it safe by signing up for, instead of one of Cage's offerings, William Troy's relatively standardized modern poetry course (for which I eventually wrote a paper trying to figure out William Carlos Williams's "variable foot"), Rollo May's Zen and Existentialism, and a poetry workshop taught by Kenneth Koch.

Kenneth's class was held in the afternoon. Sitting very upright at one end of the long table, he invented as he went, uncertain in spots, but with surges of glee at the edges of his thought. (The slight stutter, which seemed integral to his personality then, was later cured by extensive psychoanalysis.) Part of each les-son, the fun and suspense, was watching him steer the language toward describ-ing graphically the pleasurable aspects of the poetry he liked—the poetry of Walt Whitman, Arthur Rimbaud, William Carlos Williams, Wallace Stevens, W. H. Auden, Federico García Lorca, Boris Pasternak, Max Jacob, and Guillaume Apollinaire, as well as of his friends Frank O'Hara and John Ashbery. Then, too, he would make an analogy between some moment in a poem and the sensibilities of New York painting—the amplitude of a Willem de Kooning, Larry Rivers's zippy, prodigiously distracted wit, or Jane Freilicher's way of imagining with her paint how the vase of jonquils felt on the window sill in that day's light. All of these things would dovetail into the writing assignments Kenneth gave us, which were designed to (and really did) help precipitate and sustain energy and surprise in our poems. In the margins, next to certain passages, he wrote com-ments with a pencil, like "Good," "I like this," or "Maybe cut this," "Too digestive"

(anything visceral or suggestive of sex in a tortuous way was apt to be jettisoned). In conversation he cast a withering glance on anything suspect of exaggeration or pretense. His suspiciousness was offset by the fullness of his commitment to whatever pleased him as beautiful and true.

At the Cedar Bar one spring afternoon, I introduced myself to Larry Rivers, not only because Kenneth had mentioned him, but because I had seen a photograph of him and Frank O'Hara collaborating on lithographs. The man I spoke to wasn't Larry but another painter, a near look-alike, named Friedel Dzubas. That was the beginning of a beautiful friendship. The reason I had wanted to meet Larry was that, based on the little I knew then, I had decided that he represented the most dynamic conception of what it meant to be an artist: much

Photograph by Mario Schifano, © Archivio Mario Schifano

Left to right: Bill, Patsy Southgate, and Kenneth Koch, 1964

handiness, restless curiosity, sophistication (hip), a life and an art both zoom-
ing full tilt, and the nerve to sustain a daily overload of what was then called
the Absurd (the spillover, mostly, I would later realize, of a frenetic self-regard).
I was going on twenty; in a few months Larry would write an autobiographical
essay for *ARTnews* with the sentence, "When you're twenty you want to be some-
body, when you're thirty you want to do something." Just about on target for the
limitations I didn't know about and anyway wouldn't have acknowledged then.
I thought from seeing his paintings that Larry Rivers must be the sharpest per-
son alive, but when I got to know him he seemed as confused as anyone else, not
sophisticated at all. How could that be? Frank said: "Maybe he's just come out
the other side."

Fast and furious—the general quality of forward motion in early sixties home-
town art set the pace for my extended initiation into the facts and mysteries
involved. The endlessness of getting to know New York painting was simi-
lar to that of finding out about poetry; in both there was always, so to speak,
more at the door. The difference for a follower of painting has to do with the
apparent contradictions of style and attitude that follow from the art world's
prodigal, souped-up sense of fashion and generational shifts. In May 1959 at
the Janis Gallery I met painting in the form of Willem de Kooning's landscape
abstractions. John Cage's *Indeterminacy* was issued on LPs, and John Ashbery's
long knockout poem "Europe" was just around the corner (it would appear in
Big Table the following spring), as was Donald M. Allen's *The New American
Poetry*. Toward Christmas I drifted into the Stable Gallery on West Fifty-Eighth
Street and screwed up my face before Rauschenberg's *Monogram;* the whole
arrangement—wooly stuffed goat, car tire, canvas-covered platform with letter-
ing on it, sad daubs on the goat's face—signaled one vector of the shift occurring
under my feet.

The best poem I could imagine then would have something like those de
Koonings' expansiveness and speed. A year later, seeing Philip Guston's work—
especially his drawings, with their slower accumulation of image—I was struck
in a different way. The mass effect of his line was more like a confirmation. In
the case of de Kooning, I felt, "Oh God, I'd love to write like that, but I'd have
to hurry up." I wasn't fluent at that level. Whereas with Guston I felt, "I do write
like that," having some inkling of his process—a fellow inchworm!—"and
there's something in it, too!" Something similar occurred in reading and know-
ing Frank O'Hara and loving his incredible acumen; I tried to approach it but
couldn't hold on. I had to realize that, attractive as Frank's quickness was, I didn't
work that way. My drive was more stubborn, contemplative, and I wasn't so con-
vinced about what the subject matter was. I couldn't say, as Frank did, "What is

happening to me goes into my poems," which implies an instantaneous sweep approaching the speed of light. But I could say, with Guston, "I want to end with something that will baffle me for some time" and "I really just want to nail something down so that it will stay still for a while."

Pretty soon life in this expanding universe became identified with Frank O'Hara and his poems. I was crazy about Frank's poetry. The poems I was writing were largely amalgams of what I saw in his and Ashbery's work—and it was plain how he figured in the ambience known to its inhabitants as "downtown." Of the New York poets, he was the one who was most, in Franz Kline's phrase, "around it." Aside from his own poetry, Frank was the enthusiast insider whose normal workday at the Museum of Modern Art was buoyed by his approaching it as if it were a composite of salons at the court of Louis XIV and the thirties Warner Bros.' lot. I met Frank because one day after class Kenneth suggested that I accompany him and his wife Janice to a party given by Jane Freilicher and Joe Hazan. (Others at the party would have included Ann Troxell, Harry Mathews, Fairfield and Anne Porter, Kenward Elmslie, Joe LeSueur, Jimmy Schuyler, Alvin Novak, John and Jane Gruen, Alex and Ada Katz, Larry Rivers and Maxine Groffsky, Nell Blaine, John Myers and Herbert Machiz, Morris Golde, Arnold Weinstein, and Barbara Guest and Trumbull Higgins.) By the end of the next year Frank and I had become fast friends. I quit Columbia and went straight to graduate studies as an office worker at *ARTnews*. A frame of reference was rapidly getting knocked together. Like professional sports, the art world, small and intense as it was then, bred insiders overnight.

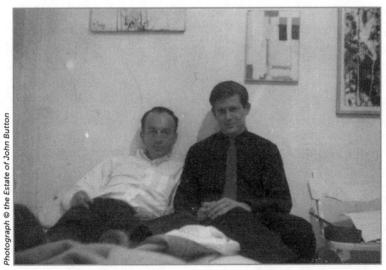

Photograph © the Estate of John Button

Bill with Frank O'Hara, 1961

primitive American sophisticate
—confused at times, never really crazy

I immersed myself in rounds of lofty chatter, alcohol- and vanity-fueled weeps and rages, raw camp, and cooler, subtler forms of intelligent behavior, all of these oddly bundled, often indistinguishable. My experimental character was by turns sweet, sharp, and silly or stiff, sullen, and occasionally quite nasty. (The Beast again, but this time chin-to-palm and haughty, like young Arthur Rimbaud in Henri Fantin-Latour's *Un coin de table*.) I was way ahead of myself. Everyone I met was interested in sex and seemed to assume it could take any direction or form, depending on the circumstances, which were limitless, even if one's preferences weren't. I liked unhinging people's assumptions about how consistent anyone's character ought to be (though I was troubled when John Myers accused me of not having any). I loved the show-stopping energy release of sensibility outrageously charged in that perhaps compensatory way I knew previously only from black music. Frank had a funny way of lauding such obstreperous behavior, mine or anyone else's, as "cute": "Joe was so cute last night. Guess what he said to Norman at Mike and Patsy's!"

Try it this way: Even though my parents were newly, and not even conspicuously, affluent, I come from a level of the urban upper-middle class that, for generations, bred extraordinary dimness and repression. A level from which, to live, one must go down, or up, or out. I was not good at down. Up meant aristocratic pretenses or dandyism. Out meant crazy, drugs, fast cars—some form of excess, or maybe art. One needed "out" from the doldrums of blank, uninflected young adulthood; anyway, in my early twenties, although pretty clear about my sexuality, I wasn't quite a "man" yet. I remember thinking that a new style of artistic dandyism was possible; it went with "bespoke" suits from Burlington Arcade, elegant women, and the kind of artistic persona I was constructing in my (like they say, "playful") poems. But to be a good dandy, one must lose circumspection (that side of so-called common sense) and watch only the self-fabricated from the outside in. There's no gainsaying advantage.

Frank's feelings for concert music, especially French and Russian (Gabriel Fauré, Francis Poulenc, Sergei Prokofiev, Sergei Rachmaninoff, Alexander Scriabin), and for suave or sentimental thirties movies were infectious, as was his habit of getting all worked up, gasping and crying at the ballet just as at any vehicle for Greta Garbo, Ruby Keeler, or Louise Brooks. I took to the wonders of George Balanchine, and modern dancers like James Waring, Merce Cunningham, Paul Taylor, and later the Judson Dance Theater group, especially Yvonne Rainer, on whom I developed my first aesthetic crush. An exquisite bonus in those days was attending the Little Players' shows, including their riveting *Macbeth*, given for subscription audiences by two puppeteers in their living room

on Central Park West. Downtown, at the Cherry Lane, first Ruth White, then Lucie Madeleine Renaud appeared as Winnie in Beckett's *Happy Days*. (For one night only, Renaud was joined by her husband Jean-Louis Barrault as Willie.) Rudolf Nureyev and Margot Fonteyn rocked the Met. Of the New Wave filmmakers, before Jean-Luc Godard hit his stride, Michelangelo Antonioni was the genius that everyone, painters especially, talked about. My appointment calendar for a typical week (winter 1961) lists going to see a new French movie (*Zazie dans le métro* by Louis Malle); the New York City Ballet at City Center; an evening at my place with Frank, Joe LeSueur, and Norman and Cary Bluhm to watch a Busby Berkeley musical on TV; a raft of lunches; two big midtown art parties (Earl and Camilla McGrath and Fay and Kermit Lansner); a Saturday date at

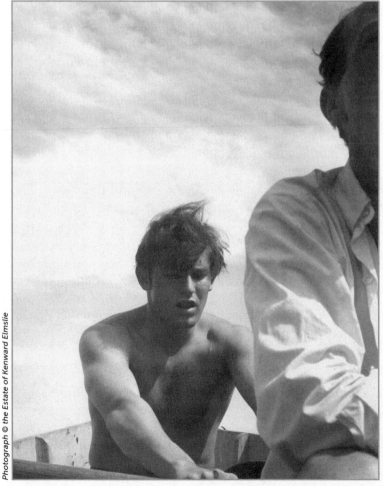

Photograph © the Estate of Kenward Elmslie

Bill rowing with Frank O'Hara at the Prow, Water Mill, 1961

the tropical gardens; and Mingus at the Jazz Gallery after. A couple years later, at a benefit for Amiri Baraka at the Living Theater (money for legal fees to clear *The Floating Bear* of obscenity charges), Frank and Morton Feldman played four-hand piano. Frank told me that he sweated out trying to lay his fingers as softly as Feldman could on the keyboard. Feldman's hands were big; it was remarkable that he could make such quiet sounds as his pieces required and that his own large fingers could muster.

My first book, *Saturday Night: Poems 1960–61,* came about because John Myers said to me in his gallery one day that winter, "I want you to give me a book of your poetry to publish." "But you don't know my poetry," I replied. "It doesn't matter," he protested, "you're in the air!" My poetry was changing so rapidly in my own estimation of it that none of the four or five poems I had published by the time John offered to do the book actually made it into the manuscript, which anyway John accepted without comment. Indeed, the only remark he ever made to me about the work was occasioned by my reaction to the schematized American-flag graphic he surprised me with, using it for both the front cover and the title page. We had hit an impasse in discussing which artist was to design a cover and/or frontispiece. I wanted Jasper Johns or Norman Bluhm, but Johns was somehow out of reach and Bluhm had too rocky a business history with John and Tibor de Nagy. Besides, John, logically enough, wanted an artist affiliated with the gallery, which eventually disqualified all of my choices.

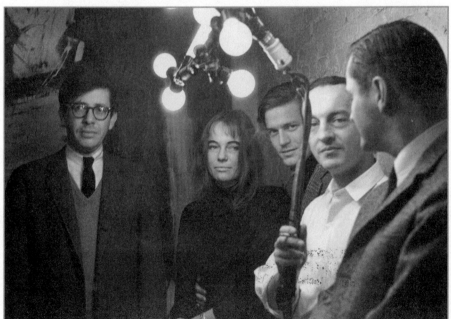

Photographs by Mario Schifano, © Archivio Mario Schifano

Left to right: Kenneth Koch, Patsy Southgate, Bill, Frank O'Hara, and John Ashbery, with a lamp by Larry Rivers, at O'Hara's loft, New York City, 1964

Finally, I thought John would just come up with something by someone appropriate. But a drearily offset no-star flag image presented after those already epochally unfurled by Johns and Rivers? Proud though I was of the book as such—the first copies arrived from a Venetian friars' print shop two months before my twenty-second birthday—that red, white, and blue ink job made me sick, and John Myers compounded my queasiness by saying when I confronted him about it, "Your poems are as American as apple pie!"

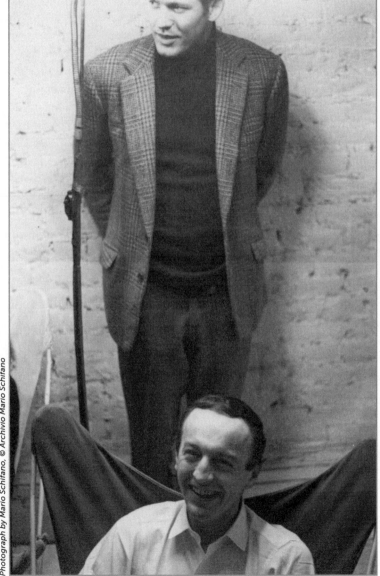

Photograph by Mario Schifano, © Archivio Mario Schifano

Bill with Frank O'Hara, 1964

But "Hey," de Kooning said, taking the book I had just signed for him and seeing the dropout title lettering on the cover in the blue field where stars would be, "I did a painting called *Saturday Night* too." "Don't I know it!" I beamed back at him. Indeed, the book could be read as an account of my art-and-poetry education to date. Titles of the poems ("Christmas Eve," "October," "Russian New Year," among others) reflect variously de Kooning's (and O'Hara's, Koch's, and Schuyler's) usage of the names of days and months in titling works that may or may not otherwise directly refer to them. Cage's radio pieces suggested the idea of a simultaneity on the page of blocks of text entering from several vectors. Then, too, I was finding out about composers like Charles Ives and Anton Webern and Igor Stravinsky through the ballets George Balanchine made on their music. In the early sixties I put LPs of Ornette Coleman and Webern on the turntable while writing. I wanted to emulate in prosody something like the "events" and silences in Webern and Feldman, the "interruptions" I imagined in Cage, and the chortle-and-hrumph-provoking, double-take chords of Thelonious Monk. Through Ives, meanwhile, I discovered my own taste for bumptious Americana, as well as the plausibility of willfully mixing idioms within a single work. Four years later, Ted Berrigan's review of *Saturday Night* in *Kulchur* magazine noted: "Special care is language, and fusing things going on in him and on his personal TV . . . " Fair enough.

Night life: Rendezvous Room, Stork Club, Palm, Jimmy Ryan's, Club Samoa, The Metropole, Penguin, Rough Rider Room, Club Fourteen, Madison Pub, Bon Soir, Cedar Tavern, Chez Madison, Clavin's, Malachy's, Frey's, Dillon's, P.J. Clarke's, Le Club, El Morocco, L'Interdit, Downey's, Ondine, Bowl-a-Bite, Egyptian Gardens, The Brasserie, Isle of Capri, Casey Lee's, Peppermint Lounge, Wagon Wheel, Small's Paradise, Five Spot, Half Note, Birdland, Jazz Gallery, Armando's, Elaine's, The Dom, The Blue Angel, Sardi's, The Russian Tea Room, King Cole Bar, Carnegie Deli, Carnegie Tavern, 20 Grand, Hickory House, The Embers, Chez Regine, Shepherd's, Martell's, The Jumble Shop, White Castle, Riker's, Arthur, The Ninth Circle, Studio 54, Max's Kansas City, Sing Wu, Ratner's.

As my 1960s toodled along, I shuttled between downtown, where the artists and poets were, and the uptown parties, bars, and clubs where other friends, and most particularly the women I was attracted to, could be found. I had a terrific wardrobe, which put me often in debt. If my "Fifth Avenue consciousness, Roman-coin personality, and messy mind," as Larry Fagin once described them, kept me at a distance from the downtown artists' way of life, they also kept me from cracking up. When I went searching for my own apartment in 1961, Kenneth Lane told me about a single room with a roof terrace five flights above a drugstore

at 124 East Fifty-Seventh Street, between Park and Lexington, for sixty-two dollars a month. Later I had a second, slightly larger place on the second floor in the same brownstone until 1968, when the building was sold to Fortunoff. I remember feeling that having this place sold out from under me was tantamount to an identity crisis. In fact, it was just that. I moved to a small ground-floor apartment at 107 East Tenth Street, a block away from the Poetry Project at St. Mark's Church.

Flashback and fast forward: My grandmother had died in 1963 and left me $500, which I used to go to Europe that spring. I left *ARTnews,* spent part of the summer in the South of France, Venice, and Veneto, and, with Maxine Groffsky's help, found an apartment in Paris on avenue de la Bourdonnais, near the École Militaire. I enjoyed the nightlife in Paris, but nothing of much purpose happened there, not a single poem that I can recall. I do recall October 11, the day that first Edith Piaf and then Jean Cocteau died, and sitting on the terrace of the Café de Flore with John Ashbery as, one by one, the newspaper editions appeared, carrying the news that—progressively, as the air was full of it—saddened all of

Easter Sunday Poets Softball, Staten Island, 1969: *back row, left to right,* Peter Schjeldahl, Jim Carroll, Linda Schjeldahl, and George Kimball; *third row, left to right,* Susan Kimball, Lewis Warsh, Anne Waldman, Ted Berrigan, George Schneeman, Dick Gallup, and Carol Gallup; *seated, left to right,* Tessie Mitchell holding Emma Rivers, Katie Schneeman holding Gwen Rivers, Sandy Berrigan, Bill, Ron Padgett holding David Berrigan, and Pat Padgett holding Wayne Padgett; *front, left to right,* Emilio Schneeman, Joan Fagin, and Elio Schneeman

Paris. In late November came more news, this time of the first Kennedy assassination, with the French press going straight to conspiracy theories. Toward the end of my stay, I heard from Frank that Kenneth, who by then was teaching full-time at Columbia, had suggested that I apply to teach a poetry workshop at the New School the following year. I started that summer. I was twenty-four. At least half of the students over the next five years, those that weren't men or women in their forties or older, were about the same age as me, so although I'd had a faster orientation, we were mostly starting from the same scratch. That workshop became a protracted realignment of my feelings for what poetry could be, as well as a place where friendships with my peers became newly possible. Through the New School connection, I got to know Ted Berrigan better, and Anne Waldman, George and Katie Schneeman, Jim Carroll, and John Godfrey, none of them students, but friends, for all our comings and goings, for life.

 My voices always tell me when it's time to move, and where. "Now you have a cabin," said Bill Brown as he and Jack Boyce inspected the exposed beams of the kitchen ceiling at 230 Fern Road, the little house I bought in 1971 from a Sacramento asparagus farmer and his wife, who had become too old and infirm to travel there for seaside weekends. The previous year, feeling I had exhausted New York for myself, I told my mother of my plan to try living in California for a time and the feelings that prompted this decision. "I don't care how you feel," she responded, "I think it would be good for your work." In June, I landed in Bolinas and set about awkwardly negotiating the ways of small-town life as modified by intense, period-style open-house gatherings, intense local politics, nonstop musical accompaniment, and drugs. From the curb, as Jim Carroll and I geared up for the drive across the continent from Tenth Street, Ted Berrigan sneered, "What are you going to do out there, raise chickens?" Stopping briefly at Allen Ginsberg's farm in Cherry Valley, we asked Allen about life in California: "Just don't take snapshots of yourself," he said. A month or so later, I stood in a phone booth on Elm Road talking with Tom Hess in New York about writing on Philip Guston's new pictures for that October's issue of *ARTnews;* probably sensing how abstract the occasion was for me, Tom signed off with his own caution, put delicately: "Don't get lost out there." After a few months of drawing complete blanks as to what to say or do, confronted, as I felt I was, by the large question of what space exactly I intended to fill or delineate, I sat with Joanne Kyger, who, recognizing my thoroughgoing displacement, said simply, "You don't want to be looney." Eventually, after a somewhat prolonged phase of disorientation and determinedly inert, monkish self-reflection (hampered by what Ted Berrigan smartly diagnosed as "pronoun trouble"), I decided to go with what I had.

A pretty village bounded by Mount Tamalpais on one side, a lagoon on another, and the ocean on a third, Bolinas figures existentially a few miles beyond Brigadoon along the road to Arcadia. It is of course not all that smooth: there is weather, famously temperate but made of fog and more fog driven off in turn by nerve-wracking winds, long weeks of rain, and with all that, cabin fever; there is also little regular employment to be had and an often balefully narrowing worldview. (Not that the famously jack-hammered sensibilities of city dwellers guarantee any larger scope.) The literary scene that developed in the early seventies was contradictorily so broadly based in those who came singly or as couples to live there—Lewis Warsh, Tom and Angelica Clark, Robert Creeley and Bobbie Louise Hawkins, Joanne Kyger, John Thorpe, Jim Gustafson, David and Tina Meltzer, Duncan and Genie McNaughton, Philip Whalen, Aram and Gailyn Saroyan, Lewis and Phoebe MacAdams, Jim Carroll, and so on—that there could be no unified poetics, and hence, happily, no "school." (This, despite rumors circulated by the early eighties of the insidious "New York–Bolinas Axis" that ruled American poetry in quarters extending from penthouse to woodshed.) Instead, our socializing, aside from the intermittent living-room or kitchen-table poetry fest, consisted of discussing firewood or septic tank practices and passing around books. "What do the poets do?" asked one resident; before a week had passed, she came up with an answer: "They talk a lot and laugh at what they say."

230 Fern Road, Bolinas, California

Once settled on Fern Road, during a perceptible lull in small-press publishing, I began Big Sky. Joe Brainard's *Bolinas Journal* was the first Big Sky book, soon followed, at Lewis and Phoebe MacAdams's suggestion, by John Thorpe's first collection of poems, *The Cargo Cult*. The name of what turned out to be both a magazine and a press for poetry books, postcards, and broadsides was suggested by the breadth of the starry sky as seen on clear nights from the Bolinas mesa. Then Tom Veitch reminded me of a line from a Kinks song, "Big Sky looked down on all the people." (By the time it was over, Big Sky was credited with being a "bridge" between the East and West Coasts, or, more scandalously, representative of the aforementioned transcontinental "Axis.") For the magazine, I had wanted a comic-book format, which proved impractical for small print runs. Another impracticality was my original editorial stance of printing whatever arrived from those invited to contribute. After two chaotic issues, I put this policy on hold by devoting the next number solely to Clark Coolidge's work. With the fourth number—bearing its great wraparound Philip Guston cover and strong contributions by Creeley, Padgett, and Bernadette Mayer—I hit my stride as an editor. That was 1972. Six years later, after twelve issues of the magazine and twenty books, I decided I'd done the job.

Baffling for almost everybody were the courtship procedures in what Ed Sanders called "a psychedelic Peyton Place." For those used to the relative anonymity of a big city, Bolinas then had next to no neutral corners—no movie theater or jazz club or crowd in which to get lost, just "the bar" (Smiley's, by name) and group gatherings at assorted houses. Even before my arrival, mutual friends had more or less directed Lynn O'Hare and me to be a couple, and indeed, "earmarked" as we were, we took to each other immediately. Two years later we were together, and in another two, married. It was a good match until, sadly, with one thing and another, it wasn't. Our son Moses was born in our bedroom in January 1976. Another specific delight was adopting Lynn's daughter from her second marriage, Siobhan, a.k.a. Chou-Chou, the youngest of my "instant family," which included Andrew and Lisa, both from Lynn's first marriage. Larry Kearney said: "Welcome to the wonderful world of family living." The cabin gradually expanded in two directions plus gained an upstairs and a couple of outbuildings. For over twenty-two years—allowing for times spent away in Mexico, Rome, and an odd year on the South Fork of Long Island— Lynn and I made a life there. *Lush Life,* the book Kenward Elmslie made of poems I wrote between 1975 and 1983, is dedicated to her, and the extended prose of *Start Over* is about the joys and perplexities of being, as they say, head of a household.

The things you do by the time you're in your fifties are either fewer, by way of refined possibility, or more various. Risking scatter, I've been inclined to do

Big Sky no. 1, 1971

Bill with his daughter, Siobahn,
New York City, 1973

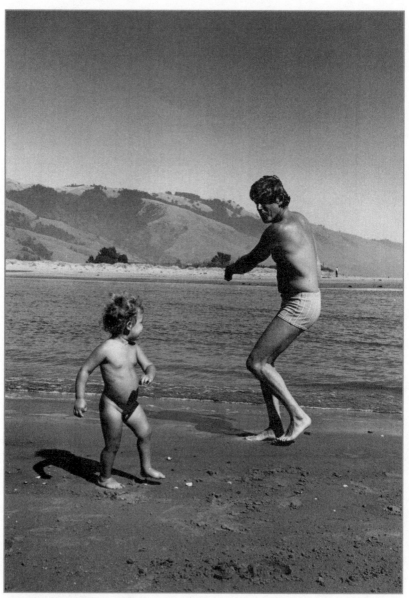

Bill and his son, Moses, on Bolinas Beach, 1977

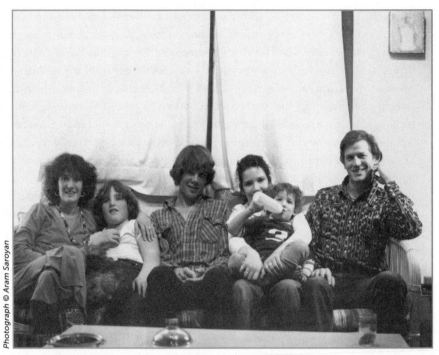

Bill with his first wife, Lynn O'Hare, and, *left to right,* daughter, Siobahn O'Hare; stepson, Andrew Kleinberg; stepdaughter, Lisa Kleinberg; and son, Moses Berkson; 1977

Bill and Lynn, 1991

more. By the late seventies, with the American economy tightening after the OPEC crisis, the sweet-doggy life of reading, writing, random house-to-house visiting, and occasional odd jobs became untenable. For me, it had meant mostly short-term poetry residencies in public schools, plus shorter stints as a bookstore clerk and freelance copy editor. Friends left to find work, some to pursue get-rich schemes of writing for the movies in L.A., others to get PhDs, thence to infiltrate academia as a power base for whatever idea of poetry they espoused. Arthur Okamura suggested that, with my background in the art world, I could teach at an art school. I began with a graduate seminar in art criticism at the California College of Arts and Crafts. Then, in 1984, Jan Butterfield phoned to say she was leaving her position at the San Francisco Art Institute and asked if I would be interested in replacing her. She described the job of organizing public lectures throughout the school year and teaching courses in contemporary art. "Sounds like regular work," I said, which was what I wanted. "It is," she said. I taught there for twenty-four years. Teaching is probably the most efficacious, painless link to the world away from writing poetry. (Especially, I found, the theatrics of teaching art history with slides, as opposed to sitting at a table behind a pile of books or student manuscripts.) Administrating, which I did at times (interim dean for one year, director of Letters and Science for four), is less healthy because, although it's nice to find that you're capable of such things as diplomacy and planning ahead, it demands so many small points of focus and, conversely, eats up miles of mental space. Teaching never keeps me awake nights, unless for good reason, like springing a fresh idea.

Morton Feldman's "Let's make music into an art form" is applicable to poetry. Whenever I taught poetry at the Art Institute, all but very few of the students seemed to take writing poetry as a relief from the stress of making artworks for studio classes and writing papers for the required humanities curriculum. That is, they didn't see poetry as an art. For myself, it took a spring and summer sabbatical after almost twenty years of lectures, seminars, and organizing public programs, together with a lot of articles for art magazines and museum catalogues, to confront whether writing poetry, supposedly my first order of business, fit, if at all, and whether I was even interested in it. In the early eighties Ron Padgett had said something to the effect that from then on, we would see, vis-à-vis continuing as poets, who would have the stamina. (That particular "we" referring to those then having entered or just entering their forties.) As if starting all over again, I found that writing poetry was the most interesting, and, no matter how maddeningly difficult, the most pleasurable thing, and that was a kind of renewal. In the past ten or so years I've written more poems and published more books than in all the previous years put together. In part, it has been that more doors in the art that poetry is have opened to me in whatever age span I exist, and the actualities they provide are more various.

About writing criticism, it seems, one must always be ambivalent. When I resumed writing for art magazines regularly in the mid-eighties, I made myself a promise not to act like a twenty-year-old chasing fires and instead to let the rumors of new artists come to me apace and then play my hunches. Getting back into writing more or less conventional expository prose was difficult at first, and I found myself so often surrounded at my desk by crumpled wads of paper, evidence of so many false starts, that I decided to get my first computer, a by

Bill with Jay DeFeo's *The Rose,* San Francisco, 1995

then outdated green monstrosity in the form of a hefty IBM XT clone. Art writing never gets any easier, but at least there was less paper waste. Writing reviews for every issue of *Artforum* over five years, I pounded the pavements looking for each month's story. It was interesting—at the end, I felt like Lou Gehrig, never missing a game—but enough was enough. I remember reading that Fairfield Porter fantasized that his art writings might make him better known as a painter; I've held out the same vague hope that readers of art magazines, if intrigued enough by my prose, would start looking for my poems—good luck. Virgil Thomson once said, "Writing a review is not giving an examination; it is taking one." The subject in question is whatever artistic occasion one has attended. In American education, starting with grade school, criticism, though not identified as such, takes primacy: first you write book reports, then term papers. But the adult professional critic is as liable as any artist to the rebuke Alex Katz once fired off about Morton Feldman's music: "What kind of thing is that for a grown man to be doing?" Contrariwise, to describe how criticism works I like to paraphrase Alex on painting: the words go across the topic, making discriminations.

I was a heavy smoker for forty years. In a late-December 1995 downpour in Madrid, crossing between the Prado and the Reina Sofia with Connie Lewallen, I had a sudden coughing fit and continued coughing and became feverish for the duration of Connie's and my travels in Spain and Portugal. On return, I was diagnosed with severe emphysema and told rather blithely by the examining pulmonologist that, at fifty-six, I was "too old for surgery." I had no idea what surgery might have been an option. Over the next nine years or so, as the disease progressed, I became shorter of breath, dependent eventually on round-the-clock supplemental oxygen, and lost a lot of weight and mobility. Connie's care and vigilance and good pointers from the nurses (pursed-lip breathing for shortness of breath) saw me through. Walking uphill became an ordeal. (Connie remarked that my sensitivity to the slightest rise in pavement made me a perfect surveyor's tool.) There were times of near panic when I would lean over the nearest available support—in the streets, this often came in the form of the hood of a car or lid of a garbage can—to regain what breath I had. I became neurotic about oxygen. One time, towards the end of a seminar at the Art Institute, my portable oxygen canister ran out, and the students carried me in a chair to my car and drove me home to where the big refill tank was waiting in the garage. In mid-2003, Dr. Michael Stulbarg at UCSF Medical Center told me I was at "end stage," meaning that if I were to get a serious infection I would probably get pneumonia and die. I was shaken. Dr. Stulbarg had little patience with my shakes. He looked hard at me and said, "Everyone dies." I later understood that part of the vehemence with which he said this derived from his own condition, the bone marrow

disease that had come to get him as he had been told it would or might one day. Then, in an adroit turnabout the next time we met, he suggested that I might be a candidate for lung surgery and went about making the appropriate appointments with the UCSF thoracic surgery team for me. At first it seemed that, because of my age (I was then sixty-three), I was still "not a candidate" for surgery. The surgeon, Charles "Chuck" Hoopes, contradicted this, or at least said I should try to qualify with all due testing. The testing was like qualifying for the Marines: heart and other organs, arteries, skin, bones, digestive tract, eyes, teeth, psyche, physical stamina, all had to pass muster. Astonishingly, by the following spring I made the grade, and what followed was a successful bilateral lung transplant on June 18, 2004.

I was fearful of transplant surgery partly because of the fact of, as they say, "going under the knife" and partly because of the prospect of an afterlife as a constant patient, painfully alarmed about germs, stuffed with medications, subject to relentless testing. I've been very lucky. The reality unfolding has been fair enough. Living post-transplant is hemmed in by cautions, yes, but none of these intrude enough to gainsay the pleasure of living each day with renewed capabilities, together with a strong appreciation of how great it is to be alive. I remember waking up in the ICU after the overnight surgery and immediately sensing that

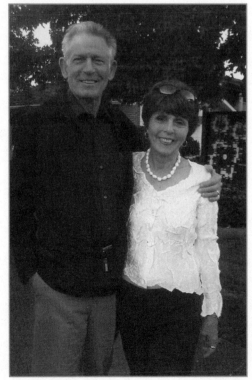

Bill with his wife, Connie Lewallen,
Napa, California, 2009

I could breathe freely without using the oxygen-delivery device attached to my nose. Minutes later, Dr. Hoopes was in the room, telling me to get up and walk in the hallways: "Those lungs need to know they have work to do," he said. A day or two after surgery, rounding the turn in the hall where the hospital windows give onto a clear overview of Kezar Stadium, I wondered how to use some of my renewed capabilities and thought, "Basketball." I told both Moses and Connie about this and got two balls, one from each of them, for my sixty-fifth birthday. Not one for making resolutions, I try to stay awake to see what happens and what to do next. "Each day's light has more significance these days," as Frank O'Hara put it.

When in the mid-nineties Connie and I became, as our certificate then had it, "domestic partners," it was evident that San Francisco was our only real option as a place to live. Since then, the unreconstructed New Yorker in me has had to overcome a distrust of San Francisco, for all its niceties, as a down-tempo toy city in order to let me live there without absurdity or rancor. Just as Rudy Burckhardt's films helped me see the populous air of New York and what Edwin Denby called the city's "noble proportions," so have Nick Dorsky's helped with the textures, light, and spaciousness of San Francisco. Connie is a New Yorker like me, from a similar neighborhood and schooling, and because we knew many of the same people when growing up, sometimes we imagine how we could have been together even then. Married in the Marin County Civic Center on December 11, 1998, we live in a house on a hilltop between the fog lanes, in sight of the whole downward length of Market Street, to the Ferry Building and, off to one side, the Bay Bridge—what Connie confidently calls "our domain." Every morning, weather permitting, we take a walk on the hilly streets, and when the going gets steep I recite favorite poems to myself by Shakespeare, Thomas Wyatt, Edwin Denby, Frank O'Hara, and if I'm lucky, one by me.

1996 / 2002 / 2016

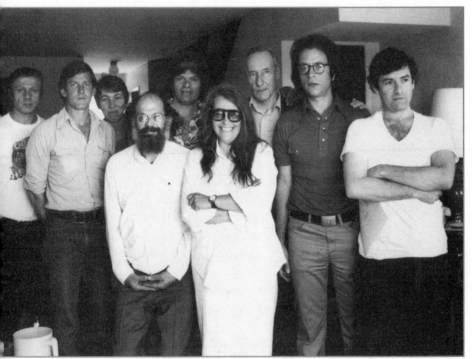

Naropa Institute, 1978: *left to right,* Peter Orlovsky, Bill, Pat Donegan, Allen Ginsberg, Gregory Corso, Kate Millett, William Burroughs, Michael Brownstein, and Larry Fagin

Misunderstandings for and about Kenneth Koch

How about a can of Coke? Yes and no. Kenneth Koch.

"I think you are very talented," wrote Kenneth beneath one of the poems I handed him at the first meeting of his poetry workshop at the New School for Social Research, January-something, 1959. I think I thought "talented" meant something like "accomplished." Later I understood that for Kenneth, talent was strictly for openers, a professional responsibility to be cared for, to enlarge.

A line I wrote that spring in a poem now lost:

Your legs like ice cream cones cross and cross again.

Years later it is Kenneth's delight in finding this line that prompts me to remember it, or more precisely, to remember Kenneth saying it aloud back to me, and his excitement, which was itself then—and remains—a kind of poetry.

One of Kenneth's favorite classroom quotations, from Paul Valéry: "[A poem is] made by someone *other* than the speaker and addressed to someone *other* than the listener."

One day that spring, after class, Kenneth said, "Come to Jane and Joe Hazan's party Saturday night. Frank O'Hara will be there, and . . ."—and this is the part I may have misunderstood because Kenneth always denied having said it— "Frank will become a germ in your life." But it was true, Frank did, even though "germ" is mightily uncharacteristic of Kenneth.

Hefty black spring binders stuffed with new poems and much revising with broad strokes of red pencil. At Perry Street, Kenneth would bring out the latest of these workbooks before supper (Janice's famous chicken in a pot, often). Ravenous, I would study them while Janice stirred and Kenneth, in his crew cut, talked and laughed and their very intense daughter, Katherine, sat on the sofa, looking on.

Once after dinner in Water Mill, New York, a year or two later, I read another set of Kenneth's new poems and before long went out on the lawn and threw up. Kenneth misunderstood: neither the dinner nor his poetry had made me sick, but forever after he kept half-humorously insisting.

One very odd time at Kenneth and Janice's on Perry Street was a dinner for Paul Carroll, then the editor of *Big Table,* who was visiting from Chicago and who had just accepted a poem of mine for the magazine. Another guest that evening was Norman Mailer. Something about me—young, athletic-looking— spelled out a challenge to Norman's notably inflated sense of his own manhood. At the end of the meal, as we rose from the dining table, he began trying to goad

me into a fight, eventually lunging to strike a karate chop at my neck, which I deftly sidestepped, whereupon Kenneth and Paul intervened, and Norman soon left. The next night he was arrested for stabbing his wife, Adele.

Another of my misunderstandings then was not about Kenneth but about love poetry. When I met Kenneth I was eighteen, an age at which love poems normally have the highest priority. But there were confusingly few contemporary models: except in popular song, twentieth-century poetry in English wasn't very welcoming to the love lyric until Kenneth and Frank, and a few others like Robert Creeley and John Wieners, came along. Until then, I misunderstood this dearth as a sign of local sanction: in English, as opposed to the more emotive Russian, Spanish, French, and Italian languages, the love poem was out. The first of Kenneth's poems that I came to know really well cleared up that muddle in a jiffy. The poem is called "To You," beginning:

> I love you as a sheriff searches for a walnut
> That will solve a murder case unsolved for years
> Because the murderer left it in the snow beside a window
> Through which he saw her head, connecting with
> Her shoulders by a neck, and laid a red
> Roof in her heart. For this we live a thousand years;
> For this we love, and we live because we love, we are not
> Inside a bottle, thank goodness! . . .

As Kenneth got older, his poetry stayed quick and funny but also deepened, became more personal, and exposed the philosophical bent that was always there. One of his best books was one of his last, a collection of apostrophes called *New Addresses*. With age, Kenneth's suspiciousness lessened; during his final years, with cancer threatening, he understood how much his friends cared for him, loved him, and this set him free to show how he cared for them.

Here's a story I always liked, but some of the details I may have messed up along the way: it was when Kenneth, Larry Rivers, Mal Waldron, and others sent up the poetry and jazz craze at the Five Spot, and Billie Holiday was there. Accompanied by Larry on the saxophone, Kenneth read from the telephone book as if a poem, and afterwards Lady Day came up to him. "Man," she said at the bar by way of approbation, "your poetry is *weird*."

1995 / 2002 / 2004 / 2015

What Frank O'Hara Was Like

I remember that Frank O'Hara talked on the telephone a lot.
He drank a lot. He smoked a lot. And he ate in French restaurants a lot.
I think that almost everything Frank did he did a lot. He went to parties
a lot. He laughed a lot. Loved a lot. And he cried a lot.
—JOE BRAINARD

Beginning from early in my acquaintance with Frank O'Hara, and even before knowing him, Frank and his poems were like a calling card for entry into a new world. Early spring 1959, I met a girl named Freya at the Cedar Bar. Tall, beautiful, with spectacular long red hair, she lived nearby, in a small apartment at 90 University Place. "A poet just moved out of here," she said and showed me the book he had left behind on the floor near where she had put her mattress—*Meditations in an Emergency* by Frank O'Hara. That summer, I walked down to the swimming pool at La Fiorentina, the grand villa in the South of France near which my mother and I were staying with family friends. Lying poolside, a somewhat older youth saw that I had in hand a copy of *Meditations in an Emergency*.

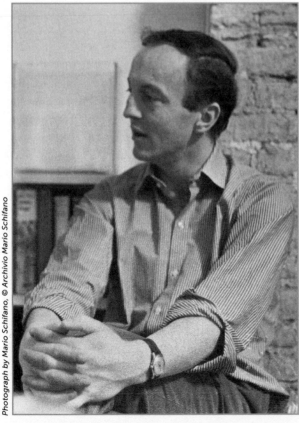

Frank O'Hara, 1964

"Oh, do you know Frank O'Hara?" he intoned. The lounger by the pool was Kenneth Lane, almost instantly a close friend, and later a famous costume jewelry designer, who had known Frank at the University of Michigan–Ann Arbor, when Frank was getting his MA there. Kenneth's and my New York nightlife escapades—and extended lunch hours on the terrace of the Central Park Zoo café—ran parallel but at a distinct remove from Frank's downtown orbit.

I first met Frank at a big artists-and-writers party at Joe Hazan and Jane Freilicher's house on West Eleventh Street in May 1959, but the beginning of our friendship dates from our coinciding a year and a half later, in Paris, October 1960, when Frank stopped there on the way back from Spain, where he had traveled accompanied by John Ashbery to research the New Spanish painting and sculpture show for the Museum of Modern Art. A postcard he wrote care of American Express letting me know how to reach him in Paris ends with a characteristic flourish, a paraphrase of Bertolt Brecht:

Dear Bill, it is apparently later than we think, and me not out of Barcelona yet! I expect to arrive in Paris Wednesday evening, or sooner if possible. Why don't you leave your address with Joan Mitchell so I'll know where you are? The Pont Royal is full—who knows where we'll all be on Coronation Day? See you soon, Frank

His apartment at the time, shared with Joe LeSueur, was at 441 East Ninth Street: second floor, front, facing Ninth Street, Garfinkel's Surgical Supply Company, and a candy shop across the way. You walked through the apartment door into a kitchen with tub, plywood over the tub (beneath which cockroaches made their habitat), a couple of butterfly chairs and Frank in one of them, and Joe sitting at the kitchen table by a row of smudgy windows. A refrigerator painted black. Paintings by Larry Rivers, Giorgio Cavallon, Grace Hartigan, Michael Goldberg, Joan Mitchell, and Norman Bluhm; a Willem de Kooning *Woman* in pencil; his "orange bed" painting, which Frank had been given by Fairfield Porter; and Elaine de Kooning's portrait of him with face wiped out ("more Frank than when the face was there," said Elaine).

The portrait of Frank that rings truest for me is Alex Katz's cutout, front and back, of him on the balls of his feet, poised, ready to spring into action—to deliver a tirade, a gushing accolade, a smack on the lips. Edwin Denby once spoke of Frank as "a fighter." His was the bantamweight Willie Pep/Bob Cousy look and style of attack, the impetus coming from everywhere in him at once, a distribution of energy that precise. And that was true of his affectionate side too. (Frank's "flamethrower" affection, I call it.) But, like de Kooning as Denby described him, Frank was "interested in the contrary energy," and "self-protection bored him."

His performance (for such it was) in Richard Moore's film for *USA: Poetry* is a fair account of the man, true to life right down to his getting, as the filming went on, progressively tipsy and, with it, a bit too arch.

In "Day and Night in 1952," Frank describes someone as being "intensely friendly if not actually intimate." In Frank's affection syndrome, intimacy constituted a blurry area somewhere between love and friendship, and our particular relationship rushed into that blur. Frank and I charmed each other. I myself got dizzy in his regard and attentiveness. At times, Frank appeared as an older, brotherly complement to my young self. To him I owe my general cultural education of that period, as well as a great deal of useful knowledge about life and manners. It was all talk and attitude. There was no sex involved. If Frank spent any time "trying to make" me, as the poem "Biotherm" at one point suggests, he never let me know it.

Almost all of Frank's old friends disapproved of, or at least were bemused by, our behavior. Out to shock, perhaps, playing out my juvenile contrariness, I was capable of such rhetorical flippancy as "I am a woman in love"—which was actually a response (delivered in gushing Garboesque) to John Ashbery's mild inquiry to Frank and me at the Café de Flore (October 1961) as to what was really going on between us. Frank indulged this showy aspect. It could be said that Frank spoiled me—if so, only because I was ripe for spoiling. But Frank was nobody's fool. For all my absurdities and gratuitousness, he must have spotted something—in the person, in the art—that merited his attention.

One day in Paris, cooling off an argument about social behavior, Frank said quite plainly how important it was to him that a man be an artist and not something else—how, in some respects, it seemed to him impossible to be anything else and still be said to exist. Kenneth Koch describes his "way of feeling and acting as though being an artist were the most natural thing in the world," adding, "Compared to him everyone else seemed a little self-conscious, abashed, or megalomaniacal." His seriousness was such that he could be luxuriantly flippant about his own ambitions, which were, naturally, very keen.

Frank worked every weekday at MOMA, and his friends used to drop in to visit him, sometimes to have lunch at nearby restaurants. The first time I did so, we went with Diane di Prima to P. J. Moriarty's, a kind of glorified workingman's bar and grill. Later on, the scene shifted to Larré, a nice bistro on Fifty-Fifth Street where André Breton and other immigrant surrealists used to gather in the forties. Long lunches with lots of drinks, often followed by a stroll around the gallery shows. Frank's office was tiny for the two big desks, his and that of his assistant, Renée Neu; it was in the old 21 West Fifty-Third Street building, a former townhouse. Visitors applied for entry via the receptionist at what was known

as "the 21 desk." One window facing an air shaft, a door with a clear glass panel (there are photos by Renate Ponsold of Frank looking through it). Down the hall, Porter McCray's office, and Waldo Rasmussen's; across the hall, the in-house editor we all relied upon, Helen Franc.

In 1964, Frank invited me to make a selection of Robert Motherwell's writings for the catalogue accompanying the retrospective he was organizing at MOMA for the following year. Eventually, for the Nakian show and a grand David Smith book project that somehow was never realized, my specialty became the compiling of the artist's chronology, or, in the haughtier phrase, "biographical outline." "His chronologies are very serious," Frank wrote in one of a set of Gertrude Stein books he gave me at the time.

Frank was devoted to the museum as the vehicle for modern art in America. The household deities were Alfred Barr, Dorothy Miller, and, at some distance, Dorothy Miller's husband, Holger Cahill. For its part, the museum (meaning the administration and trustees) knew that Frank was their chance for immediate access to the downtown art scene in terms the artists could appreciate: he could talk to them as a colleague and neighbor rather than a critic or entrepreneur. He was the liaison, the conduit between corporate MOMA and the artists. The older artists—de Kooning, Rothko, etc.—had a long history of being snubbed by the museum during the years when MOMA's recognition might have meant the difference between total isolation and poverty and a modicum of stature in the larger world.

Frank was more than a conduit, of course; as curator, he was exquisitely professional, all the more so because he had such a strong sense of occasion. But if he was useful as a conduit it is important to understand why—why precisely the artists both recognized him as a kindred spirit and trusted his view of things. The answer, I think, is found in Morton Feldman's account, "Lost Times and Future Hopes." Morton says that part of what made Frank extraordinary was the sense that he actually wanted you to be great, that that was part of his grand scheme for you and the world as he imagined it:

> To us he seemed to dance from canvas to canvas, from party to party, from poem to poem—a Fred Astaire with the whole art community as his Ginger Rogers. Yet I know if Frank could give me one message from the grave as I write this remembrance he would say: "Don't tell them the kind of man I was. *Did I do it?* Never mind the rest."

In 1964, the museum asked Frank if he would reply to questions about modern art posed by teenagers who had visited the galleries. The questions and Frank's

answers were published in the December issue of *Ingenue* magazine as "Teens Quiz a Critic: 'What's With Modern Art?'":

Q: Is it in poor taste to admire and like an artist who is still alive and near to the art world, especially if what he paints appeals to teenagers in style and color?

<div align="right">Jane Coe Salmy, Morristown High School, New Jersey</div>

A: It is never in poor taste to admire anyone, except possibly Hitler. It is especially important to admire an artist while he is still alive, so that he may have some pleasure and comfort as a result of his efforts. If what he paints appeals to teenagers, it should hardly be held against him since teens are the future and an integral part of his audience.

It's interesting to consider Allen Ginsberg's contrary view of Frank's "uptown" MOMA coordinates in his elegy: the "mixed with money" and "if you wanted your walls to be bare" riffs from Allen's staunchly "downtown" point of view; such disparagement was amplified, though from a very different perspective, by Virgil Thomson, whose only commentary on Frank posthumously was the bitter one that he had been taken in by "the Modern Art racket," by which he meant the museum that had spurned, after embracing, the neoromantics Pavel Tchelichew, Eugene Berman, Maurice Grosser, et al., whom Virgil favored.

MOMA provided a forum, in a way, for Frank's courtliness, his sense of occasion, as well as his "fatal" charm and love of gossip and intrigue. The meetings, receptions, installations, and openings of shows—all Byzantine in the maneuverings to get the thing envisioned done—all got his "movie-fed" blood going. (The hard part was writing the catalogue essays, which he tended to sweat out at

Motherwell opening at MOMA, 1965: *left to right,* Robert Motherwell, Frank O'Hara, René d'Harnoncourt, and Nelson Rockefeller

home, always at the last minute or later.) I don't believe that working for MOMA hampered Frank's ability to write. For one thing, all that writing on the job gave what poems he wrote there a clandestine edge they might otherwise have lacked. But eventually the combination of his museum days, his heavy socializing and dissipation, his complicated friendships and love affairs exhausted him. Finally, it was all too much. The so-called catalyst couldn't keep all the elements in order. At forty, his poetry was demanding another turn, and he wasn't allowed the time—sensibly, he wasn't as fast as he had been—to make that turn.

The connection between Frank's poetry and the visual arts, though an important one, can be overemphasized. Music, dance, the movies, the theater are all there too. Partly this had to do with living in New York, a big city where (just as in L.A. or San Francisco) the arts figure as necessities in the urban life force. Again, Kenneth Koch once said that of all the New York poets in the fifties, Frank knew the most about all the arts. In the poems, this knowledge is like another poet's knowing the geology and plant life of his home district—it is subject matter, and to that extent, nature, to him.

All the arts, poetry included, involve a great deal of collaboration: poetry collaborates with other poetry, with language, with experience, cognition, general culture. Ordinarily, the huge amount of energy Frank O'Hara poured into the activities that his younger friend, the artist and writer Joe Brainard, lists in his memoir would allow little left over for other pursuits, like sitting down to write a poem or staying alert to one's surroundings. But energy is often the first thing you notice about an O'Hara poem—the energy of the words themselves, the exciting surface they make, as well as of the strong feelings and keen perceptions they can evoke. Vitality is right there, on the surface: sometimes the poem seems to be speaking directly to someone, or it has the vividness of a conversation overheard, playful and/or intense, angry or elated, interesting for what is being said but also for surprising turns of phrase and shifts in the tone of address. The urgent attentiveness and affection with which Frank confronted everyday life are present in his poetry, just as poetry was a part—he once said the "better" part—of his very full, though too brief, life.

Another quote from Joe: "I remember Frank O'Hara putting down Andy Warhol and then a week or so later defending him with his life." What Frank came to share with the New York School painters he most admired, many of them older than him—and what he in turn imparted—was attitude. It wasn't aesthetics so much, or method, but a sense of, as he and Larry Rivers put it, "how to proceed," and also of what the stakes of such procedure were. Frank's dramatic monologue, only putatively the transcription of an interview with Franz Kline,

has Kline saying at the end, "To be right is the most terrific personal state that nobody is interested in."

Quotes and inscriptions:
 "Ah, yeah, surely, of course."
 "Oh, so that's the tack you're going to take!"
 "Well, who wouldn't?" (or, "Who isn't?")
 "You don't want to be just part of the landscape."
 "Sassbox!"
 "You big sack of shit!"
 From a letter to Jane Freilicher on why Larry Rivers (who had been writing poems) is not a poet: "He doesn't care for his poems, doesn't study them hard enough to learn from them, so merely writes the same poem over again."

 To his brother about his mother: "I don't like families. I believe in treating people the way you feel."

 And about David Smith's sculptures: "It is the nature of sculpture to be there. If you don't like it you wish it would get out of the way, because it occupies space which your body could occupy. Smith's sculptures are, big or small, figurative or abstract, very complete, very attentive to your presence, full of interest in and for you. As an example, they have no boring views: circle them as you may, they are never napping. They present a total attention and they are telling you that that is the way to be. On guard. In a sense they are benign, because they offer themselves for your pleasure. But beneath that kindness is a warning: don't be bored, don't be lazy, don't be trivial, and don't be proud. The slightest loss of attention leads to death."

Attention was Frank's message. The horror, as well as the irony, of the accident that resulted in his death was that of an uncharacteristic distractedness, a momentary lapse that could not be taken back. As of this year, he would be ninety-one years old. Nowadays, when people ask what he was like, I know less and less what to tell them. Some fifty years down the line, I know less about the man and far more about the work.

 One thing that strikes me looking at the hundreds of photographs and paintings of Frank is how glamorous he still seems. (Or is it more as time goes by?) He's in the Nijinsky–Picasso–Marilyn Monroe line of photogenic genius. Another thing is how everyone writing about him uses completely different words than everyone else, and all of them are true, to Frank, and to those people. Frank has his own character, and everyone else's stands all the more revealed in relation to him.

Larry Rivers

Before I met Larry Rivers, I associated him first with Kenneth Koch, who in his poetry workshop at the New School for Social Research occasionally mentioned Larry's paintings as analogous to the kind of poetry that he, Kenneth, and his New York friends were then writing (Kenneth probably had in mind Larry's "smorgasbord of the recognizable" period, just then concluding), and next with Frank O'Hara, partly because Frank was one of those New York poet friends, and also because I had seen an ad in the latest issue of *Evergreen Review* (winter 1959) for a forthcoming portfolio: "*STONES* / A Portfolio of Lithographs by / Larry Rivers / and / Frank O'Hara / A contemporary art fusing drawing / and poetry / 12 pages plus title page," and so on.

As was my habit in those days of often somewhat loony aspiration, I scrutinized the look in Hans Namuth's accompanying publicity shot of both Larry and Frank intently: Frank in classic "Frank O'Hara" profile (Roman schnoz and all), applying words in crayon to the lower center-right of the fat stone slab; Larry sucking on a cigarette, so that in fact his face appears leaner, more delicate, than the one I would come to know, more like Larry years before the photograph was taken.

Larry Rivers's drawing of
Bill (*Boy in Swimsuit*), 1961

Illustration © the Estate of Larry Rivers

To Kenneth, Larry would be always an instance of "a floating subconscious—all intuition and no sense"; to Frank, recalling how he had burst into the early fifties downtown milieu, Larry was cast immortally as "a demented telephone"; "nobody knew whether they wanted it in the library, the kitchen or the toilet, but it was electric." To get an only slightly exaggerated sense of Larry's presentation of self in everyday life, watch his star turn as the young painter propelled by sexual overdrive in Rudy Burckhardt's *Mounting Tension,* but two other performances, not by Larry but by people who would have known his mannerisms—Robert De Niro in Martin Scorsese's *New York, New York* and Ed Ruscha in Alan Rudolph's *Choose Me*—get Larry's baseline character at speed.

Eventually, Larry and I were featured players, running mates, actually, in Kenneth Koch's play *The Election,* which ran as an after-hours show at the Living Theater during election week 1960. Larry was Lyndon Baines Johnson, and I was John Fitzgerald Kennedy. Since Kenneth's script took off from Jack Gelber's play *The Connection*—about addicts waiting for dope—we, the candidates, were likewise strung out, needy for the vote. My part consisted largely of lying around front stage in a stupor of "vote" withdrawal while Lyndon/Larry speechified on the shortcomings of democracy. Before Kennedy became president, his distinctive Boston-Irish intonation wasn't so familiar to us. Kenneth knew he had gone to Harvard, so he wanted my jivey entrance line delivered with a WASP Ivy Leaguer's lockjaw drawl, or what Jimmy Schuyler once identified as "Episcopal throat." *Oh mahn, ah'm wiggin'*! I intoned, and then the desperate plaint: *Whaar's*

The Election, 1960

Jawkie? The improbability of following Kenneth's direction without appearing entirely off the mark got a laugh every time.

Meanwhile, spending more time in Larry's company—going to parties at his Third Street loft and later on Fourteenth Street, visiting him in Southampton (the site of a few of Frank's and my "St. Bridget" poems), and one time posing for him, I became more familiar with his peculiarly skewed, white bopper's version of radical innocence.

The essay he wrote about himself for *ARTnews* reinforced my sense that his take on things intersected significantly with the disorderly self-view I was then cultivating. "A Discussion of the Work of Larry Rivers" appeared in the March 1961 issue, about a year into my tenure at the magazine. I could very well have proofread Larry's piece, but mainly I studied it. The sentence about the shift in one's identity markers between twenty and thirty became enlightening later, when its importance had already become retrospective (I could pass it on to students), but it was the sizeable number of remarks around that one and, or more importantly, the tone and attitude projected that seemed crucial and, for few years, talismanic. A few quickies in the way of quotation may suffice:

"So much in the making of art is energy, energy to power the mind as it insists through a barrage of endless interruptions . . ."

"One of my theories about the art of the last hundred years is that more alterations to the image of painting have been brought about by the boredom and dissatisfaction of the artist and his perversity than anything else."

And: ". . . the human body at most is a rectangle. A bashed-in milk container."

In "Life Among the Stones," Larry's memoir of collaborating with Frank and also with Kenneth Koch, he allowed, "Maybe I'm an artist, but I have gone from a baby to having the soul of a nail. I get a physical thrill in being cruel. My cruelty consists of destroying the ease I see in the presence of cliché and vogue."

During a visit together with Bob Motherwell and Helen Frankenthaler to Hans Hofmann's studio in Provincetown, Larry began complaining to his old teacher about his difficulties with his sons, Joseph and Steven. Hofmann interrupted Larry midsentence: "You have no talent for being old" is what he said. But Larry heard only the first part of Hofmann's pronouncement. "I have no talent?" he echoed, a pained look on his face.

Larry's limitations, both personal and artistic—as he put it, "that funny man who falsely faces himself in public"—were fairly plain to everyone who nevertheless would never wish him either to go away or be any less in their lives.

Willem de Kooning

Standing in the Allan Stone gallery in the late sixties, looking at an early de Kooning called *Summer Couch,* Edwin Denby told how, in the forties when the painting was done, de Kooning had wanted the feeling of "a wind blowing across the surface" to keep the parts of his pictures off kilter while their overall compositions settled in. The painting's furniture scheme admitted an undertow—there were sharks in that wind—and a finely tethered, wobbly balloon.

A honey of a picture, it's the one Frank O'Hara refers to in "Radio" as his "beautiful de Kooning," the one with "an orange bed in it"—famously, too, a gift rescinded by Fairfield Porter, who needed it back so he could sell it to finance his and Anne's caring for Jimmy Schuyler after Jimmy's psychiatric breakdown. (Would that he had told his reasoning to Frank, who otherwise took Fairfield's demand as uncalled for, and that ruined their friendship from then on.) It was Fairfield who, in a review from 1959, most clearly defined what there is to be most appreciated in de Kooning's art:

> There is that elementary principle of organization in any art that nothing gets in anything else's way, that everything is at its own limit of possibilities. What does this do to the person who looks at the paintings? This: the picture presented of released possibilities, or ordinary qualities existing at their fullest limits and acting harmoniously together—this picture is exalting.

Around the same time as that gallery visit with Edwin, Joe Brainard and I collaborated on a comic in honor of our favorite contemporary artist. "I Love You, de Kooning" includes a fair account of the nature of my occasional meetings with de Kooning, especially those in his East Hampton studio: "Whenever I see Willem de Kooning he says 'Hi, Bill. Hey, you look great!' Then I say, 'You look great too, Bill!' Then we sit down and think about it."

The downstairs of the house de Kooning built for himself in East Hampton was mostly studio. The whole place resembled a glass-sided ocean liner, its enormous portals giving onto views of trees and, in one direction, an incongruous gazebo. The upstairs bedrooms had flesh-pink doors.

De Kooning's charm, which seemed natural and unprepossessing, made approaching him easy, but there remained that sense of his towering greatness. (That he was aware of it, too, was part of the joke as early as the thirties: as Rudy Burckhardt told it, whenever Bill went into the subway he thought he heard the little bell at the turnstile ring a little louder.) It was my luck to see him always in good shape, never the drunken, unhappy (or unhappy-making) Bill that others sometimes had to contend with.

As it happened, my wife Lynn and I saw a lot of him and Elaine during the year we spent in Southampton, 1979–80. Elaine had returned to the Hamptons to be with Bill, although they continued to live in separate houses. One night they came to our place on Hampton Road for dinner. "Can we give you something . . . ?" I said as they entered. "Mineral water!" Elaine cried out with all the force of her and Bill's recent training at Alcoholics Anonymous. So the evening settled in, Elaine and me at one end of the table, Bill and Lynn at the other. Every so often, if Bill overheard a familiar name being repeated by Elaine and me, his interest perked, Elaine would cue him with the name:

"We're talking about Clyfford Still, Bill."

"Oh yeah, Still. I always admired him because he didn't compose. I have to compose."

And: "Phil Guston, Bill."

"Oh—I dunno why he started doing all those clocks and shoes. He vass doing alright with dat abstract stuff."

Later, Lynn told me of an exchange they had at their end of the table about Bill's outings in Accabonac with his dogs. "So," she asked him, "you take walks with your dogs?" "No," Bill answered, "I'm a man. My dogs walk with me."

The summer before, on June 27, Bill and Elaine arrived for dinner at Patsy Southgate and Joe LeSueur's in Springs. Joe said, "Bill, do you know what day it is?" Bill looked curious but a little dumbfounded. "It's Frank O'Hara's birthday," said Joe. "Oh, how is he?" said Bill. "He's dead, Bill." "Oh yeah, that's terrible." As dinner ended, because I knew Bill was a great reader and always said interesting things about what he had been reading, I asked him if he had read anything particularly interesting lately. "Y'know, I don't anymore, I don't read at all," he said.

Photograph © Connie Fox

Composite of Bill and Willem de Kooning, 1980

"I just paint all day long, and then at night I watch television and I keep a pad on my knees and draw while I watch."

Sublimely out of it, the greatest living painter was all he was. That full-time occupation then entering what came to be known as its "late phase," the work as ever was full of a mysteriously unyielding personal charm—or what de Kooning would call "countenance"—and even larger than that in its significance.

1990 / 2011

Edwin Denby

Once when we were having lunch at the Oyster Bar in Grand Central Station, I complained to Edwin about hearing myself on a tape of some recent poetry reading. "Yes," Edwin said matter-of-factly in his customarily soft, slightly gravelly voice, "that resentment tone." Thinking back on it over the years, I may not have understood the intriguingly commiserating aspect of Edwin's remark. Another time I wondered aloud to Alex Katz about how few, if any, new poems by Edwin were appearing. As Ron Padgett put it later, "He kept revising his new pieces out of existence." I had seen Edwin's notebook open on a table in his Chelsea loft—two pages of lines in black ink, almost all crossed out. "He's conceited," Alex said. "He thinks he's better than we are." What Alex meant, I think, is that Edwin's standards wouldn't allow him to write the sometimes awful stuff that most poets need to write to get to the good things, the poems, anyway, that one can bear.

Encouraged by his heroes de Kooning and Balanchine, and by continuously rereading the poetry of Whitman and Dante, Edwin set himself very high standards, indeed. In de Kooning's paintings, he found himself reacting to "the beauty that instinctive behavior in a complex situation can have—mutual actions one has noticed that do not make one ashamed of oneself, or others, or of one's surroundings either," then commented, "I am assuming that one knows what it is to be ashamed."

After Joe Ceravolo and I read together at the NYU Loeb Center, Edwin remarked how curious it was, "two young poets equally interested in history." Edwin is one reason why we need a better general history of New York's artistic and intellectual climate during the thirties and forties. You can see segments of it in his friend Rudy Burckhardt's earliest films, in which people as diverse as Aaron Copland, Elaine de Kooning, John Latouche, and Edwin himself appear. And then there was Edwin's connection with Orson Welles, John Houseman, and Virgil Thomson at the Federal Theater and the rise of George Balanchine and his various companies. Picture a party at George Gershwin's with all the above, plus Vincente Minnelli, Oscar Levant, Yip Harburg, Martha Graham, Paul Robeson, Bill and Elaine de Kooning, Gypsy Rose Lee, and perhaps a French surrealist or two for good measure. Or at the San Remo in the fifties, with Tennessee Williams, Judith Malina, Jack Kerouac, Allen Ginsberg, William S. Burroughs, W. H. Auden, Truman Capote, James Baldwin, Paul Goodman, Frank O'Hara, John Ashbery, Jane and Paul Bowles, and the like.

All the same, I remember being horrified at a party at Virgil Thomson's Hotel Chelsea apartment by Virgil's dismissive attitude toward his old friend—as if Edwin hadn't panned out in the big world, had failed to fulfill the mission to

become great or at least famous, as Virgil and others felt that they themselves had done. Like Rudy Burckhardt, Edwin was, in John Ashbery's phrase, "a subterranean monument."

The "Chelsea Ethos"—the manners of that other Chelsea, of lofts and cafeterias further west—assumed that if your work was strong enough, "they" (the publishers, producers, and gallerists) would seek it out; there was no point in pushing it. That was the attitude—a well-bred and respectable one, as far as I'm concerned, although tempered it should be, too, by a sense of obligation to the work itself, that it have its place in the world. Of course, Edwin was the one who stood at Frank O'Hara's grave and spoke of how O'Hara would be "appreciated more and more" as time went by—so he was in no way oblivious to that aspect of a poet's value in the scheme of things.

Edwin's poems are full of rhymes going every which way—end rhymes, internal, slant, false, and so on—along with a wealth of other recombinant syllables and unique Latinate inversions mixed with New York street slang phrasings. ("Disorder, mental, strikes me; I / Slip from my pocket Dante to /Chance hit a word . . .") His sonnets are at once highly compressed and large in scope and scale. The sometimes-halting rhythms in them find release in a sudden declarative sweep. In San Francisco in the eighties, after I read city poems by Edwin, Jimmy Schuyler, and John Godfrey to a small group, one of the poets present expressed his interest in Edwin's poems. "But oh," he said, "those rhymes!" I said, "Yes, Rodgers and Hart." The poet, only a few years younger than I, drew a blank. He had never heard of Rodgers and Hart; never mind that, whatever the circumstances of his upbringing, songs by Rodgers and Hart were part of the common culture from the twenties onward. The difference between nose-to-the-grindstone A-students and people of general culture thereby became much clearer.

Incidentally, the present-tense narration of some of Edwin's sonnets (as in "I stroll on Madison in expensive clothes, sour") is a likely source for Frank O'Hara's "I do this, I do that" poems, the first of which, "A Step Away from Them," not only mentions Edwin but also was written about the time Frank wrote his review of Edwin's second book, *Mediterranean Cities*.

In an essay for *Modern Music* about writing opera libretti, Edwin wrote: "Meaning is a peculiar thing in poetry—as peculiar as meaning in politics or loving. In writing poetry, a poet can hardly say that he knows what he means. In writing he is more intimately concerned with holding together a poem, and that is for him its meaning."

I remember Edwin breaking off from getting dressed for an evening out and suddenly going into one of his German dance-theater routines, twisting dramatically between bits of furniture in his underwear. As in his dance criticism,

he seemed fascinated by whatever transformation any type of movement might make for oneself. In his sixties, he was photographed demonstrating the postures of tai chi for Edward Maisel's book *Tai Chi for Health*. The practice itself he referred to as "my Chinese dance class."

As Edwin found, and generously let his friends in on, the best sight lines for watching dance at City Center were in row L. Starting from row L, you had the advantage of seeing the dancers' feet above the orchestra pit. "Row L" was the title Frank O'Hara and I gave to the piece we wrote together when Edwin asked for something to include in the set of poems for the souvenir New York City Ballet program Lincoln Kirstein had asked him to edit for the company's 1961 season. Among the other poets Edwin invited were W. H. Auden, Marianne Moore, Kenneth Koch, James Merrill, and Diane di Prima. With typical excess modesty, Edwin left himself off the roster. Although all the poems made it into the publication, not one of them pleased Balanchine, who considered any commentary on his ballets an intrusion, anything that smacked of analysis, interpretation, or waxing "poetical." It should be said that Edwin himself, in his dance writings, never offended in such ways; he told you crisply, exquisitely, sentence by sentence, what he had seen on stage, communicated his pleasure or displeasure, as the case might be, and let you imagine the rest.

Edwin was introduced by Richard Buckle to an elderly balletomane, English probably, who went on about having once seen Vaslav Nijinsky perform, and how he leaped and stayed poised momentarily in the air "just like a bird." Edwin said, "But birds don't fly with their feet."

The talk in the City Center lobby during intermissions in the early sixties was, like that at many New York art parties then, both extroverted and tense. Edwin's own manner in these settings was reserved; rush up to him, as one might, to hear how he had seen what had just happened on stage, and he would deflect, asking instead how you had seen it, smiling patiently as you tried (perhaps too hard) to communicate both the thing seen and the right, bright words for it. Everyone knew that Edwin's looking was so acute. Catching him at the rear of the orchestra seats during one break, I saw that he had opened a little tin of NoDoz caffeine tablets: "I was looking so hard at the last one," Edwin said. "Now I have to stay awake for the next."

In Edwin's late years, aside from his generous attentiveness to what young poets were doing, he concentrated primarily on reading Dante's *Paradiso*. He killed himself in Maine on July 12, 1983, a short while after Ted Berrigan died. Unwilling to put up with the onslaughts of senility, he took sleeping pills and alcohol in the house he shared with Rudy Burckhardt and Yvonne Jacquette. Edwin seems to have made up his mind well in advance about how to end it, so that when he heard from mutual friends of Ted Berrigan's dying just a week or so

before, on July 4, he surprised them: flinging his arms open wide, he exclaimed, "That's marvelous!"

Another side of Edwin in action (overheard): sensing an impasse in conversation with a younger writer, he said firmly, "I see that now we are beginning to embarrass each other," and turned his attention elsewhere.

2015

Elaine de Kooning

In the context of New York School glories, I quickly learned that Elaine de Kooning embodied a particular measure of grace and integrity. Frank O'Hara wrote of her as "the White Goddess: she knew everything, told little of it though she talked a lot." Elaine's talk was passionate, sharp, and on the level. A no-nonsense attitude made her a penetrating critic and teacher. It was she who persuaded Tom Hess to start hiring poets like Frank, Barbara Guest, John Ashbery and Jimmy Schuyler—as well as their painter friend Fairfield Porter—as staff reviewers for *ARTnews*. By the mid-sixties, her loft was a meeting place for young artists, writers, and others engaged, as Elaine herself was, with the politics of the time.

Her portraits show a prodigious sympathy, a sense of characteristic occasion, and expansive human scale. ("Expansive" was a favorite word of hers, signaled in the paintings directionally up and out.) The general scale is grand and democratic. Elaine conferred a frontal dignity across the board, be the subject a couple of gangly kids, a president with a bad back, or the hirsute Greek-émigré artist Aristodimos Kaldis in lumpy attire.

An old friend of Elaine's who lived down Fern Road from Lynn and me in Bolinas was Paul Harris. When Elaine came out to do prints at Crown Point Press in San Francisco, she also visited Bolinas, staying with Paul and his wife Mimi in their house near the cliffs. One day she accompanied Paul and Mimi to the Redwoods, a retirement community in Mill Valley where Mimi's aged mother was living. Seeing how excellent were the facilities at the Redwoods, Elaine determined that if and when Willem de Kooning needed round-the-clock care, this would be the place, and in order to assure that she would be near him, she bought a house across the road from the Harrises—it belonged to the local Presbyterian minister who at the time was moving on—and arranged to have a studio for herself built on the property as well. As it turned out, Elaine died before this plan could be put into effect, and Bill never entered the Redwoods.

A few days after hearing Elaine had died, I chanced to see her cameo performance in Rudy Burckhardt's early fifties movie *Mounting Tension*. Strawberry blond, dressed in a tailored button-front suit like some Rockefeller Center Ninotchka, she stands her ground on a busy sidewalk to deflect the advances of the sex-crazed painter Larry Rivers. Elaine turns the bit part into a high-speed adagio number with perfect aplomb, straight ahead. "Elaine de Kooning faces her experience directly" is what Fairfield Porter wrote of her painting, a remark that held true for her spirited social self as well.

1991

Allen Ginsberg

Space Dream

Broken headline column:

"YOU ARE GO
ING TO END"

Allen Ginsberg dives through the space hatch.
I watch him from the rim, hear his voice
trail a message "MAN ISSSSSSSSSSSSS.........."
as he disappears through dot-hood.
The Poets—Anne Waldman, me, "all the poets"—float
in interstellar space, a substance I
can touch, a fine sheen. & then I'm up against the sun,
its soft orange neon glow. "THE SUN," I say, "IS BIG!"
Pause, & a chair sails silent past me into solar radiance.
"CHAIR INTO SUN!" I remark.
 Then we are back on Earth,
speed skating on the silvery
 Power Cones.

The one time I read "Space Dream" aloud in Allen's presence he asked about the Power Cones, what they were, how they looked in my dream. "Shiny, metallic," I told him, they fitted snugly on the bottoms of all our shoes, like the big cones in Fernand Léger's early abstract paintings, but also in their brilliance like coils in thirties Jean Hélion. We spun in a crowd marvelously around one another in an outdoor arena like a roller rink.

It took me almost thirty years to relax about being in the same room with this poet, whose close-up stare in Harry Redl's photograph I had stared back at for hours, holding a copy of the "San Francisco Scene" issue of *Evergreen Review* and listening to the accompanying LP with his familiar New York tenor (viz "drear light of zoo") on an expurgated version of "Howl." My first sight of him was from a distance in Paris on the Place de l'Odéon during summer 1958.

The next spring, we were introduced at the Cedar Bar by Paul Goodman, whom I had just met during intermission at the Living Theater between sets of a reading by Edward Dahlberg and Josephine Herbst. (In the crowd that same night, I caught a glimpse of William Carlos Williams.) Allen slid into the booth at the Cedar Bar to greet Goodman. Still in my junior-beatnik phase, I had just read

publically for the first time at the Seven Arts Coffee Gallery near Forty-Third Street on Ninth Avenue, preceded by a young Haitian poet and Jack Micheline. I was reduced to silent posturing while Paul next to me and Allen across the table traded remarks on the poems of John Milton—a razzle-dazzle master class cum poet-scholar cutting session for this cute kid's benefit.

By now most people know how great are the long poems—*Howl* and *Kaddish*, at least—but there should be a separate selection, as with W. H. Auden, of the great shorter poems: "Sather Gate Illumination," "The End," "Wales Visitation," "City Midnight Junk Strains," and some of the even breezier, occasional pieces from *Planet News*.

Later, we sat together in Bobbie Louise Hawkins's gazebo, Boulder, summer of 1994. I had left one marriage and not quite settled into the next; Allen spoke of his sadness in getting "divorced" from Peter Orlovsky. We were suddenly two men of a certain age discussing our marital troubles.

> *Joy and suffering at a certain point become one taste, because it's existence itself, the crying over existence, not non-existence. . . . The tears are an appreciation of existence and the beauty and mortality and sadness of leaving existence. And the suffering of existence which is so deep it's joyful. To exist is joyful just by its very nature of existing even if it's suffering existence. Grief is not unadulterated pain. Grief is also mixed with a sense of majesty and finality and realization of ultimate reality. That's why people weep, because they realize that the ultimately real is ultimately real . . . and irrevocably so. There's only one life and this is it.*
> —ALLEN GINSBERG, *What Happened to Kerouac?*, 1986

"How are you today?" Allen's matter-of-fact greeting brought me up short near the big tree where the crowd attending Frank O'Hara's funeral was just dispersing. I had cried out "Oh, Allen!" wanting to let go—let my hair down, so to speak—after the formalities graveside. When Allen died, Larry Fagin said, "It's as if the sidewalks have disappeared." Strangely, what seems most absent now, much as all that high, vibrant purpose and those goofy asides, is his grand stability.

Burroughs at First and Later

A June afternoon, 1959, Harold Norse brings me to William S. Burroughs's room in the Hotel Gît-le-Coeur. A tall, skinny Englishman about my age answers— Ian Sommerville, I later learn, the young mathematician Norse had introduced to Burroughs not long before. Burroughs not in, we enter, I see the latest *Big Table* on the round table in the middle of the room, number two, the issue with a picture of a younger Burroughs whom the gangly English youth perfectly resembles. Spooked, I follow Harold out the door. Sommerville closes it with a polite good-bye.

A little later that month, we return. Burroughs has changed to a smaller room on a lower floor, welcomes us in three-piece gray suit and black tie, repairs to a tiny desk next to the one window to finish rolling joints. Harold and I sit on the bed. Silence, Harold babbles, then suddenly Burroughs swivels, his voice crackling out from under: "How long are you going to be in Paris, Berkson?" Recovering from the sensation of being shot back against, or through, the bare plaster wall, I manage to reply factually, "Two weeks."

July, I'm in Saint-Jean-Cap-Ferrat when Harold's postcard arrives, announcing that Burroughs will read at George Whitman's bookstore on August 1: "Be there!"

At Le Mistral bookshop, second floor, the crowd surrounds a wooden table with a small tape player. Someone rises to the push the switch. Out comes a voice: "I can feel the heat closing in . . ." Olympia Press had just published *Naked Lunch.* Burroughs, "el hombre invisible" (a.k.a. "No glot . . . C'lom Fliday"), is nowhere to be seen.

Another of Burroughs's friends in Paris was the American painter David Budd, who shared his fascination with carnivals and circus performers. David was married to a bareback rider. With him and Burroughs, the Parisian restaurants of choice were usually Moroccan or Vietnamese, but once, when my mother visited, David threw a big party at a bistro. When, sitting next to my mother at dinner, he learned how her father, my grandfather, had been an advance agent for Ringling Bros., he leapt to his feet and yelled to me from the far end of the table, "Now I know why I love you, you're *circus!*"

After Grove Press published *Naked Lunch,* Burroughs was increasingly in New York. The first time was shortly after my book of poems *Saturday Night: Poems 1960–61* came out. Burroughs came to visit at my mother's house and I handed him a copy. I remember him snorting fondly over such Burroughs-sounding lines as "Settle for ginger ale in the / Big House /resumed the habit of smoking . . ." Burroughs thought these poems—and the John Ashbery poems

like "Europe," which appeared in *Big Table*—were worked out according to the same cut-up method he and Brion Gysin were then using. We exchanged letters about this: I wrote that Ashbery's way of taking the language apart was partly a collage technique without grids, but for me there was a ready-made cut-up that bypassed such mechanical procedures, handily accessible in one's own mind; I think he must have known that already, so didn't feel any answer was required.

In person, Burroughs's long silences could be stunning. The mask was something sinister, but at the root was a kind of perverse civility—friends would say, "Oh, William is just shy." The pursed lips and bright, youthful eyes were giveaways. One night we sat for an hour or more in the San Remo without a word passing between us. Finally, a drunk staggered over from the bar to our table and began addressing no one in particular. Eventually, he gave up. "There's one in every bunch," Bill said.

for City Lights Bookstore's celebration of the
fiftieth anniversary of Naked Lunch, *2009*

August 14, 1992: John Cage

Yesterday John Cage died at almost eighty of a stroke in a Manhattan hospital. First flashback: bowling games—with automated pins and metal disks—at Dillon's bar on University Place, Cage, Merce Cunningham, Jasper Johns, Frank O'Hara, and me, grouped variously near the entrance at the bar and the one bowling machine at the far end.

Cage once said that he had noticed that his work became popular every ten years. In seminars at the San Francisco Art Institute over twenty-four years, I repeatedly brought up what Cage had made happen and each time realized that, although Cage was right when he said at a certain point that he'd done what he had set out to do, to open people's ears to the sounds around them, the job still had to be done again, perhaps every generation or two. Certain kinds of art lead a double life as arcane bedazzlements and primary lessons for any viable commonality. It may be that the culture beyond Cage's intimate audience has already absorbed his music and the ideas that go with it without knowing it and without ever consciously assimilating them.

During a Cage conference in Paris, at which Connie gave a talk, I mentioned to the composer Emanuel Dimas de Melo Pimenta how, as opposed to the simmering eroticism of Marcel Duchamp, with whom Cage felt a connection, there is really no sex in John Cage. Pimenta then told us of discussing male and female with Cage, who said: "But there is a third thing—how mushrooms of different kinds are compatible and others aren't."

At a Crown Point Press opening in San Francisco, January 1990, Cage told me about not exchanging drawings with Willem de Kooning. He had sent a mesostic in homage for the de Kooning issue of *Art Journal* that Rackstraw Downes and I edited. "How did you like the poem?" Cage asked at Crown Point. "I thought there was probably a story that went with it," I said. "There is," he said, and told how the two of them had arranged to meet at de Kooning's Tenth Street studio so that de Kooning would get one of Cage's scores and Cage would get a de Kooning drawing in exchange. Almost as soon as Cage had entered, they began discussing whether or not an artist should want to be great—de Kooning said yes, Cage said no. Then Cage looked at de Kooning's drawings and couldn't find one he wanted, so he left the score and went out empty-handed. As usual, Cage laughed broadly at his own story. A little later in our conversation, I said: "You know, John, I've wondered, because you left California for New York and I left New York (though not that long ago) for California, if you've ever considered returning to the West." Cage said, "Oh no, for a composer there's really only New York!"

Twenty-Three Things about W. H. Auden

One day, while he and Stephen Spender were students at Oxford, Spender told him that he was thinking of stopping writing poetry. Auden stopped in his tracks, took firm hold of Spender's arm, and said, "You must keep writing poetry, Stephen—we need you."

After relocating to America in 1939, Auden lived on Middagh Street in Brooklyn, and in Manhattan on Cornelia Street, East Fifty-Second Street, and then, for a long time, at 77 St. Mark's Place and was a parishioner at St. Mark's Church-in-the-Bowery, though he made a point of leaving the latter in the sixties when the rector modernized the liturgy and removed the pews.

Frank O'Hara told me that once, around 1949, while he and John Ashbery were at Harvard, they were in the Grolier Bookshop together and saw Auden browsing the shelves. Nothing passed between Auden and the then very young poets. After Auden left the shop, John said to Frank, "Wouldn't you think he'd know?"

Frank also said that Auden's poem beginning "It was Easter as I walked in the public gardens" inspired some of his "lunch" poems. Another time, at the Free University on the Lower East Side, Frank spent a whole class reading aloud from Auden's long work *The Orators*.

Like many great poets, Auden said provocative but inaccurate things, like "There is no daylight in New York."

In April, 1939, Auden and William Carlos Williams read together at Cooper Union. Later Williams wrote of Auden: "There is no modern poet so agile—so impressive in the use of the poetic means. He can do anything—except one thing."

One of Auden's early books is called *The Double Man*. In it, he quotes from Montaigne: "We are, I know not how, double in ourselves, so that what we believe we disbelieve, and cannot rid ourselves of what we condemn."

A masterful, funny, and genuinely pornographic poem of his called "The Platonic Blow" was pirated by Ed Sanders, who printed it in 1965 as a supplement to an issue of *Fuck You: A Magazine of the Arts*.

I met Auden only once, at a dinner party in the late sixties at the journalist and songwriter Irving Drutman's uptown apartment. I was late for the occasion because of the poetry class I was teaching at the New School for Social Research, and by the time I got there, not only had everyone else sat down to dinner, but Auden had already drunk a lot of wine and was, as he liked to say, "tiddly." I sat next to him at the table while he held forth, precisely and with great emotion, about his life. "It took me fifty years," he said, "to know that I belong to the same social class as my parents." He left right after dinner, which was, Irving Drutman told me, the usual thing ("early to bed") for him. Later it occurred to me that he had made his remark about family class structures for my benefit.

Auden was born in York, England, on February 21, 1907, within a few years of my parents, not to mention Willem de Kooning, George Balanchine, Edwin Denby, and Count Basie.

He wrote his first poem in 1922, at age fifteen; it was entitled "California," and the first stanza reads:

> The twinkling lamps stream up the hill
> Past the farm and past the mill
> Right at the top of the road one sees
> A round moon like a Stilton cheese.

He wrote poetry, plays, essays, an oratorio, kept a commonplace book, lectured and taught in various schools and colleges, edited anthologies, and collaborated on opera libretti (including one great original, *The Rake's Progress*) with his long-time lover Chester Kallman.

He was a rarity in the twentieth century for being both witty and profound.

He said, "A professor is someone who talks in someone else's sleep."

He also said, "Real poetry originates in the guts and only flowers in the head. But one is always trying to reverse the process . . ."

As with Keats's poetry, the first few lines of some of Auden's most famous poems tend to be better, or anyway more memorable, than what follows. One example is, "Lay your sleeping head, my love, / Human on my faithless arm," and another, "It was Easter as I walked in the public gardens."

Coming out of the bathroom at a Greenwich Village party in the early sixties, I overheard Richard Howard in the hallway telling how Auden kept "an apple on his desk to remind him of the deliquescence of the world." (Ugh, I thought, though it was Richard's haughty way of delivering the word "deliquescence," as if he owned it, that was maddening.)

"What about Ashbery?" asked an interviewer in the early seventies. Auden (grinning): "I don't understand a thing he's written."

He left strict instructions in his will that no letters of his should ever be published and asked his friends to burn whatever letters from him they had.

He was a heavy smoker, and in his fifties, came to look puffy and creased, the result of Touraine-Solente-Golé syndrome, or pachydermoperiostosis, "in which the skin of the forehead, face, scalp, hands, and feet becomes thick and furrowed," like elephant hide.

He liked wine and pills (uppers and downers).

He died on Saturday, September 29, 1973, sleeping on his left side in bed in a hotel room in Vienna.

"One fine summer night in June 1933," as he told it,

> I was sitting on a lawn after dinner with three colleagues. We liked each other well enough, but we were certainly not intimate friends, nor had any one of us a sexual interest in another. We were talking casually about everyday matters when quite suddenly and unexpectedly, something happened. I felt myself invaded by a power which, though I consented to it, was irresistible and certainly not mine. For the first time in my life I knew exactly—because, thanks to the power, I was doing it—what it means to love one's neighbor as oneself. I was also certain, though the conversation continued to be perfectly ordinary, that my three colleagues were having the same experience. (In the case of one of them, I was able later to confirm this.) My personal feelings towards them were unchanged—they were still colleagues, not intimate friends—but I felt their existence as themselves to be of infinite value and rejoiced in it.
> I recalled with shame the many occasions on which I had been spiteful, snobbish, selfish, but the immediate joy was greater than the shame, for I knew that, so long as I was possessed by this spirit, it would be

literally impossible for me deliberately to injure another human being.
I also knew that the power would of course be withdrawn sooner or later
and that, when it did, my greed and self-regard would return. The experi-
ence lasted at its full intensity for about two hours when we said goodnight
to each other and went to bed. When I awoke the next morning, it was still
present, though weaker, and did not vanish completely for two days or so.
The memory of the experience has not prevented me from making use of
others, grossly and often, but it has made it much more difficult for me to
deceive myself about what I am up to when I do . . .

Arnold Weinstein

Arnold Weinstein was like a bison with the soul of a gazelle. I met him first, as I met all those friends of Kenneth Koch and then of Frank O'Hara, at some party or other around 1959–60. At the time, Arnold was known mainly as a translator of Roman and Greek literature. Years later, he did a theatrical version of Ovid's *Metamorphoses* at Yale School of Drama. I remember him talking brilliantly about Bertolt Brecht (whom he also translated), late-sixties rock and soul music, Venetian countesses, and, as we stood, both of us on LSD, elbow to elbow in Barney's Beanery one afternoon in Los Angeles, about Shakespeare's late plays.

Arnold was some kind of great lover. Kenneth, at a party once, in one of his more spiteful moments, looked at Arnold across the room and sighed, "Arnold is Love." He was dead right, for cherubic Arnold often was the spitting image of Cupid/Eros, albeit man-size with an expanse of raggedy hair atop his smiling face. (The smile persisted, even when mixed with a kind of grimace, as Arnold was prone to much inward pondering.) But Kenneth, impatient with anything that seemed less than bright, was attacking Arnold's sentimental, guileless side.

In those first days of my knowing Arnold, his girlfriend was the blond, impossibly beautiful Maria Teresa Cini, whom Kenneth coveted, as did I, I must admit. Then he was with Jane Romano, who starred in Arnold's *Red Eye of Love* at the Living Theater and who died of Hodgkin's disease as Frank's friend Bunny Lang had done some six years before. After Jane, there was the wide-eyed and very funny Barbara Harris, and then others I didn't know.

One of the funnier times I had with Arnold was going to my mother's bungalow in Acapulco with him for a week or so in what must have been 1967. We did a lot of double dating with a couple of my mother's women friends (they weren't out of Arnold's age range, and only slightly out of mine). I also did a lot of picking up after Arnold, especially his underwear, which he seemed bent on leaving at various points poolside and on the patio.

For his role as the famously jowly Richard Nixon in Kenneth's *The Election*, Arnold inserted two rubber golf balls in his mouth, one in each cheek. At one dramatic turn in the play, he reached in, pulled them out, and pitched one after the other into the audience.

From the mid-sixties on, Arnold had a productive association with William Bolcom and his wife, the singer Joan Morris. There's a terrific album of Weinstein-Bolcom cabaret songs sung by Morris called *Black Max* after a waterfront Rotterdam character de Kooning had told Arnold about. For Bolcom, Arnold also wrote notable opera libretti—for *McTeague* and *View from the Bridge*.

Unfortunately, *What Did I Do?*, the Larry Rivers autobiographical survey Arnold co-wrote with Larry, is a dud; it's not Larry's voice but Arnold's that tells

Larry's life story, and it just doesn't ring true, not as "Larry Rivers," anyway. On the other hand, the fact of it allowed for a rather notorious presentation at the San Francisco Art Institute by the two of them, during which many successive footfalls of women offended by Larry's vainglorious sexism resounded down and away from the lecture hall steps.

"Great!" "Terrific!" "Marvelous!" Arnold found his own idiom for whatever, to him, was the latest good news: a dinner invitation, a beautiful person, or a poem. I can hear his raspy voice nailing it in two syllables, simply Arnold: "Aces!"

Doc Humes

I knew Doc pretty well. One thing I never will forget is running into him on a vaporetto in Venice and him reciting Yeats's poem "Lapis Lazuli" from start to finish in full voice before we got from San Marco to the Lido. Doc's recitation seemed to carry across the entire lagoon as he declaimed the lines:

> For everybody knows or else should know
> That if nothing drastic is done
> Aeroplane and Zeppelin will come out,
> Pitch like King Billy bomb-balls in
> Until the town lie beaten flat.

Doc (Harold L.) Humes was the man who was, then wasn't, there. One of the great inventors of this age—his inventions ranged from originating the *Paris Review* to paper houses—he would carefully watch over any scheme of his to the point that it verged on materializing and then magically disappear.

I met him first him through Mike Goldberg and Patsy Southgate, and then again through Terry Southern.

For years I kept after Maggie Paley to find the right biographer (if not Maggie herself). At least there is the sympathetic and excellent documentary his daughter Immy made of Doc, his brilliance and warmth and all his foibles.

The Yeats recitation occurred on the day he was putting together the Art Writers Guild with whatever prominent European directors were there. On the vaporetto, he said, "Come out to the film festival tonight. Meet me in the lounge. Godard, Duras, Fellini—they'll all be there." Indeed, they were. The idea was to put American novelists—Terry Southern, William Styron, Norman Mailer, and others—together with the continental directors for film projects. Good idea, but one that never happened, except for that one Venetian night.

Doc himself wrote two terrific novels, *The Underground City* and *Men Die*.

July 22, 1962: Frank O'Hara had read his poems, with me introducing, in the courtyard of the New School for Social Research. Afterwards, Mike and Patsy suggested we go to Le Club, where they were hosting a party for *Marlene Dietrich's ABC*, which had been ghostwritten by Doc. So we went. At one point Doc took hold of Frank and me and steered us over to Dietrich's table, where she was conferring with her business manager. Doc shoved Frank into the banquette next to Dietrich with high-flying remarks to the actress about Frank as "America's greatest poet," etc., which clearly meant nothing to Marlene, as she said a quick hello and went straight back to talking business. For my part, I remember all this so well, including the date, because minutes later at the same party I noticed an

extraordinarily beautiful woman looking in my direction, holding one arm with her hand folded in close to the shoulder in a manner very like that of Delphine Seyrig in *Last Year at Marienbad*. The band was playing. I went over and asked her to dance. We did, it was a waltz, and so began what would be, over the next four or five years, the most prolonged, ultimately futile romance of my young life. Impossible on both sides—"in love," as it were, in our separate imaginations, we had no business being together aside from the grip of oddly scripted passion that bound us, a passion that eventually fizzled or in any case became diffuse. (Had this been opera, Doc Humes's role was that of Fifth Business, the accidental go-between.)

Doc died in 1992, at age 66. The last I knew of him, he was handing out large-denomination bills on the Columbia University campus. Immy's film tells a great deal of the rest of his and his family's story.

2015

Morris Golde

The parties of Morris's that I attended in the sixties were occasions for Urbane Greatness to strut its stuff. These amounted to the preeminent New York artistic salon of the epoch, where theater and music people mixed with smatterings of poets and painters. Conversationally, there were intense assertions pro and con, prolonged gushes, quick slaps, and suavely orchestrated quips crackling in sequence around the room. People stood in twos, threes, fives. Every so often, a single voice, impassioned or giddy, dominated. Downwind, the buffet table was simply and amply stocked, deli-style; the floor space near it, cleared for dancing—as the night progressed, the best show in town. Out back, as I recall, was a little terrace where, if you wanted to, you could get some air.

A partial guest list: Annie Troxel, Maggie Paley, Edward Albee, Richard Barr, Clinton Wilder, John Gruen, Arnold Weinstein, Gene Myers, Scott Burton, Maxine Groffsky, Morris's niece Ellen Golde, Vincent Warren, Virgil Thomson, Aaron Copland, Ned Rorem, William Flanagan, Leonard Bernstein, Chuck Turner, Alvin Novak, Irving Drutman, Michael de Lisio, and, in spirit (from before my time), Morris's main man, the too-early-departed Marc Blitzstein. The painters were Jane Freilicher, Jane Wilson, John Button, Maurice Grosser, Roger Baker, Alvin Ross; the poets, Edwin Denby, Frank O'Hara, Kenneth Koch, Ted Berrigan, Tony Towle, Barbara Guest, Kenward Elmslie, Jimmy Schuyler, John Ashbery, Anne Waldman, Ron Padgett, and me.

Morris's parties gave Frank O'Hara an optimal setting for late-night, far-flung tirades, wondrous in scope, searing in logic, and of a musicality that made them somehow commonsensical, though stupefying in all other respects. I can still hear Frank's morning-after phone voice pleading, "I hope I wasn't too awful—I just thought something ought to happen!" To Morris, hearkening back to the party he gave after their first New York reading in the early fifties, Frank and John Ashbery would always remain "the Baby Poets." Morris was also the only person who could ever get away with calling Frank "Frankie."

Then, too, Morris had his own unique sense of more intimate occasions: viz long dish-the-dirt lunches for two at Dinty Moore's, or a candlelight dinner hosted just so my mother, her Irish friend Sybil Connolly, and I could meet Virgil Thomson. Forever after, Virgil, when I saw him, would lead off by saying, "How's Mama?" As it happened, the last time I saw Virgil, after his lecture on libretto writing at the Marin Community Center in San Anselmo, he repeated the question, and when I replied that she was then eighty-five, he pursued the matter: "Still working?" "Yes." "She must be very rich!" he beamed.

Over and over—considering Morris both as a friend and as a figure central to the diversity of artists he helped draw closer in communal force—it bothers

me that he may not have known, that we may not have told him, what a treasure he was, how much his friends, the artists, the members of the audience loved him, that it was understood and appreciated that his generosity, faith, joy were unparalleled, and he was no one's fool—he knew the right and wrong moves as well as anybody—but he wanted art to be great, and he wanted his friends to realize that greatness. What I suspect never occurred to him was the grandeur of his feeling for how artistic creation matters—how this feeling, the way he let it show, matched in importance the arts for which Morris so perfectly cared.

From a letter to Gene Myers, with a few details added from memory
To be read by Maggie Paley at the memorial for Morris Golde,
November 13, 2001, New York Society for Ethical Culture

Morton Feldman

Josquin ... Mozart. I like that particular type of music that does not push.
—MORTON FELDMAN

In 2001, Chris Villars interviewed me about Morton Feldman for his Morton Feldman webpage (www.cnvill.net/mfhome.htm). What follows is a slightly revised, corrected version of my parts of that interview.

CV: Do you have any recollections or other writings about Feldman that you would be willing to have reproduced on my Feldman website? I'm always on the lookout for new material.

BB: Funny, as I said to Clark Coolidge yesterday, I'd love to write something about Morty Feldman, but every time I think about it I get no further than the image of him leaning forward over a small lunchroom table on Lexington Avenue in the mid-sixties, huge baffling eyeglass lenses in black frame, checked sports jacket, tie, delicate fingers wrapped around a cheeseburger, no pause in the talk.

CV: Your description reminds me of one of the well-known photos of Feldman in a very loud checked jacket.

BB: Yes, tasteless. Manufacturing end of the garment trade was his turf. He stayed there, in character, I suppose. But with impeccable manners. As for the dress code, remember this is the time when artists, unless they were playing at being working class or artisans, appeared in public in jacket and tie. For most, that was the size of it, no fashion consciousness included. Something serviceable, the most "uptown" being from, say, Brooks Brothers (Harrods to you). Cage, for one, always seemed to dress like a college boy, with that silly flattop hairdo and all.

CV: Do you know what Feldman actually did in his father's business? B. H. Friedman tells us it was a business manufacturing children's clothing, but not what Feldman's job was. Did he ever talk about that?

BB: He never mentioned it at all.

CV: Did Feldman talk about anything and everything, or was it always art talk or music talk?

BB: No, about everything. Very curious about people, but not much gossip. Along that score, I always felt he had a secret life. He was interested in writing. But when he asked me to put together a poets' evening at the New York Studio School around 1968, I could tell that the poetry my friends and I were making was not for him; the students were enjoying it, but midway through the reading, Morty slipped out of the room. I didn't see him for a

long time after that. I left New York. When I saw him twelve years later at the Philip Guston memorial at St. Mark's Church—he entered with Francesco Pellizzi—he kept calling me "Bergson."

By the way, have you ever contacted Feldman's first wife, Cynthia? We always liked each other. She was an editor, I think. God, I'm vague! I remember their place on, what was it? 337 Lexington Avenue, above what I thought was a tailor or dry cleaner or both. Somehow, I got the impression the ground floor was Cynthia's family's business, but it turned out to have been completely separate, a Chinese laundry, in fact. A steep, dark, narrow flight of stairs, as I recall. Second floor, turn right into simple flat, beautiful "old-world" furnishings, except for the paintings—Guston's *Attar* on the far wall. A composer's place, one quadrant of the room taken corner-outward by the piano, the corner by the windows.

CV: Do you recall when and how it came about that you met Feldman for the first time?

BB: I don't. I think it must have been at a gallery or concert. Probably either Guston or O'Hara introduced us. I was interested in Feldman's music long before I met him, and the fact in those days of anyone's being so attentive to one's work was enough to start a friendship. I don't recall Feldman at artist bars or even parties. One place I would see him was at David and Ellen Oppenheim's, their parties. Do you know about them? He was a clarinetist and, as I recall, an A&R man or some such under Goddard Lieberson at Columbia. Anyway, he was involved in record production. Ellen is the actress Stella Adler's daughter, a painter, a beauty, and was very close with Morty.

CV: I'm trying to picture that apartment you describe, with *Attar* on the wall facing you as you enter. I believe that's a four-foot square painting! What an effect that must have been! Do you recall what other paintings were there? Did he have his famous Rauschenberg on the wall too?

BB: I'm trying to picture it too. As I spoke with Clark Coolidge this morning, the image of the second floor began to include a shop at the rear of a corridor, with the door to the Feldmans' flat at the top of the stairs to the right. Yes, *Attar* on the facing wall, a painting Feldman later sold, much to my amazement, although we all can be forced to give up such treasures from time to time. I don't recall any other work. I know Morty had that early Rauschenberg. And wasn't there a Pollock, a drawing perhaps? I can think of very delicate Pollock drawings that absolutely "go with" Morty's music.

CV: Were your visits purely social or did you go there to study with him at all?

BB: I am not a musician but a poet. Odd, but I also have no recollection about how this friendship—for such it was, for a while anyway—was struck.

There's a common etiquette in New York that in such relations the younger of the two people calls on the elder. We always met in Morty's neighborhood, sometimes just at that lunch room—like one of a million such places, call them delis or sandwich shops or hamburger "joints"—in New York. I think I went to the apartment all of four or five times. I seem to recall Morty drinking Cel-Ray tonic, a celery soda common to Jewish delicatessens but also favored by dancers, probably low calorie. That, with the cheeseburger. I would have had the same. Maybe even a bacon cheeseburger. Feldman and I both smoked cigarettes constantly, pausing only to eat.

Feldman, who was large and tended to be overweight, slimmed down radically at a certain point in the late sixties; he explained that it had been his custom to drink a half gallon or more a day of orange juice and that on his doctor's advice he had given up this orange juice, and with it had gone a lot of his weight. The orange juice was that high in calories, or so Morty's theory had it.

cv: Am I right in thinking that Feldman was living with Cynthia throughout that period that you knew him in the sixties, that their separation only came about later on?

bb: Yes, or anyway I knew nothing of the separation until after Morty was gone.

cv: You say you always liked her. What was she like?

bb: I was a kid writer. She was an editor, probably at least ten years my senior. She treated me with respect and a sort of big-sister tenderness. She never stayed in the room while Morty and I talked, nor did she ever join us for lunch.

cv: Did she accompany Feldman to events or in his socializing?

bb: Off and on, yes, but mostly not.

cv: You've hinted at Feldman's involvement with other women. Is that what you were alluding to when you said you always felt he had a secret life, or was it something else?

bb: Secret to me. Yes, I always thought that he had another life with a particular woman. The thing is, Morty was very, very charming. I can imagine him working his charm on women, and I can imagine that he was somewhat woman (not "girl") crazy. That he saw and experienced women in a romantic Russian-novel manner.

cv: I was going to ask about Feldman and Frank O'Hara, how they got on together, whether you recalled any particular exchanges?

bb: Did I ever send you or did you find "A New York Beginner" in *Modern Painters* magazine? There's a story in there about Frank and Morty playing four-hands at a Living Theater benefit, for Amiri Baraka, I think. Well, "Lost Times and Future Hopes" is Morty's statement as regards Frank. And, as

I've written elsewhere, you have a little view of Frank and Morty playing together. Frank and Morty amused one another no end; they were contemporaries, and of course O'Hara had begun as a pianist/composer—he "switched" to poetry while at Harvard in 1946 but never lost his love of the repertoire.

CV: Apart from that event you describe at the New York Studio School around 1968, did you ever get any feedback or encouragement from Feldman on your own work?

BB: I never showed him any poems. As far as I know, he didn't read the literary magazines. It was all conjecture, speculative: I, you, he, it work/works this way or that, or neither.

CV: Apart from the poets and writers in the immediate milieu there in New York, do you recall any other literary figures Feldman particularly referred to?

BB: I think we talked about John Ashbery but nothing conclusive. Kierkegaard, Sartre, Kafka, Beckett—those writers were in Morty and Philip's canon. Nope, offhand, that's all. Jasper Johns was another topic; the philosophical and melancholic implications of Johns's work were fascinating to us both.

CV: Did you write anything when Feldman died?

BB: No, and I think you can see why. Morty's music has come more and more into focus for me. There are so many recordings now, mainly, I guess, because of how he's appreciated in Europe. I pay attention every time a new one appears. I think of him—especially his voice, his grammar—fondly. I hear him saying "Schoyn-boyg." I admire him no end, and I am also amused by the figure he cut, how he shaped that. But the particulars of the man have gotten fuzzy in my mind. That may have to do with how we lost touch when I moved to California, how he rejected the change in Philip's work—although he changed his mind later—and the inexplicable remoteness of his greeting, or so it seemed, when we did meet again, at Philip's memorial.

Hello, Philip

"Always meet your heroes" is a good suggestion passed along by Robert Creeley, who had his own early brushes with greatness. At normal distance, some heroes can deceive (or, more likely, you deceive yourself at the expense of what's for real); up close, the worst they can be is disappointing—you were expecting someone else? Occasionally, it's good enough, or, best-case scenario, a perfect fit.

For me, Philip Guston became a hero and a friend almost simultaneously. He was nearing fifty, I was in my early twenties. I remember going with Frank O'Hara to his studio one flight up in an old firehouse on West Eighteenth Street and for the first time experiencing that peculiar, discrete phenomenon: a painter's studio packed with elements of a substitute world. A weight in the air differed from the buzz or frantic mess of other painters' lofts. The ambience was other than business as usual. Philip said later that I had been strangely silent. I'm sure that was true; I had no answer for being thunderstruck. The next day, annotating my memory of the scene in a journal, I scratched the word "INTEGRITY" in tall spindly letters, as if, for this initiate, the spectral cliché of artistic probity had suddenly broken clear, an old-time value that walked right up, extended a meaty, capable hand: "Greetings."

In Michael Blackwood's film of Philip at work, we see the beautiful gesture he makes as he walks slowly back toward his picture in progress to put on more paint: he looks to be swimming in air like a Chinese dancer, and the hand not holding the brush is raised, masking off an area of the composition as he zeroes in. It's still a composition at this point, and on the voice-over commentary he's saying: "Well, everybody has notions. But notions are not reality. Reality is when you feel to take pink paint, and you put it down, and for some mysterious reason, some magical way, it becomes a hand. Then that's painting. The public, the looker, thinks you have a blueprint for it, and there isn't a blueprint . . ."

Seeing Philip's work around 1960 was a confirmation for me, as much any poem, that the seemingly arbitrary, often hesitant way of writing I was then pursuing was not mistaken and that even my doubts might generate some worthwhile thing. Later he and I could laugh that he became an "Ideal Reader" for the poems—because copying them out with a quill pen in bold, cleanly spaced lettering and drawing around them, he opened up certain of my poems for me, as to subject. Typically, Philip pondered both the process and the outcome. In a postscript to one of his mid-seventies letters he wrote, "Poems and drawings give each other new powers—energies!" He took it upon himself to "picture" whatever he read that, ever unpredictably, had meaning for him.

Philip's conversation about painting had overtones for poetry. For the poetry I was then trying to write, he had an uncanny way of pinpointing the process

I was going through but didn't know enough to talk about. I knew enough to recognize the parallel in what he said and in his paintings. Philip was interested in work, how he worked, and what it meant to do, as he would say, "all this stuff." Personally, we didn't see very much of each other. Eventually, living in different towns, and then on different coasts, our friendship peaked in exchanges of letters. When we did get together during the seventies—once in San Francisco and a few more times in Woodstock—there was always that charge, everything left to say.

His letters were good news. What he wrote about his work habits transmitted a terrific energy, as if a buzzer were going off, a reminder not just to keep at it but evocative of the necessary spirit involved:

> We are in great spirits these days. . . . The images that appear somehow reveal more in terms of forces than what the images represent. Is it possible? So this is what I've been after—after so many years—a good heavy foot in the door of this room, finally. What a difference—to live out a painting instead of just painting it. . . . Any emotion can enter now . . .

And from another occasion, visiting the Woodstock studio, I recall his saying, "Sometimes all you remember from a particular event is the eye in one eye."

Enigma Variations was the realization of a project we had talked about over the years, the idea of putting together, in book form, some of my poems with drawings by Philip. In 1974, four years after moving to California, I finally got up the gumption to send Philip a short manuscript with the suggestion that he might put some drawings to the poems and we could then have a book, "our book." He responded with stunning alacrity: within a month or so, he sent eighteen drawings, each with a note attached telling why that particular drawing went with the designated poem.

The idea was, yes, collaboration, although collaboration a continent apart and by design rather than hands-on. I had already written the poems, and only one of them with Philip especially in mind. Philip, for his part, made some drawings expressly in response to certain poems, but most he selected from work done in more or less the same time frame, 1967–74. Further, as Philip said warily, the drawings should not be seen to "illustrate," but rather to accompany, the poems. ("Illuminate" was an alternate verb we both felt comfortable with.) Thus, the poems and drawings "read" one another across the margins, so to speak, incisively.

There are about a dozen of Philip's paintings and drawings in our home. First, an ink drawing I picked out in late 1962 during my first visit to the Woodstock

studio. I had written an effusive appreciation in *Kulchur* of his Guggenheim ret-rospective earlier that year, and Philip liked my account well enough to offer a gift. The drawing is one of those nonstop weaving ones with many loose ends. Near the top is a circle, ambiguous about its relation to gravity—it could be either a balloon or a rock. In the middle, another funny shape, squared off at one end and narrow like a cardboard box (the kind for long, thin charcoal), and tapering in the other direction like a syringe. Then down below is a fat sort of schlong that, but for its size, might have been a tracing of someone's thumb in profile pressed flat. This drawing has all the mystery and canniness in a slow accumulation of image that I admired from the start.

Then there is the "primary lesson" of four little paintings on Masonite sent just before my son Moses was born. Reading from left to right across the living-room wall: an open blank book; a personal mailbox with a brick on top; a black and red cup, huge against registers of gray, black, green; and a bulky easy chair with studs, flat, dirty white, edged with black.

> Dear Bill, As I was mounting these little oils, I thought how nice they would look hung on your wall as a cluster, joining the small one you have of a canvas on an easel. They look to me like a primary lesson—*The Book, The Chair, The Cup,* and, of course, *The Mailbox*—also as a little present to you & Lynn and baby. Soon, no? Naturally, the book is for baby—not a mark on it—yet—clean. All you will need is a hammer (I mean, to hang them on the wall).

As fate would have it, it fell to three or four young poets, including myself, to be the core audience for Philip's work during the early seventies, when he had pretty much absented himself from the New York art world, and vice versa. Each of us in turn got the Philip we needed, or deserved—in our lives, for the poems. (It says something about the fitness of his world, I think, that he could feel at home with our diversities.) Philip in person was as changeable, as inclusive, as fierce, as articulate as his paintings. Among friends, the same sweep that manifested terror and absurdity in his art transmuted itself to a social grace—expansive was how he appeared, even when probing introspectively. Philip's charm often dis-played a devilish turn, but his flattery, if that's what it was, registered a will to elevate each occasion of artistic friendship to the most plausible Olympian ledge.

1993 / 2016

Schuyler Entries

An emergency, reading that James Schuyler "was born in 1933"—so says the jacket note on *The Crystal Lithium*. That would make him a mere six years older than I, seven years younger than Frank O'Hara, one year older than Ted Berrigan, and so on—a fact behind his accomplishment that my vanity calls unacceptable. But the jacket for *Hymn to Life* says "born in 1923." So there. (Though where vanity rears its horny head there can be no real relief.)

The city poet who knows, like no other, the names of all flowers. Of whom else can it be said, he is our best (or only) descriptive poet? Was this ever said, as it might have been, of John Clare? "You can't get at a sunset naming colors." Every poem, a view. The sense in each of a scrim of exact detail so carefully woven as to be seamless, impregnable to the monsters raging, ready to pounce or tear through from the other side. The central character, if any, of most of his poems is the day, the poem geared to get it down, nail it in its lineaments as it appears and goes: "a nothing day," "day the color of a head cold," "dark day," "a day subtle and suppressed," "May 24th or so," "a day like any other," and so on. The diurnal figure's good luck just to be there, posing, gesturing for such a poet. The poems have what filmmakers call "room tone," cf. Charles North's remark about Schuyler's "perfect pitch."

One hot day in 1961, when I was working in the office at *ARTnews,* Tom Hess said, "Go down to Jimmy Schuyler's and pick up his reviews." I hardly knew Jimmy then, but I had heard from John Myers that he had been having psychiatric troubles. The reviews for that month were long overdue; Jimmy apparently had told Tom that he had them but in his present mental disarray couldn't manage the trip uptown from his place on lower Broadway to deliver them. Once there, I rang the bell a few times and got no response. Baffled as to what to do next, I went to a corner phone booth and called Frank, who suggested I try Jimmy's number. That worked, and Jimmy buzzed me in. The apartment was a mess, Jimmy, in pajamas, sort of silently, aimlessly padding around the front room. No, he said firmly, giving me a somewhat stony look, there were no reviews. I left, feeling useless and rude, an intruder in someone else's private soul dust.

Schuyler told an interviewer that, to engage his interest, he sometimes wrote the first drafts of his art reviews in verse lines, then later rearranged them, closed up and slightly altered, in paragraphs. According to Frank, the fifties *ARTnews* poets Barbara Guest, John Ashbery, and Frank himself used to show their monthly

short reviews and longer articles to Jimmy for style checks. Frank said, "Jimmy was the real writer; he knew where the commas were supposed to go."

> CY TWOMBLY (Stable; through January), fleeing for his creative life from the white hell of Black Mountain, shows Siberian slabs (those diamonds they've found there, what makes them so sure they're not just frozen tears?). Fabulously underpriced. (J. S., 1957)

Schuylerism: The prose is golden, in the same sense as Jane Freilicher's great painting *Goldenrod Variations,* the prodigious scope alive to, never stumped by, whatever vibrant detail is there, and the sense, too, that all this happens in time and constitutes, in its way, history, human and otherwise. Such accurately directed empathy taken to its eternal edge. About the hornet in the room in "Buried at Springs": "One of us will have to go." Or how incomparably, as if Francis Ponge were taking a refresher course in how real both things and the words for them can get, "Trembling, milk is coming into its own." The under-appreciated (although now in reprint via New York Review Books) novel *What's for Dinner?* does just what Henry Green ordered, "[draws] tears out of the stone." The poetry follows suit, even increasingly edgier:

> So many lousy poets
> So few good ones
> What's the problem?
> No innate love of
> Words, no sense of
> How the thing said
> Is in the words, how
> The words are themselves
> The thing said: love,
> Mistake, promise, auto
> Crack-up, color, petal,
> The color in the petal
> Is merely light
> And that's refraction:
> A word, that's the poem.
> A blackish-red nasturtium . . .

February 11, 1989
Dinner after Jimmy Schuyler's reading at the Art Institute, Washington Square Bar and Grill, with J. S., Tom Carey, Lynn, Kathleen Fraser, and Bob Glück.

Corner table by the door. The talk breaks into facing twos: J/T, K/L, Bob and me. Jimmy is gracious—it's more of an after-reading group than he'd bargained for, and the restaurant is noisy, replete with piano accompanying a girl singer who can't quite meet the old standards ("Am I Blue," etc.) head on. Eventually, I catch Jimmy's face out of the corner of my eye—a look of sweetest sadness with a faint cry of help at the corners of his mouth. No coffee, no dessert, and Bob drives Jimmy and Tom back to the Friary.

The reading had been astonishing. Jimmy seated at a card table with French blue tablecloth, blue Mexican water pitcher, Chinese enamel tin mug. He read musically, steadily, softly intoning each word. A few flubs, where word or phrase got gummed. One poem—"Fauré Second Piano Quartet": Fauré, Schubert, Chopin—that range of precise, stately, sorrowful piano, groundswells of his poems, with fully rounded, openly flung vowels. Something else: in the insistent patching together of detail—a thing said for each aspect in a day, a view. The whole took about forty minutes. He enjoyed the funny parts, the audience's response—"They were so nice," he said after the applause died down. Melodious he was, as I hadn't expected. An Anglo melody in part (Auden, yes, but then reaching back to clear, hard Chaucer), plus the chortle and edge of manic American fact. Newly heard among the poems: "Evening Wind," "Eyes at the Window," "Korean Mums," "Now and Then," "A Man in Blue," "What Ails My Fern?" (a crowd pleaser), and before those, he always seems to begin "Past is past . . ." ("Salute"). Most sound longer than they look on the page.

February 13, 1989

Showing Jimmy the plum tree in our Bolinas yard that occasioned a poem I wrote for him. The tree is now in flower, as then it was in bud. And three plants he wanted to know the names of—watsonia, solanum, salvia—I didn't know but Lynn told me later, and I sent the names on for Jimmy's gardening registry. And the rose he recommended: Belle of Portugal.

In last night's dream I confused Jimmy with Milton Greene (not difficult—they are near look-alikes). I was sleeping in the entryway to his studio when he appeared at the door. Before that, a non-sequitur party with jazz musicians, Ornette Coleman and others (not Jimmy's scene at all).

Jimmy by the Bay, Minuses and a Near Plus:
He hated the hills, the incessant up-and-down of them, in cars.
He hated the long cross-continental plane ride.
He liked Bolinas and the Friary. (He had really come to see Tom.)
He visited Don Allen with Bob Glück.
Me: "How was Don?" Jimmy: "As asp-ish as ever."

> *Blue is the hero of* Three Friends at a Table, *a blue that varies from a*
> *night-blue wall pierced by a shining grey window to one mixed with violet*
> *and pink in a man's sweater; or it becomes slightly chalky, a "French" blue*
> *on a cup, or that of an iris under artificial light, or one with a clanger to it*
> *in the enamel of a teapot, or one that looks silky in the geometric pattern of*
> *a blouse. It is air within the paint and gives it breath.*
> —JAMES SCHUYLER, "Nell Blaine: The View from 210 Riverside Drive,"
> ARTnews, MAY 1968

At Yaddo, June 1968, no sooner had I read the start of that first sentence than I was off the bed and typing in title caps "BLUE IS THE HERO" up top of my poem-to-be. Eventually, I mailed Jimmy the poem, and he wrote back, revealing that in fact his line had been prompted by an earlier one by Frank O'Hara (also in *ARTnews*) about Fairfield Porter, "that luminous grayness which is the hero of much contemporary painting." Then, closing the circle in late August, Jimmy sent a poem for my birthday, "Gray, intermittently blue, eyed hero."

A Page from 1971

Vermont
The pearlized opalescent amethystine hills
are looking very well this evening.
 James Schuyler
 August 24, 1971

Dear Dill Dirkson,
The first sentence is prose. I would not venture to say
the same for the second.
 love,
 Palme Dutt

The friends who come to see you / and the friends who don't.
For all the kindness Jimmy showered on me, I was mostly at a loss as to how to please him. Partly, there was never enough quality time together for us to feel at ease with one another. Back in New York in 1971, I learned that Jimmy was hospitalized, and Maxine Groffsky invited me to go with her to see him. Shy of sickbed visitations, I gave Maxine a pound or more of tangerines to take in my place.

April 12, 1991

Phone message from Anne Waldman this morning: Jimmy Schuyler dead of a stroke at 7 a.m. And looking at his typescript poems on glaring orange bond, with alterations scribbled in tentative, thin but ever upright script—plus an inscription in *The Home Book*: "for Bill / father of / Moses— / love— / Jimmy / Jan. 9, 1977."

> Of your Charity Pray for
> the repose of the Soul of
> JAMES SCHUYLER
> April 12, 1991
> —Our Miraculous Lady of Kursk
> [Funeral Card]

Tiger, Tiger: A Few Days with Joan Mitchell

"You sure had a tiger by the tail!" said a lady by way of commiseration after Joan's and my talk at the San Francisco Museum of Modern Art, spring 1988, on the occasion of her retrospective there. "Not me," I replied, although during the Q&A some members of the audience had been severely unnerved by her readiness to attack anything that struck her as less than apropos. Joan liked to play rough. "What kind of stupid question is that?!" she demanded of the first one up. She then went on, prompted by I can't remember what, to expound beautifully on the gists of Hans Hofmann's classes and their importance for her in the early fifties.

When the San Francisco Museum of Modern Art curator Graham Beal had asked Joan to lecture on her work, she said she wouldn't, but she would "talk about poetry and painting with Bill Berkson." Accordingly, in a letter to Joan in advance of the event, I wrote out a few ideas about what our "talk fest" might consist of, marking possible poems for her to read and reminding her of some guidance she had given me when we had talked briefly earlier (for which John Ashbery poems to select, she indicated, "early, lyrical"). As it turned out, Joan had no intention of reading anything herself and left the whole presentation up to me while agreeing to mount the platform for those final ten minutes or so of impromptu patter.

> *Oct. 31, 1961—Frank O'Hara pronounces*
> *John Ashbery "the foremost poet in*
> *English of our time." Joan Mitchell concurs,*
> *BB grunts, Jean-Paul fixes the camera.*
> *Joan says, "God! How I worked over that poem!"*
> *[meaning John's poem "Europe"]*

The listing in my little black engagement book for 1961 shows Joan and Jean-Paul Riopelle's Paris residence as 10 rue Frémicourt in the then working-class, now posh fifteenth arrondissement. When I first visited there the previous fall, Joan spoke of plastiques exploding nearby, the Algerian militancy being then fully active. I remember Joan's home studio as enormous, with the usual alcove for dining, equipped with a long wooden dining table at one end and much more daylight than her New York loft on St. Mark's Place, which always seemed dusky and confining and where she appeared less happy. The occasion for Joan's remark about John's long poem "Europe" was the appearance in her loft that afternoon of the page proofs of *The Tennis Court Oath*, the book containing that and other poems written in John's then new disjunctive manner. (She went on that day to specify her sense that "an extraordinary death of culture" was what "Europe" was all about.)

On that same or perhaps another Parisian occasion, she confessed to Frank and me, in a one-liner that, as she might well have foreseen, became an epigraph for one of Frank's poems: "I think the happiest days of my life were when I was going to a chiropractor. Isn't that the most depressing thing you've ever heard?"

Mostly we met in Frank's company, sometimes in New York with Frank's apartment mate Joe LeSueur (whom she called "Joey") or in Paris with John Ashbery, Jean-Paul, Frank, and two of Joan's friends, Mario Garcia and Marc Berlet, or in larger company, with others of the crowd of American painters— among them Kimber and Gaby Smith, Shirley Jaffe, and Shirley Goldfarb— then living there. Such encounters were few and far between. During our San Francisco reunion, Joan vividly recalled a time, still hard to get to in my memory, of sitting on the floor of my mother's Fifth Avenue apartment with Frank and me, the three of us reading poems aloud to one another. Another instance I do remember was at La Closerie des Lilas with Jean-Paul telling us how Francis Picabia, in his late years, would drive up to the brasserie in one of his big cars, eagerly greeted inside by younger artists as "Cher Maître."

Joan was the best of the so-called second-generation abstract expressionists. Shortly before I came to Paris in 1963, *ARTnews* had featured an article headlined "Is A-E Dead?" Joan had seen it and plainly wasn't going to let the notion get by her without a fight. She stormed around the studio for a while, trying out with every stride across the floorboards a different intonation of the question, Is A-E dead? Then, having momentarily gotten that out of her system, she invited me to join her over at the table and, together with offering something in the way of lunch, proceeded, in her lay analyst mode, to ply me with tumblers full of cognac, egging me on to spill every scintillating detail of an ill-fated love affair she had heard I was stuck in. Joan's intense curiosity about everyone's private life was something to contend with.

Then again, in 1980, when she came to visit Elaine and Willem de Kooning for lunch in Springs, Long Island, I was struck by Joan and Elaine's mutual affection and the extraordinary professional respect both de Koonings accorded Joan as one who had fulfilled her early promise and then some. The collegial warmth was such that Elaine's sunlit luncheon area seemed all the brighter for it.

2010 / 2015

"Everyday Expressionism":
Michael Goldberg and Painting in the Fifties

Thinking of Mike Goldberg, I see a curvaceous, white, modern-style coffee table with a jumble of books, art magazines, and catalogues, Rimbaud's *A Season in Hell* in the good-enough Louise Varèse translation among them; a big ceramic ashtray and tumbler or two; Mike seated on a divan, leaning forward slightly, vigorously intent on meaning whatever he thought to say, a cigarette (that gauge of sincerity) poised between fingers, and me opposite, likewise smoking fiendishly, in a straight-back chair. Occupying the painting wall, one of the square or near-square "slash" pictures comprising a pavement of monochrome wine red or dark green, divided by two or three thick directional swipes of dirty white laid on with a very wide trowel. It is spring 1963; within a few months I will be living in Paris in an apartment, one wall sporting a picture from that same series, a "loaner" Mike arranged through David Anderson, at whose gallery on the rue de l'Echaudé those much underappreciated works had been exhibited.

I have no precise recollection of where or when I first met Mike, but it was probably through Frank O'Hara's good graces around 1960, at one of Mike and Patsy Southgate's parties at the house they shared near the White Horse Tavern on West Eleventh Street. Mike and Patsy were great party givers in an era of great parties. The company was, as typical of New York School evenings, whether private or at an opening or theatrical event, artists and poets, one or two congenial critics, editors, and a smattering of professional people—the dentists, psychoanalysts, journalists, and lawyers, all of educated taste, some given to collecting the new art. One night, center stage, there was Willem de Kooning, just back from Japan and telling about it: "It's so terrific, you know," he said, "but kind of silly, too—everywhere we went they would want you to smell their beautiful flowers!"

By the time I got to know him well, Mike's studio was the one in the landmark address 222 Bowery, a vintage 1884 structure amid street-level restaurant-supply shops. Fellow tenants eventually included the performance poet John Giorno and, in the so-called bunker below, William Burroughs. The space Mike occupied had been Mark Rothko's studio previously, and before that, a YMCA gym. The windows were some twenty feet up, arrayed horizontally above the painting wall on the south end of the nearly fifty-foot-long room.

For all the languor of what Frank called the "blank gorgeous art" lying about Tenth Street and elsewhere, the early years of Mike's art coincided with a period of extraordinary health in New York painting culture. Within the mix apparent by 1950 (the year that abstract expressionism, as Clement Greenberg put it, "gelled as a general manifestation"), the new painters enlarged the element of

rococo splash that their elders had put in front of the image. As many Goldbergs of the fifties and later attest, Pierre Bonnard was the newly discovered modern master. The salutary effects of large traveling exhibitions of Bonnard's paintings—passing through New York's Museum of Modern Art first in 1948 and again in 1964—were visible across the board, whether in an abstract artist's candid orange slab or the raw sensation of contour that spelled a gestural realist's account of someone's ear.

Of the decade's flagrant splish-splash largesse, Mike's (and almost everybody else's) primary mentor Hans Hofmann may have been the unwitting instigator, just as he was of the loosening of terms between abstract and figurative, and between style and personality to boot. Postwar students arrived in Hofmann's classes expecting to get the message of modern art, which they did, but what became more pressing was what, if anything, it meant to be an artist—since that was, as it seemed, the only thing to do—and then, once that was settled, how to proceed. In such achingly absurdist times, an ethos of back-to-scratch prevailing, the will to archetype defaulted to negotiations on the shoals of personal happenstance. The desperation tactics of first-generation painters—Jackson Pollock, Willem de Kooning, and others—had been taken up by the next generation with more irony than angst, as well as more assurance, if only because assurance was everywhere in the air, these being the peak years of Empire. Younger painters talked the talk of existential doubt where in fact absence of faith and the ergo-requisite determination to go with what one had—the intuition that a painting was there to be made and that one had the aptitude, particular as to both character and technique, to act accordingly—were givens.

In 1963, I was invited by *ARTnews* to write a "Paints a Picture" report on Mike Goldberg at work. I had just written one on Mike's great friend Norman Bluhm, with the photographer Jerry Schatzberg taking pictures of Norman at work. Jerry, whose studio was a floor below Norman's in the Tiffany building on Park Avenue South, got the Goldberg assignment as well. (A little later Jerry gave a huge party in his loft for the Rolling Stones on their first American tour and then made a movie with his fiancée, Faye Dunaway; no more art shoots for him.) *Bed*, the picture Mike worked on during these sessions, had that look of having been "to Mars and back; sort of bumpy and battered looking" that he had claimed as a virtue of his work in a statement for *It Is* some years earlier. It also announced a contrarian view of the notion of a fixed style as a mark of personal integrity, which set Mike apart from many of his contemporaries. (If, in the era of "style makes the man," Hofmann could apologize quite candidly for having "too many styles," Goldberg could be said to have had just the right number.) As Mike said of the eponymous image drawn and then painted over on the canvas, "It's going to disappear, but I'll

know it's there, underneath." It is in fact structurally palpable in the two soft gray bands that firmly claim pride of place amid an otherwise vertically oriented traffic pattern.

"EVERYDAY EXPRESSIONISM" is a phrase among others I scrawled on one of the large sheets of drawing paper I sent Mike in 1964, encouraging him to draw or paint next to or over the words, as he wished. After a number of bizarre turns, the details of which I have never completely understood, he had landed in the Psychiatric Institute at New York–Presbyterian Hospital. Frank and I decided on a plan to both cheer him up and trick him into action by each sending him words on surfaces that left plenty of space for whatever else he could put there. In Frank's case, there apparently had been a plan going back a year or so—words by Frank followed by images by Mike, all related to Frank's recent European tour on business for the Museum of Modern Art. For me, it was all freestyle, no guidelines whatsoever: above my "EVERYDAY," Mike drew a calendar nude; on another sheet there were just cutout stars, and on yet another (similar to those he did for "Dear Diary" with Frank), a tilted, disconnected bridge.

As the sixties wore on and Mike moved into the loft full-time, it became the venue for some of the more memorable parties attended by Mike's new friends, younger New York poets. (I recall one with particularly dramatic highlights, featuring, beside myself, Jim Brodey, Ted Berrigan, Peter Schjeldahl, Vito Acconci, Bernadette Mayer, and Kenneth Koch.) Though Mike retained his taste for modern jazz, the dance music segued readily from hard bop (Horace Silver's "Moanin'" was a reliable start-up tune) to R&B and rock, just as whiskey and vodka had given way to white wine and psychedelics. The ardor with which Mike took to the Lower East Side poetry scene as it was then developing shows in the drawing he made for the cover of the seventh issue of Lewis MacAdams and Peter Schjeldahl's great magazine *Mother* in 1966: a black goat under blue lettering.

Our tacit, end-of-decade farewell session took place at 222 Bowery on July 20, 1969, when Mike invited Jim and Tandy Brodey, Susan Burke, and me over to watch the moon landing on what I recall as a small black-and-white TV. By then Mike had pretty much gotten over the vicissitudes of divorce and nervous breakdown. His pictures went on determinedly, passionate without a break, some of the new ones greeting the Apollo crew's success with lunar subtlety, others verging grayly on utter eclipse. Within a year I would leave for California, with New York becoming at most an intermittent pleasure. The last of Mike I saw was when Connie Lewallen and I bumped into him at the 1998 Rothko exhibition at the Whitney. He and Connie had known each other years before when she worked with Klaus Kertess at the Bykert Gallery, and as they exchanged pleasantries I glimpsed the strength of Mike's charm exercised afresh. In an instant, the old

charm faded, replaced by a Bronx-style gruffness I knew went with it: "It's too damned dark in here," he growled, surveying the museum's tightly partitioned spaces. "They've hung everything much too close together." A parting gesture— "Nice to see you!"—and Mike moved on.

2010 / 2016

Jane Freilicher (Letter to Lizzie Hazan)

Dear Lizzie,

It seems so odd. The past few years of us waving at each other across crowded rooms, and Jane and I doing mostly likewise, except for one terrific lunch at Maxine Groffsky's last year . . .

It was at a Jane-&-Joe party in spring 1959 that I met almost everyone—including Jane & Joe, Frank O'Hara, Maxine, and a few others—who would be important to me in the following years.

Everyone mentions Jane's wit and no-nonsense approach to art and everything else, but at the core was that seldom-remarked-upon integrity. She was "Jane" in every respect. (The description in the *New York Times* notice the Friday after she died ends with the words "integrity and poise.")

Regrets: why I never got to write about Jane's work beats me. Maybe because she never asked—I don't think she knew how I loved what she did, even though once or twice I tried to tell her. Maybe it went with missing too many of her shows after moving to California.

Speaking of which, one of my favorite moments: Jane alighting from a car in Bolinas after driving up from Santa Barbara, where she had a residency, remarking on the blue-green coastal landscape: "Now I see what the painters here are up against—that awful palette!"

Two of her pictures have brightened my life everywhere I've been since getting them, the first soon after that party in 1959, the other, a knockout drawing, in the early sixties. Years later, when I showed her the first one, probably from the mid-fifties—its splurge of white narcissus with a decisive, flat orange vertical in the center of the bulbous vase, all in a wilderness of red, green, and blue thumb-size marks—Jane said, "Oh, the years of struggle!"

I could go on, but this is really just to register a feeling of loss as well as what a wonder she was.

Love,

John Bernard Myers

"Bitch, bitch—bitch, bitch, bitch!" John Myers on the telephone, I'm standing somewhat apprehensive in my kitchen in Bolinas, California, 1984, some days after my review of John's not-tell-all autobiography, *Tracking the Marvelous,* appears in *Art in America*. My review says that John is "brave, hyperactive, witty, outrageous, impossible," and yes, marvelous—especially his sense of *La Gloire,* capital Glory, that long-lost measure of "something ought to happen" (and often did happen, around John) in life and art—but the book wasn't the John Myers I knew: no "bitch, bitch" in it, too few of the great stories he knew to tell, no juicy gossip to speak of. John Myers, like George Sanders as Addison DeWitt in *All About Eve* (whom John physically resembled—George Sanders, not Eve), had the goods on everybody; he knew where the bodies were buried in the art of our time. "OK," John says, "here's what happened . . . " Random House had just faced disastrous libel proceedings on account of Kitty Kelley's juicy Frank Sinatra biography, so the house lawyers tucked into poor John's *Tracking the Marvelous* with tweezers and sponge mop, wiping, plucking, excising, eviscerating, poof.

The book had far less character than its author, the John Myers I first met when I climbed the stairs to the Tibor de Nagy Gallery, East Sixty-Seventh Street, to look at pictures by artists I heard about in Kenneth Koch's class at the New School for Social Research (right next door): Larry Rivers in his "smorgasbord" period; Jane Freilicher, whose painting, Kenneth said, did something analogous to modern poetry in the way it communicated how it felt to be a bunch of flowers on a windowsill at exactly that time of day and light; Fairfield Porter, mentioned in passing as one of the best downtown painters; and Willem de Kooning. For $500 inherited from my grandmother, I went back down the stairs the proud possessor of a Rivers v8-can studio still life, a Porter Maine island landscape (its miniature lawn chair, three strokes scaled like a floor-to-ceiling de Kooning), and a splurge by Jane of white narcissus with a lot of orange and blue around it and red beneath. That was 1959. Fall 1960, in the new gallery space on Seventy-Second Street, John says, "Next I'm going to do a volume of your poetry." Terrific. I am earning my Tibor de Nagy/John Myers "in-the-air" wings. Next summer, the book floats in from Tibor de Nagy Editions' monk's school of printing in Venice—by gondola direct to Water Mill. Thrill—and a touch of despair about the silly-looking U.S.-flag cover.

Obstreperous, campy, floppy, exuberant, often vengeful and mean, John had more than his fair share of fixed ideas—one of which was how the New York poets he published all got born full-blown out of the godhead of French surrealism that, among modern art movements, had been his first love. Telling about this at a University of Connecticut symposium on Frank O'Hara in 1983, John

stopped to wonder if any of the students there knew what he was talking about. "Who here knows about surrealism?" he called out. It seemed the whole college was silent. "Who here knows about *Hitler*?!" Later in the day he said that Frank's poetry was good because he was "so French," and so it went, leaving everyone nonplussed.

Then there is the sad tale of why I am not in John's *The Poets of the New York School* anthology. John proposed the book and invited me as one of the several poets whose books, often first books, he had published under the Tibor de Nagy Editions imprint. All well and good, until one day John called to say that he was removing me from the book because of something I reportedly had said at Elaine's the night before. "What was that?" I asked. "An anti-Semitic remark," John said. "Impossible," said I, "there must be some mistake." "I am removing you from my book," said John. Did John realize that I am half Jewish, and, in any case, never given to making anti-Semitic remarks? I protested to no avail. So I let it go. But word got around. Jimmy Schuyler called to say that he had told John that if I was excluded from the anthology, he, Jimmy, would exclude himself as well, in protest. I told Jimmy not to do this, that it really didn't matter—which, given the remove I felt from the older New York poetry scene at that point, early 1968, was true. Jimmy relented. Either before or after Jimmy's call, John Myers called back to say that he had found out that his informant had admitted his mistake, either my remark wasn't anti-Semitic at all or it wasn't me that made it. "You are in the book," John said. "No," I said, "I am not, and won't be." I now regret my vain stubbornness, but that is how it went.

The great loopiness of John Bernard Myers: everything he wanted about him was Front Page News.

2016

John Wieners

July 5, 1969, I visited John at Central Islip State Hospital and then left the grounds and drove with him to my mother's house farther out, in the village of Belle Terre, overlooking Port Jefferson Harbor and Long Island Sound. The hospital was dismal: gray halls inhabited by Thorazine-dimmed inmates padding around, each absolutely withdrawn from purpose. Other mutual friends had visited before me—Lewis Warsh, Anne Waldman, and David Rattray, among them—but none had prepared me for the bare look throughout. "How is it here for you?" I asked John once we had strolled a little and settled under a large oak downhill from the main building. "Well, I no longer think I'm a Polish count," he replied.

In his journal of the time, John calls the Belle Terre house a "pavilion," a term that is in fact very accurate for the feel, if not the architectural bearing, of the wide, pink, one-story stucco house my mother had had constructed a few years before, set back on a lawn that ended abruptly at the edge of a sand cliff from which, on a clear day, you could see across the sound to Bridgeport, Connecticut. Of the time we spent there—only an hour or so at most, I suppose, because John couldn't be away from the hospital for much longer—I remember very little. We stood in silence at the cliff's edge awhile, admiring the calm open water. Once inside, in the living room, I put on the just-released Procul Harum LP, *A Salty Dog*. Then, at one point, John, smiling at the whole setup and me, said rather breathily, "You're such a prince." (A nice follow-up, conscious or not, to our conversation recounted above, about the benefits of Central Islip treatment.) Of the drive back and presumably, for at least one of us, reentering institutional space, I remember not a thing.

Sensibly or not, Robert Duncan remarked, when asked about John Wieners, with whom he had something of a running battle, "John has a lot of dementia in his poems. I like to have 'mentia' in mine."

Of all John's and my times together, few as they seem to have been, the standouts are mostly John's readings: the first at the Hotel Albert in Greenwich Village, organized by Diane di Prima, in one of the hotel "ballrooms" (actually used for business meetings) where one could sit or lean on old steamer trunks stored for guests or left behind by some who would never return to claim them; some years later, in the rotunda at the San Francisco Museum of Art, preceded very briefly by Robert Creeley, John in slinky pajamas embroidered with palm trees; and, last, again in San Francisco, at the Roxie, when John chose to stage-whisper his poems but then turned up the volume joining with Kevin Killian for impromptu helter-skelter repartee.

How well did I know John Wieners? I knew his poems, struck by them from having been introduced to *The Hotel Wentley Poems* first by Kenneth

Koch, reinforced by Frank O'Hara's more intimate and absolute admiration for that book, and then from seeing him in the company of others in *The New American Poetry*. (He belongs to that interesting subset of poets born in 1934: Diane di Prima, Anselm Hollo, Ted Berrigan, Amiri Baraka, George Stanley, Ray Bremser, and Joanne Kyger.) But that was just the start; Wieners's poetry amplified, got wilder, more unpredictable, and hence ever more inspiring, if not a little terrifying at times as well. Plus, he had a wonderfully thoroughgoing sense of occasion. When asked for some poems for *Big Sky* in the early seventies, he responded quickly and added a note, "I'm so glad you're doing it!"

The contents of any book of Wieners's writings are always news to me, yet his authenticity is such that it is never less than characteristic. No false notes. Not that every poem or jotting is all that great, but the purity of commitment and intimation is unbroken, true to what one might call "informed sources," taken at their word.

2008

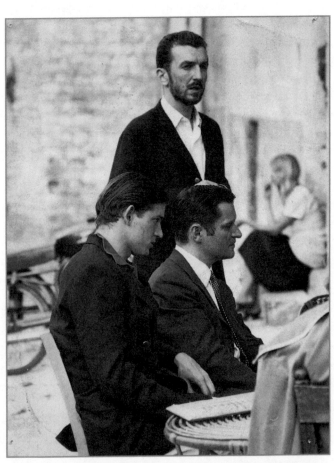

The Festival of Two Worlds, Spoleto, Italy, summer 1965: *seated,* Bill and John Ashbery; *standing,* John Wieners

Philip Whalen

December 1969, Lewis Warsh was living at John and Margot Doss's house on Brighton Avenue in Bolinas. Margot was sort of the keeper of literary salons in those days. Poets read their poems at her houses in both downtown Bolinas and on Russian Hill in San Francisco—Jim Brodey, Anne Waldman, and so on. She was also good at finding her poetry friends places to live; in fact, it was Margot who directed me to a house for sale in Bolinas when the rental I was sharing with Joanne Kyger, Peter Warshall, and Keith Lampe was no longer available. Margot was very close, as well, with Joanne, Philip Whalen, and Donald M. Allen. During my first visit to Bolinas, Lewis showed me the room Philip lived in before leaving for Kyoto. It was in fact the same room Lewis was staying in then. On the wall was a scroll with Philip's hand lettering of Stéphane Mallarmé's poem "Un Coup de Dés." Lewis remembers that Philip, when he vacated, had given it to Joanne, who in turn gave it to Lewis, who then held onto it.

Also, stored under a window seat at the Doss's, there were some small silk-screened broadsides that Whalen and John Armstrong had made. One said, "It's National Stop / Listen / Look Out the Window Day."

At Philip and Michael McClure's birthday lunch at the Hartford Street Zen Center, October 20, 1999, Michael started talking of Mallarmé's "white" poem, and I interjected how I remembered that scroll in Philip's room, so beautifully lettered and all, but I couldn't recall whether it was in an English translation or the French. Thereupon Philip smiled cryptically. I was later told the calligraphy was in French only.

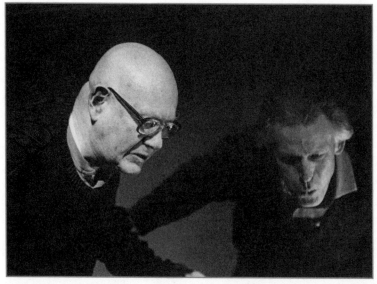

Bill blowing out candles with Philip Whalen, 1996 107

Bagatelle [French from Italian bagattella]—1. trifle. 2. any of various games involving the rolling of balls into scoring areas—basket, hoop, net, goalpost, strike zone. 3. a short literary or musical piece in light style.]

Zip, zip, zip: I always think of the lines of Philip's poems as slicing clean across the page. Light, fast, irritable, alert to the "rollings" of those balls into their appointed slots. I don't mean to suggest that Philip wrote trifles. Quite the contrary, the slightest Whalen has an urgency put behind each syllable, ample and articulate in the way of the big-band music of classic poetry (in English, we call it "Elizabethan" for short).

Philip's fullness, *rotondo come il cerchio di Giotto*, round as Giotto's freehand circle.

Wanting to write, not knowing what or how, I toss through pages of Whalen. The random articulation gives one hope; his goofiness corrective of everybody else's self-importance.

Philip was like this in person too. Around 1994 he gave a Dharma lecture at the San Francisco Zen Center on "Life and Death"—that was his title, he could handle that. He prefaced the talk by saying, in the precise vibraphone treble phrasing that was all his: "I've got all kinds of things wrong with me, I could croak any time."

"Croak" forever after will ring up a Whalenesque timbre to my ear. Even so, I'd rather he hadn't.

1999 / 2002

My Life (and Bob's) with Robert Creeley

> *Yet I ride by the margin of the lake in*
> *the wood, the castle,*
> *and the excitement of strongholds;*
> *and have a small boy's notion of doing good.*
>
> —ROBERT CREELEY, "THE WAY"

Call it the Creeley Concentrate, his way of hitting the mark to bare its coordinates or else lay it (or you) flat. As for the latter, Bob could speak of one friend as "beautifully absent," another as "a classic case" of something or other, all of it said with (like "don't shoot!") a winning smile.

St. Mark's Poetry Project, probably spring 1970, the night Bob read with (and also repeatedly "introduced") Jim Dine. After the reading, the issue was whether or not to follow along to a late-night party in Brooklyn, with the marital odds against it, Bobbie being adamantly opposed to further carousing. With a wry yet no less fierce insistence at the parish hall doorway, Bob said: "I'm just trying to be in my life!"

Bob liked to tell of Kenneth Koch's inviting him to his rooms when they were both undergraduates at Harvard. Kenneth offered a glass of sherry and put some Bach on the phonograph, a combination of such rarefied civility that Bob fled. For his part, Kenneth said that he liked Bob but felt he was always trying to take him "down some hole" of dark depression where Kenneth didn't want to go. It was that puritan edginess, always alien hence baffling to me, a lightweight in that regard: the sense that anyone's, especially one's own, direct experience of pleasure had to be suspect. ("Must / I think of everything / as earned.")

Again and again, the generational connection is intriguing: those born, as Creeley was, in 1926 include, Frank O'Hara, Allen Ginsberg, Paul Blackburn, Lew Welch, Morton Feldman, David Tudor, Earle Brown, Wallace Berman, Neal Cassady, James Merrill, Miles Davis, John Coltrane, Fred McDarrah, Harold L. "Doc" Humes.

Among Bob's many signature phrases, "not heavily"—employed as a lead-in to whatever topic might next be broached, no matter how weighty—was a constant of his time in Bolinas. His difficulties—and Bobbie's, as well—of that period I mistook as simply common to the way they were, instead of the crisis, with a long history trailing behind, of the moment. Gravity itself became complicit in Bob's way of getting through the days and nights of struggle: the objective at times, or so it seemed, was finally to arrive flat on his back in Smiley's bar, with a look that proclaimed, if only for his own delectation, "I made it!"

One day when Bob was giving me a lift from Bolinas to San Francisco, he suddenly confided that that day was his fiftieth birthday and he was shaken by it. In fact, he was on his way to see the psychotherapist that he and Bobbie had been consulting. That birthday triggered a ten-year spate of poems (Bob's doldrums period, as I think of it) musing rather desperately on his own mortality. And then, abruptly, that ended—the whole mortality riff was way premature—and we got the comparatively gleeful work of his truly later years.

Then again, the change a year or two later, with a new marriage, new family, straightening up. In the walkway of the Varsity Townhouses, Boulder 1977, with Allen Ginsberg, Bob, and just-then-met Penelope, Allen proposes we all go on to dinner at a nearby restaurant. I make apologies, my dinner with wife and kids in our "dorm" room is on the table. "Agh, you can eat with them anytime," says Allen. Bob smiles, hand on Allen's shoulder, seemingly consoling Allen, not exactly the family man: "Don't knock it."

He is one of those who give you the sort of poem you carry around to recite, if only to yourself, on occasion, talismanic like:

One day after another—
perfect.
They all fit.

Or:

You want
the fact
of things
in words,
of words.

By the seventies, the hyperintensity of the short, compacted poem—with its short, so achingly calibrated lines—seemed to demand for many poets the release that prose gave. So Creeley took the lead and wrote the extended prose of *A Day Book, Mabel: A Story,* and *Presences,* that last with its canny epigraph from Donald Sutherland: "Classicism is based on presence. It does not consider that it has come or that it will go away; it merely proposes to be there where it is."

Bob's final San Francisco reading, at the University of San Francisco, October 20, 2000, to be exact. To guard against shortness of breath, Bob sat to read new poems, expansive as they were, and are, in rhythms and rhymes that recalled anthology pieces of his youth out of Edwin Arlington Robinson, Alfred Noyes, "Thanatopsis," "Invictus," and the like. (Though the actual push in them—the urgency of age, illness, mortality—was gleaned from late Whitman.) There was

a fresh exuberance delivered with Bob's typical outlaw dash (he often reminded me of the young swashbuckling Errol Flynn, or the demonic Gregory Peck of *Duel in the Sun*). But the doggerel bent of some of the poems nonplussed a significant portion of the audience. Two rows ahead of me, an older contemporary of Bob's sternly shook his head, a knee-jerk "tsk, tsk" issuing—"sadly," as Bob would say. During the Q&A, someone who appeared to be a student asked how Bob, certifiably an avant-garde master, could write such stuff. Bob answered ecstatically, lifting one fist in the air, "Because I can!"

In his last years, our friendship was based mainly on Bob's calling now and then to gather for further strategies regarding getting in-flight oxygen so he could continue his travels to give readings and/or lectures, the last of which was his magnificent summation at the University of Virginia of his feelings for Whitman.

Seeing his attic workroom in Providence with Penelope: an ordinary writer's space, but very white, clean walls, and the usual mass of books.

Supplement V, *2005 / 2016*

Amiri Baraka

At the UC Berkeley memorial for Amiri, I read his "Tone Poem." Tone was Amiri's edge. His was an especially lovely, lilting sort of voice that, in any register, enchanted you even as it demanded that you pay attention to some of the world's more inconvenient facts.

It was from Amiri (born LeRoi Jones) that I learned one could live a kind of double life, with public and personal selves distinct from one another. Instructive, in particular, that such a life was not for me. One afternoon, possibly as early as 1964, as we were walking together down Fourteenth Street, near his home, he told me that people "from Newark" were knocking on his door "talking about how they've got guns." Amiri, the committed downtown poet, wanted none of this; "What guns? I just want to write poems" was the gist. That winter, early 1965, there was a symposium on life and art and race at the Village Vanguard with Amiri, Larry Rivers, Archie Shepp, and Jonas Mekas. Coincidentally, just before the Vanguard event, Amiri and Larry both attended a big party at Frank O'Hara's Broadway loft. I remember standing with the two of them beside Frank's fireplace, the three of us talking about baseball or some such thing and then each of them making light of the discussion for which they were then obligated to leave the party. The next morning the *Times* had the story: "LeRoi Jones Attacks Larry Rivers," or words to that effect. The attack—"You're like the others [whites] except for the cover story"—put Larry and Amiri's friendship on hold for the next twenty years.

On another panel around the same time, this one on educational television, Amiri berated W. D. Snodgrass, whose poetry was enjoying a vogue in academic circles: "You're what's wrong with American poetry, Snodgrass!" he yelled.

During the Columbia University student protests in 1968, Kenneth Koch organized a reading in a campus lounge with a few poets, including Allen Ginsberg and me, to express solidarity with the protesters. Amiri was invited but never showed up, although Allen, pacing back and forth and wondering aloud at Amiri's absence, tried every which way to conjure him.

Just about twenty years after the Larry Rivers affair, Amiri delivered a talk at the New College of California in San Francisco. The lacerating Marxist-Leninist-Maoist tenor of it was scary. "This man wants to kill me," my inner petit bourgeois said to himself. The only trace of humor was when an audience member asked about Amiri's views on Frank O'Hara. Amiri at first feigned mishearing—"Franco Harris . . . the Pittsburgh Steeler?"—but then settled into detailing both "Frank's great quality . . . that he rebelled against the dry academic bourgeois poetry . . . that we were given" and his "petty bourgeois" limitations regarding authentic social change. Then again, as I stood with Steve Emerson beside a

partition at La Rondalla, the Mexican restaurant people normally repaired to after New College events, Amiri entered and, accompanied by Ed and Jenny Dorn, sat down at a corner table. Still thinking we had nothing good to say to each other—we hadn't been in the same room since that party at Frank's loft—I saw him jump up from his chair and head in my direction. He stopped, and it was as if no time, and no attitude, had passed: "Hey, how're you doin'?" He resumed as if we had just left off.

After Amiri read his poems at San Francisco's Victoria Theatre in November, 2007, with Roscoe Mitchell accompanying on saxophone, I went backstage to say hello. Because it had been another twenty years since we had seen one another, I reintroduced myself. Taking my hand, Amiri said, "My God, when I knew you, you were just a kid!" "Yes, isn't it amazing," I said, "Now we're the same age!" In 1960 or so, when we first met, Amiri (born in 1934) was only five years older, but I was only a twenty-year-old kid poet, and he was LeRoi Jones, author of *Preface to a Twenty Volume Suicide Note* and editor of *Yugen*. Forty plus years later, with both of us in our seventies, the balance sheet had evened out somewhat, and happily, in Amiri's last years, after something I wrote caught his eye, we kept in touch.

Ted Berrigan

I am in love with poetry. Every way I turn
this, my weakness, smites me.

—TED BERRIGAN, "WORDS FOR LOVE"

Ted's walking/talking testimonials were conceived as real-life methods of salvaging what was left of amplitude and high-mindedness in the sink of late mid-twentieth-century creation. He handed himself steady employment as an orator, his poems furthering that sense of moving toward, from a choice of armchair or street, and snaking back around; he would recombine, aligning so much of what was personal with what he knew was in the air.

A never-disinterested critic: "I read Frank [O'Hara] as a manual of How to Live." So he took on the plane of the life-language process. (Taking everything that could be taken dished out on a platter was standard procedure for him.) Pinpointing confusion on my part, having just then entered my thirties, he wrote, "You are having pronoun trouble and only pronoun trouble . . ." and added some advanced creation theory: "There is always a phantasmagoria."

I loved the way how, when talking or listening, his brow would lift and eyeball go convex at the turn of a relevant, unexpected phrase.

When *The Sonnets* began appearing, they seemed to me to violate local propriety. They flew over all such cautions, admitting in no secret terms their

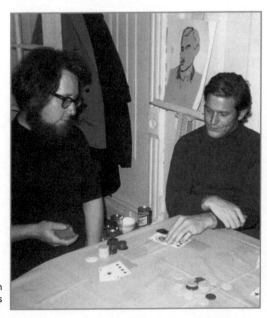

Bill playing poker with
Ted Berrigan, 1960s

original, non-abject smittenness. I felt they were in questionable taste. In 1967,
though, I got another initiation and the correction thereupon became a per-
manent pleasure. Ted read his sonnets and other poems in the parish hall at
St. Mark's Church, and our friendship took off then and there.

1991

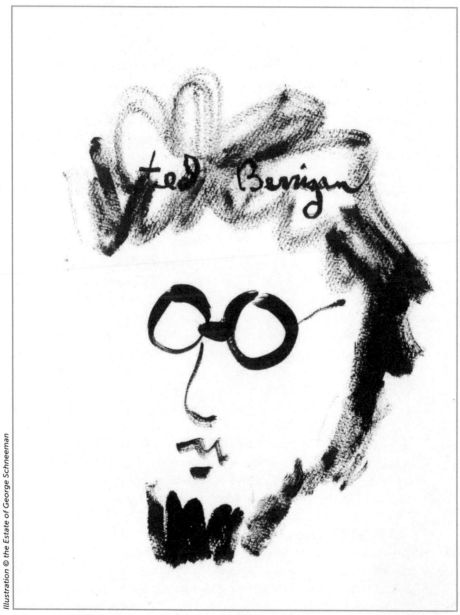

Illustration © the Estate of George Schneeman

Cover of *Ted Berrigan* by George Schneeman and Bill, published by Cuneiform Press, 2006

A Note on *Ted Berrigan*

Between 2006 and 2008, I was prompted by my finding a few pages in a notebook devoted to thoughts of Ted Berrigan. All but one sheet, an afterthought more than a year later, was done at once, as the sheet with our signatures indicates: March 5, 2006. At the time, Ted had been much on my mind, especially in the form of auditory hallucinations, i.e., my hearing him saying certain things he once said, in person and/or in letters, over time. When I told Robert Harris about this, he said, "Ted is everywhere!"

The title is a forgery from memory of Ted's signature, and George reciprocated by producing a fine likeness of Ted's head. The opening pages include various typifications, as perceived by me and others, of Ted's unique persona, together with a cover-all response from Ted or me or both in unison: "Shut yr trap." Thus the sequence opens up the likelihood of resumed conversation in what Ted liked to think of as, in any case, a continuous situation, the Afterlife— a call-and-response that dovetails finally, in "Forked Juncture," by jamming together lines from two of our separate poems about airplane travel as linked to dying. There intervenes a couple of pages with just notations meant as collegial amusements, followed by a clincher by Ted, something I recall from a panel discussion we took part in.

"Leprechaun" was one aspect of Ted I glimpsed on New Year's Eve 1969–70. We were in Gordon Baldwin's kitchen in Bolinas, Ted backed against a counter, holding forth, and as I looked and listened, the head-to-toes frame he normally held quite deliberately wide and erect began to shorten and laterally expand, somewhat in the mold of one of those gingerbread Santas, but different. Put together with Ted's high-riding tenor—more tremulous than usual at that moment—there emerged this temporarily unrecognizable elf. The delay of course had to do with the LSD that everyone that evening had imbibed and was either enjoying or not. For Ted, taking psychedelics generally seemed to be a way of testing one's will to stay in character no matter how buffeted by doubts to the contrary. He had invented a remarkable character for himself apparently from scratch; the idea, a matter of life and death as one got closer to knowing it, was that the character was fixed but its components were in constant motion, so the man's consciousness remained fluent, receptive to an extraordinary degree. "My movie," Ted would say, with that implied separatism in his evolved scheme of (like cellular) pronoun divisions (yours being you). He kept his responses open and found new combinations within what he sometimes let on was a very old self. (Maybe that ancient one was the leprechaun talking.) It's a mindful fluency that brought on the recombinant strains of *The Sonnets* and much else in his work.

Two remarks Ted made that didn't find their way into George's and my book, although at my back, so to speak, I always hear them both: One is "I have only two rules actually: Always finish what I start and never below a certain level" and the other, written in the margin of a book by Aram Saroyan: "The Obvious Solution: Get your own goat."

2011

Joe Brainard

In terms of both art and friendship, life with Joe Brainard was a matter of inti-mate collaboration. The two issues of *C Comics,* for instance, constituted a world of Joe's devising into which poets were invited, where, because of Joe's accommodating nature, they became honored guests. But the setting was pure Brainard. As for friendship, I remember a moment during Joe's Bolinas visit, of being drawn, with such peculiar sweetness, into a spot of exquisite greenery that seemed to exist only in, or because of, his imagination: a leafy enclosure—like a hut, almost—a few yards downhill from the house he was sharing with Philip Whalen. Having found this secret place, Joe gestured for me to join him; so there we sat, in silence mostly, for an immeasurable time.

There's a passage in *Bolinas Journal* where Joe's constant recalibration of how communication does and doesn't work shows itself in a series of verbal pirouettes:

> Last night in the bar a girl Bill and I were talking to especially stands out in my head. A "hippie" type. (Sorry, but that's what words are for.) Very sincere in what she believed in. But what she believed in was totally fucked up. But like I said, very sincerely about it all.

> It always bothers me, this combination. Of sincere and wrong. It doesn't seem fair. Sincere should always be right.

In the early sixties, both Joe and I were twenty-something interlopers emboldened by Frank O'Hara's keen eye for talent at the get-go stage of its devel-opment. (Come to think of it, by the mid-sixties, when Frank and Joe did their collage comics together, Joe had already refined *his* talent more than any poet his own age had.) Writing on Frank, Joe defines the in-tandem, hand-over-hand improvisational method in comparison with another intermediate, call-and-response kind:

> Actually, in the strict sense of the word, Frank and I never really collabo-rated. (Alas) never on the spot, starting together from scratch. Giving and taking. And bouncing off each other. What we *did* do was that I'd do something (a collage or cartoon) incorporating spaces for words, which I'd give to Frank to "fill in." Usually he would do so right away, with seem-ingly little effort.

What Joe does in that little paragraph is detail his two basic ways of collabo-rating, except that the comics, more often than not, were delivered to poets for text production through the mail and the speech and thought balloons filled in

with considerably less spontaneity than was normal for Frank. Comics were very natural. We had a feeling for how they worked. They were our first art and, in many respects, our first literature.

The fullness of Joe's art is augmented by the fact that he was a wonderful writer—so philosophically adroit, and as good a prose writer as any artist you can name (and that includes some very big names—Leonardo da Vinci, Eugène Delacroix, Vincent van Gogh, Pablo Picasso, Giorgio de Chirico, and Willem de Kooning, among others). For a while, it seemed that his literary masterwork *I Remember* would outstrip his assemblages and collages in the Immortality sweepstakes. Historically, it's important to realize that Joe began writing *I Remember* in 1969, at what may have been the exact midway point in his artistic

Illustration © the Estate of Joe Brainard

Air Blue by Joe Brainard and Bill, 1971

career. (Ron Padgett says that he had been reading Gertrude Stein at the time.) All of the major assemblages and a good many of the great collages, including the "gardens" series, were already behind him, and at least ten more years of brilliant invention lay ahead.

Joe was such a good writer that he could even write his "visual" works in prose, viz the series of piquant *Ten Imaginary Still Lifes,* written in the seventies, one of which reads:

I close my eyes. I see a white statue (say 10" high) of David. Alabaster. And pink rose petals, sprinkled upon a black velvet drape. This is a sissy still life. Silly, but pretty. And in a certain way almost religious. "Eastern" religious. This still life is secretly smiling.

Another example: Joe the expert portraitist manifested his acuity in both words and pictures. Here is his word portrait of James Schuyler:

Jimmy Schuyler: A Portrait
Let me be a painter, and close my eyes. I see brown. (Tweed.) And blue. (Shirt.) And—surprise—yellow socks. The body sits in a chair, a king on a throne, feet glued to floor. The face is hard to picture, until—(click!)— I hear a chuckle. And the voice of distant thunder.

Poets and painters collaborate partly for the same reasons that painters make portraits of people they know—it's another way of spending time with that person, and the artistic aspect lends an extra, more surreptitious, intensity to the get-together. Usually my collaborations with Joe were done at Joe's invitation— either he sent a comic in the mail for me to supply the text, or, as we sat around in his studio or in Kenward Elmslie's house in Vermont, he would quietly ask if I felt like doing "some works." Collaborating in person with Joe was a gas. He was usually quiet, purposeful, always encouraging, quietly amused. My favorite instance with him was an afternoon in his Sixth Avenue loft in 1973—Joe was in his "blue" period, and we did I forget how many collages all in blue with blue lettering, the title for which echoed Lizabeth Scott's classic line from the movie *Dead Reckoning:* "It's a Blue World."

Alex Katz's statement about collaborating with Robert Creeley reads in its entirety: "Working with Bob makes me feel bright." Working with Joe was bright, sweet, demanding, mysterious, and silly. Somewhere beneath the dismissive shrug of "silly" sits the etymological mother lode of "soulful." Avoidance of pretense is a prime stratagem of the pursuit of beauty and truth, hence Joe's love of the dime-store frames and slightly more expensive but just plain Kulicke

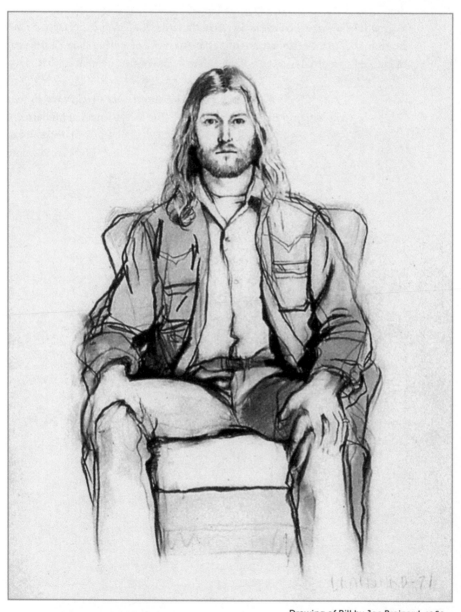

Drawing of Bill by Joe Brainard, 1969

plastic passe-partouts he somewhat casually slid his drawings and collages into. Kenneth Koch has remarked on Frank's "feeling that the silliest idea actually in his head was better than the most profound idea in somebody else's head." Smart or idiotic but never dull. Ron Padgett recalls that the poems we all wrote in groups of anywhere from two to ten in the late sixties made him laugh so hard his stomach hurt. Collaboration thrives on the nerve of putting shamelessness at the service of mutual respect and the will to be interesting no matter what.

Modern Painters Autumn *2001* / Jacket *March 2002*
Orig. lecture at Boulder Art Museum / The Sweet Singer of Modernism
(Qua Books, 2004)
Much revised, 2016

Some Jim

"Look at the cute little chipmunk!" Jim Carroll's constricted, high-nasal rendering forever memorable on the now-lost audiocassette as he, Anne Waldman, and I wandered goggly-eyed through Staten Island parkland one early spring morning, 1970. Two summers before, as I packed to go to Yaddo for a residency, Anne had called to say that Jim Carroll, whom I knew only by sight at the time, needed somewhere to stay and asked if he could live at my place. It worked out, two pure products of Manhattan, albeit of neighborhoods that didn't intersect, adding up to one Odd Couple. After I returned, Jim came and went, intermittent presence, staying nights on the plush red daybed in the front room of the two-room apartment on East Fifty-Seventh Street, and again (same daybed) when I moved down to a slightly smaller place on East Tenth, along the long block west from St. Mark's Church.

Where Jim and I met mentally was in both of us being distinctly of our neighborhoods and the persistent discrepancies of twentieth-century American culture and also each of us bearing a capacity for adding to oneself whatever cultural oddment seemed true. Here is an epic two-liner we wrote one time toward dawn on Tenth Street, 1969:

I walk the halls in overalls
For I am the Little King.

An expression Jim picked up on, Paul Morrissey's way of saying "Whaat ga-arbage"—became multipurpose at some point. Jim particularly loved and perfectly mimicked the bright disdain with which Morrissey intoned this phrase and used it often and appropriately. He had that stunning, mad Irish American Catholic mixture of skeptical knowingness and ceremonial awe. The only book I remember him giving me was the fourteenth-century manual on contemplation *The Cloud of Unknowing*.

"Enigma Variations," the one poem I wrote expressly for Jim, came about when we were still uptown and induced a momentary edge between us. The occasion was Jim having been invited by Edwin Denby to accompany him to the Royal Ballet. Sir Edward Elgar's title for the music of that night's dance performance (a piece dedicated to and portraying Elgar's own circle of friends) inspired me to start writing as Jim put on his finery for Edwin and the Met. The poem's collage format drew on incidentals from our immediate environment—lines from a large poem-painting by Frank O'Hara and Norman Bluhm that hung on one wall next to the desk, a thing or two Jim had said about a couple of creatures met at Max's Kansas City the night before, a brand of bottled apple

juice then in the icebox, some stray shards of brutal self-assessment typical of me at the time, and so on. The edge showed up in how Jim heard the last line, which refers perhaps too obscurely to the radio personality Jean Shepherd's driving up to the tollbooth outside the Holland Tunnel, refusing to pay, and the ensuing argument with the toll taker (all of this on the air), but Jim mistook the line as a thinly veiled hint for him to cough up some rent money, do his part in our tacitly

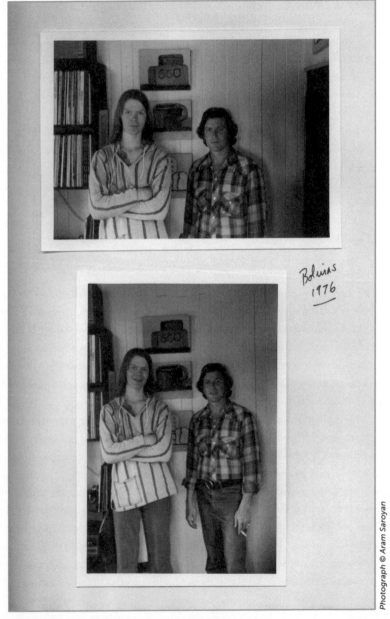

Bolinas
1976

Bill with Jim Carroll, Bolinas, 1976

casual economy. From then on, although I remained fond of the poem—if only because of its fair reminder of those goofy early times with Jim—I was careful about reading it in public whenever its dedicatee was present.

Jim was a lot smarter than the veneer of prolonged adolescence mixed with the longueurs of his heroin use let on. (It should be said that nothing is more stultifying than someone repeatedly nodding out in the midst of what is supposed to be a conversation.) One night at dinner in Bolinas he held forth at length on the most recondite nuclear physics gleaned from John McPhee's *The Curve of Binding Energy*, a book I had given him only a week or so before, the technical specifics of which Jim had clearly set himself to study and thoroughly comprehend. (This fit with his steady diet of Sherlock Holmes stories, pored over in monkish solitude, just him and a dog named Jomama, in the little house at the foot of Mesa Road.) Jim was a good student in every respect, with a stick-to-itiveness and an overriding discrimination that extended to his writing.

Along with his ever reverting to tales of how either Dick Enberg or Al McGuire had scouted him for the Knicks and the fine points of Kareem Abdul-Jabbar's style under the boards on cement courts uptown, Jim loved to tell of the Boston Celtics' point guard Bob Cousy's reply when asked what made him such a great playmaker. Cousy had a pronounced speech impediment, so "pu-wiff-ewal fi-shun" went the Carroll/Cousy account of how the fabled no-look pass got done. Peripheral vision would have come in handy, too, to catch Jim's moves, seemingly by way of strange powers of matter transmission—first near the top of key, then, in a flash, underneath for the clear shot—in Bolinas pickup games.

But it was by way of a likewise subtly expanded scope that Jim let his friends know how he cared for them, as tremulously alert to their vicissitudes as he was wrapped up in his own. Looking back on it now, the periphery of other people, their bafflingly distinct lives and thoughts, couldn't have been of easy access for one so intent on appearing, as he was, an outsized solo act. What showed was that, as he went along, what Jim called on as "heart" was indeed the center without which any act was lost. "Haahrrt," he styled it, in his lordly, adopted Inwood manner—a growl, a plea, a sly caress; that sweet, deep, sidelong regard.

July 4, 1983, with a party in full swing in our Bolinas backyard, I picked up the telephone to hear Jim saying from New York that Ted Berrigan had died. (A week later, Edwin Denby, too, would be dead.) After the fact, the blurred details, the inevitable vibrato pause. "I miss you, Jim." "I miss you, too, man," he said.

Late in the Day, First Visit to Rudy and Yvonne's

Saturday, July 31. Today Connie and I drive our rental car from where we're staying, on Mount Desert Island, Maine, to visit Alex and Ada Katz, about an hour away, and then on to Rudy Burckhardt and Yvonne Jacquette's. Alex recommends the historic scenic route, "the long way through Blue Hill, around Stonington, Castine, and Bucksport—and you'll see where the painters were: Marin, Hartley, Fairfield Porter, all of 'em." An abbreviated version of this takes us into pretty Blue Hill and, about an hour later, to the Searsport flea market, where the stalls are closing but I get a short stack of old, strangely colored floral postcards. We walk around Belfast in the midday heat and arrive at Alex and Ada's little yellow house on schedule, around 1:30 p.m. Alex has aggravated his aching back by laying into an eight-foot painting early in the day, so he and Ada won't be coming to dinner at the Burckhardts. Alex treats us to lobster rolls for lunch by the harbor in Lincolnville. Later, standing in the parlor, he takes pen to paper and draws us a concise map of how to get from Slab City to the Burckhardts' dark-red house near Searsmont.

Four o'clock. As we draw up, Rudy's son, Tom; Tom's wife, Kathy Butterly; and little blond Keno are standing in the driveway. Yvonne comes out of the house, says, "Rudy's in the woods, painting. He said he'll be back at five." In the house we sit and chat. Connie and Yvonne change to swimsuits and lead the way through the woods to the pond, where they swim in the beautiful late-afternoon light and I lean against a pine tree, striking assorted Maine-guide poses. At Alex's I see the motifs of his paintings all within spitting distance of his front door—a

Alex Katz's map to the Burckhardts' house in Searsmont, Maine, 1999

water, wood, and leaf world, much of it arranged (the woods articulated, ground tidied, cleared), the rest let be. Here, among the raggedy pines, scenes roll in mind from Rudy's movies—the pond in which Taylor Mead as Tarzan splashes, the neighbor's meadow, where the villains shot Taylor, now covered with goldenrod and black-eyed Susans and tiny blueberries, and at the edge, a 4-H Club outhouse project, now disused.

Back at the house, Rudy, who was not to be seen in the woods, answers when I ask about his painting: "A watercolor. But it didn't work out so well." Typical gesture: downcast look at his shoes quickly brought back up to level face-to-face. His face, a saggier, weary Buster Keaton face, but with always alert, often amused eyes embedded. He has been reading and rereading, he says, John Ashbery's new long poem *Girls on the Run*. A bit later there is a sudden reference—a couple of them, actually—to "Edwin's room," which goes by me, but which nonetheless casts a chill.

Now a studio tour. Rudy's studio is part of the attached barn, in it a wall of small vertical pictures of trees, close-ups, mostly. One, a tangle of branches with one central trunk, I approach. "Nature's chaos," Rudy says, pleased by the image,

Bill at Rudy Burckhardt and
Yvonne Jacquette's, Maine, 1999

the thought, its recognizable fact. "Yes," I smile back, "Who is it said 'Courage is a clump of trees'? Chaos, you know, has gotten friendlier—more of it, and more so all the time!" Rudy seems to like this thought too. We laugh briefly. Recipe for depicting fallen red needles from white pines: "Indian red and yellow ochre." We look at Rudy's image painted on a mushroom, and Rudy says casually (so that no one thinks anything of it), "The last self-portrait."

Next door are Tom's paintings, joins of bright imagery, mysterious for all their unforced logic. In another studio across the backyard, Yvonne's expansive aerial views from above Chicago, Lake Shore Drive, and, on little individually measured shelves along one wall near the entrance, Kathy's also bright, slinky ceramics. It's dinner time. A huge bowl of corn and pasta, delicious, an unheard-of Sicilian specialty Yvonne sets out on the front porch. And red wine. Rudy gestures toward one side of the round table: "Sit here so I can hear you, next to my good ear." I'm on his right. He is extra talkative, cheerful. (Later, of course, we think, "He had a plan.") "Keno looks like Virgil Thomson," Rudy observes when all are seated, "Tom looked like Virgil when he was little too." He is complimentary about the memoir I read at the Poetry Project and a little book of poems done in Vienna. About the memoir, he's specific: "No one ever writes about money, it's nice that you did." (Little does he know I wrote those parts very much with him in mind.)

Next he speaks glowingly of Nathaniel Dorsky's new film, *Variations* ("I like especially that scene with the plastic bag dancing in the street"), as well as Nathaniel's editing of his, Rudy's, old New York footage for the new documentary on Paul Bowles. Dinner ends at dusk, about nine o'clock; time to go, find the highway back to Southwest Harbor. Hugs and kisses all around. Over thirty years I wanted to make this visit, glad it's realized, now maybe we will return.

August 1. Sunday afternoon in Southwest Harbor, back from our hike around Long Pond, Connie and I hear Tom's voice on the answering machine, asking us to call. Did we leave something behind? I dial, and Tom tells me the news: "Rudy walked into the pond late last night, before dawn." Friends, relations, Yvonne "shocked, but not surprised." One guess is, old age for him was an even more confining, repulsive Switzerland. Or conversely, as Yvonne back in New York later tells me, whenever a party had hit its brightest, highest pitch, Rudy, ever decisive (and with his self-avowed short attention span), wanted out.

1999

George Schneeman

I first met George Schneeman in Spoleto, Italy, in the summer of 1965. George had driven down from Rencine on his Vespa with Peter Schjeldahl. Peter introduced us in the midst of the hubbub at the opening of a contemporary American land-scape painting show that Frank O'Hara had curated as the Museum of Modern Art's contribution to that year's Festival of Two Worlds. The inclusive range of the show was timely: next to realists like Alex Katz and Jane Freilicher were new realists Allan D'Arcangelo and Roy Lichtenstein. I recall nothing that George and I may have said to each other that day, nor whether, beyond acknowledging Peter's introduction, we said anything at all. I remember him as bearded, which now seems unlikely and may not have been the case. Many years later, in New York, George still remembered John Ashbery directing his attention onwards from the Katzes by saying "Let's go see what's on the Dash board . . ." (meaning the pictures by Robert Dash that were also included in the MOMA show).

Late nights at the Schneemans' on St. Mark's Place at the end of the sixties—in those years, everyone seemed to start the day in the afternoon and stay up till dawn—the wall-to-wall conviviality drifted from a cozily appointed living room through interim, compact bed alcove, to the broadly lit studio, at the near end of which was a long worktable with Rapidograph pen, ink, gouaches, brushes, glue, poster (a.k.a. "composition") board, and stacks of collage pos-sibilities at the ready. Over these materials and their uses, George presided gently. Perhaps due to my hazy recollection, my sense is that our collaborations proceeded, with participants sometimes as numerous as three or four at time, as if in a trance. The trance tended to favor the momentary punster—or at any rate one who would take the lid off word or phrase and transcribe the staticky emanations that accrued. Verbal doodling indulged, it fell to George to unify the often-discordant elements. White paint and black ink camouflage a multitude of bloopers.

A favorite image of George's back then, the little repoussoir figure of the Old Dutch Cleanser lady striding off with her dirt-chasing stick appears so pur-poseful we imagine a neat set of orthogonal shapes for her—edges of kitchen tiles, cupboards, counters, a broom closet maybe—but it's just bare white her clogs stomp away on. White in Schneeman's pictorial universe has the sanctity of medieval gold leaf. A taste for mild, yet no less revelatory explosions—force lines and rose-colored zigzags shooting through myriad rings and disks: car tires, open doorways, windows, drawers, funnels. Such things smack of the well-documented Schneeman love of old church art (think Expulsion, Annunciation, Descent into Limbo, and such, in the hands of Giotto, Fra Angelico, the Lorenzetti brothers et al.).

One aspect of art history that George and I agreed on passionately is that the officially endorsed wonder of the "High" Renaissance in Italy was not such a wonder after all, and that more interesting was the more or less secret underground continuity from antiquity through the so-called Dark Ages, on through the trecento and up until about 1460, the quattrocento of Sassetta, Piero della Francesca, Fra Angelico, and Luca Signorelli. There's little evidence of such continuity in painting until it picks up again in the ninth century*—in a very clunky fashion, true, but still the feeling, the light, the simplicity, and the congenial, devotional quality are there.

"George Is Going to Explode"—this posthumous headline prophecy by an art-world admirer of George's work after George died in early 2009 keeps striking me as both hilarious and full of good sense, reminiscent of Edwin Denby's saying at Frank O'Hara's funeral, more simply, that Frank's work would be "appreciated more and more" in what would be, for Frank, the Afterlife.

The main part of an artist's afterlife is the work. In George's work, we begin to see an artist even larger, deeper, more various, and more masterful than even the one we were familiar with. Although George's art never had much of a detonating effect in the arena of galleries and critics before, there seems no reason now for the word not to get around, so more people will have the pleasure of George's unique way of communicating beauty—that light touch of heaven—that anyone should be able to get.

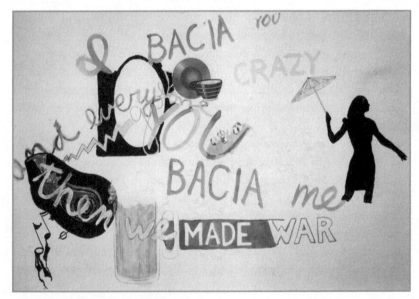

Bacia by George Schneeman and Bill, 1970

* *Editor's note:* Although the construction of this sentence suggests that Berkson might have meant the *nineteenth* century, the overall sense of the paragraph makes it more likely that he did mean the ninth century. However, both interpretations remain possible.

A Note on *Bill*

George Schneeman painted his life-size portrait of me, *Bill,* in 1969. I sat for it in the living room on the Schneemans' sofa with a blue towel under me and a white wall behind. The finished painting reflected the actual colors of the scene, except that, as he was wont to do, George left more white space around the figure, which was a much lighter "flesh" tone than appears today.

In 1970 George showed the painting, along with other similar portraits, at the Star Turtle Gallery on Bowery. In 1971, a year after I had moved to Northern California, James Schuyler bought the painting from George and, once he took possession of it, hung it first in the pied-à-terre he sublet from Neil Welliver between 1971 and 1973, and later in the rooming-house apartment he moved to in 1976. As Nathan Kernan tells it:

> Here the painting was propped up on the mantelpiece. On April 24, 1977, Schuyler caused a fire in this apartment by smoking in bed and was very badly burned. Many of his belongings suffered smoke and/or water damage, and everything that survived the fire was put into storage owned by his friend and patron Morris Golde. Following another year of illness and hospital stays and a period living in the squalid Allerton Hotel, Schuyler finally moved to the Chelsea Hotel in May, 1979. The portrait, which had suffered minor smoke damage, was returned to him, and soon afterwards he asked Schneeman to come over and clean it. Schneeman did so and "just washed it off."

Indeed, the painting was "smoked"; the blues (except for the eyes) and white areas, light brown hair and skin tones all turned to beige. In the eighties Schuyler lent or gave the picture to the poet Michael Scholnick, in whose home it hung until Scholnick's death in 1990, after which George reclaimed it from Scholnick's widow.

Standing before the picture as it hung in his informal omnibus show at Doris Kornish's gallery in 2006, George and I agreed that the painting in its altered state looked even better than before, and soon after that I bought it, even though, in effect, I had no place to put it. It remained in storage all those years, until the Poets House show of George's portraits of and works with poets in April–November 2014, and is now in the collection of the University of California, Berkeley Art Museum and Pacific Film Archive.

2014

George Schneeman, 1975

Jim Carroll, Bronx Zoo, 1975

Larry Fagin at Christo and Jeanne-Claude's *Running Fence,* Sonoma County, California, 1977

Ted Greenwald

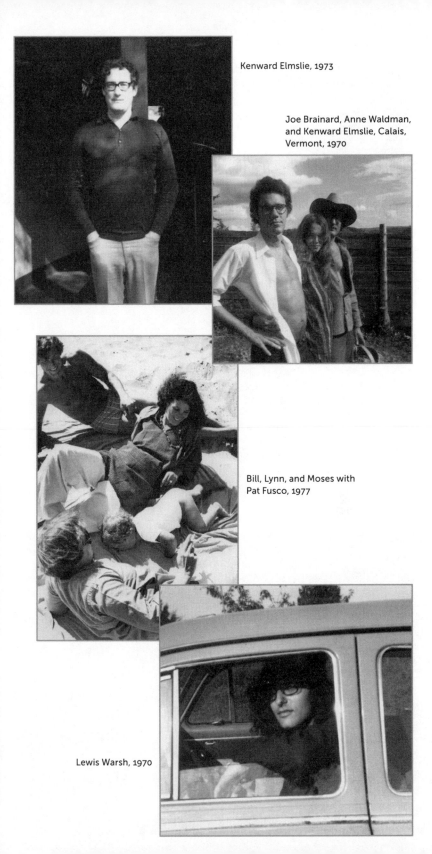

Kenward Elmslie, 1973

Joe Brainard, Anne Waldman, and Kenward Elmslie, Calais, Vermont, 1970

Bill, Lynn, and Moses with Pat Fusco, 1977

Lewis Warsh, 1970

Joanne Kyger, Bolinas, 1970

Tom Clark, 1970

Bill with Joanne Kyger and
Larry Fagin in Bolinas, circa 2011

Westhampton, 1969

Lewis Warsh, Bill,
Kenward Elmslie, and
Joe Brainard

Bill with Bernadette Mayer, Detroit Institute of Arts, 1982

Bill with Ron Padgett at Poets House opening of George Schneeman show, 2014

Connie, Ada and Alex Katz, and Bill at Gavin Brown Gallery for an exhibition of Alex's drawings, 2013

Connie, Robert Storr, Bill, and Phong Bui at Yale, 2013

SCENES AND ROUTINES

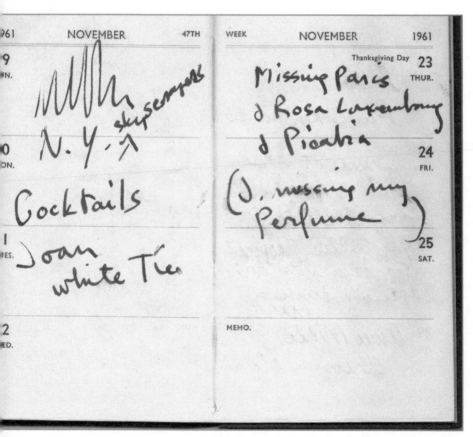

Calendar with O'Hara markings, 1961

Dearest Bill:

I enclose some family histories I found in a box of old photographs etc. I believe the Warner history begins with Ebenezer, the son of Seth Warner, who was a hero of the Revolution, and to whom there is a monument in Bennington, Vermont. That area was where Ethan Allen and the Green Mountain Boys fought the battle of Ticonderoga. My mother told me that Seth Warner's wife, Sally, was also famous for having collected all the pewter in the neighborhood and melting it up for bullets for the battle. Their granddaughter, Sally, seems to have married the Houghton, who was my mother's maternal ancestor. I'm not positive about any of this. It may have been Sally's uncle who was Seth Warner.

Juliet Houghton Craig, your great-grandmother, was one of two sisters who had a ladies' seminary in, I believe, Terre Haute Indiana. Her sister married Colonel Robert Emmett Craig and died within a year. He then married Juliet Craig, and their daughter was Helen Houghton Craig, my mother.

Your grandfather Henry Clay Lambert was descended from French Huguenots who came to Canada and then down the Great Lakes and Mississippi. Some settled in Iowa and others in St. Louis. Clay Lambert's mother was Olive Benge, also of French descent. Her ancestors, I was told, came from France to South Carolina or one of the southern states in the sixteenth century. One of several brothers married an Indian and the name Benge still exists in one of the Indian tribes.

Henry Clay Lambert was advance agent for Ringling Brothers Circus, and he and my mother spent their honeymoon on the circus train. They had four children, Grayce, Fanny, Ward, and Kent, and then twelve years later they had me and parted forever. My father came to live in New York, and I met him for the first time when I was twenty-two and came here to live. He was an impressive but remote and solitary man. He and my mother had never divorced and I do not believe either one ever had an attachment to anyone else, for when my father was taken ill he sent for me, and when he died, only his old friends came to his funeral and all spoke of him as being quite alone always.

Your father's family was Russian on both sides. Your grandfather William Berkson was, I believe, born in Lithuania and was brought to Chicago as a child. Bertha Berkson (I don't know her maiden name) was born here, but told me her parents had escaped from the pogroms in Odessa. The family seems to have lived around Chicago always. William Berkson worked as a tailor for a large firm, I think, called Kuppenheimer, for thirty years or so, and was a much beloved and respected man. Seymour was campus correspondent for the *Chicago American* while he was a student at Chicago University. He was extremely brilliant in political economy and had a Rockefeller Fellowship or something like that, but threw it over to work full-time for the paper. He then got a job on the Associated

Press in New York and worked there a year or so before Joe Connelly of Universal Service hired him as bureau chief in Rome. He worked there three years and then was transferred to Paris for three years before coming here as general manager of Universal Service. When that merged with International News Service, he was made general manager and then president.

About 1926, he married a fellow reporter he had known in Chicago. It was not a happy marriage, but when he and I met in 1934, his wife Jane was pregnant. I was also married (since 1925, also to a schoolmate with whom I'd eloped to New York), but I had been separated for four years. Though we fell in love like a bolt of lightning, we tried to stay apart until his child was born and things could be settled. It was rugged and grim, and I got myself engaged to someone else (another newspaper man, natch), but we had brains enough, or were helpless enough, to stay with the reality of being for each other.

This is the skeleton script. I'll fill you in on any part that interests you the next time we're together.

I shipped you some sheets I found in your closet. There are lots of good colored shirts there. Don't you want them? And what shall I do about all the suits? As to the books, I could not find any box marked in any way. But there is one box sealed with tape. Could that be the one?

I don't know whether you've heard that Didi and John have gone back together. I saw them at a party the other night and they looked well and happy.

The weather has been simply horrible until Sunday when it turned cool and bright. I thought I couldn't stick the heat, especially since the power was low and nothing worked in the cooling line.

Had word that my fashion show in Hong Kong was a great success. Also the Coty show turned out beautifully after the usual blood and anguish. And an especially vicious series of thefts. If it keeps up, we're going to have to search those enormous tote bags the models carry, and I dread the thought of the atmosphere that will create.

Your place sounds so delightful, darling, and I'm so delighted you are there and moving in the direction you want to go. Do send me letters often.

 All, all love.
 Mother

 1971

Family Names

During my time living in Paris 1963–64, I went to London for a few days, and at some point John Ashbery placed a person-to-person call to me there. The French operator hearing the name said to John, "Bergson? Comme le philosophe?" "Oui," John replied, "mais avec un k."

When my grandson was born, my son told me he was naming him "Henry." Immediately, I and a few others thought of Henri Bergson. (Seeing Henry's baby picture, Ron Padgett remarked on how the newborn obviously appeared full of the essence or vital impetus that Bergson called *élan vital!*)

Moses knew nothing of Henri Bergson and insisted that for him "Henry" was associated with the "Clay" of Clay Lambert (1858–1934), my mother's father, who, like many born in mid-nineteenth-century America, was named after the Great Compromiser, Henry Clay. Nevertheless, the link with Bergson prompted me to investigate further. Berkson (or Bereksohn), my father's family name, was fairly common in Jewish settlements in and around Odessa and, further, in Poland and Lithuania. Henri Bergson's father, it turns out, was of a Polish family that originally spelled their name "Bereksohn," the apparent difference being that Henri's line consisted of prominent entrepreneurs and bankers—Henri's father was a well-off musician who migrated to Paris—whereas my father's father and his father before him were tailors by trade.

2015

Dagmar and Robin

One family friend was Paul Hollister, an executive at CBS who eventually became responsible for my stellar performance on the TV show *I Remember Mama* as a lip-synching extra in a schoolroom spelling bee. You may recall that the juvenile Dagmar was played by a very pretty young actress named Robin Morgan. I had a crush on her, and you can imagine my heart rate when, during the break before the spelling bee, I chanced to see "Dagmar" at the side of the main "family kitchen" set changing her costume, and at that moment, down to her bra and panties! Gulp. I got paid thirty-two dollars for that, and with it, a social security card.

Years later, in the seventies, there she was again, Robin Morgan, at a dinner given by Ned Rorem and Maggie Paley at Ned's apartment. No longer an actress, she had become a leading feminist activist and poet. Either Ned or Maggie introduced us, and that was that, a brief how-do-you-do in passing. Our relations, such as they had been, were over, and telling her of our brush with one another back there in the CBS TV studios and her in her underwear was out of the question.

2016

Autograph Hunters

Q: When does a signature become an autograph?
A: When some kid asks you for it.

Beginning in 1951, the year Joe DiMaggio retired, spring afternoons in the sixth grade, and for a couple of years thereafter, two or three of us would venture from our last class or baseball practice and ride the subway down to one of the Midtown hotels where visiting major-league baseball teams stayed while in town to play the Dodgers, Giants, or Yankees. There, joined with up to ten more boys from entirely other milieus (other boroughs, schools, social strata, and ethnicities), we formed a compact, diverse gang. Autograph hunters (or, less charitably, "hounds"), we posted ourselves long hours on the sidewalks under hotel marquees, keeping sharp lookout for the appearance of ballplayer couples—roommates generally traveled together by twos on the town—or multiples thereof. We loitered and schemed, ready to rush up singly or en masse to ask them to sign their names on whatever flat or round surfaces might be indicated.

The Hotel Commodore did the largest business in big-league visitors. Built right into the upper level of Grand Central Station, it had its main entrance on Forty-Second Street. Its sole competitor for teams that came and went via Grand Central—franchises from St. Louis, Cleveland, Chicago, Boston, and Detroit—was the Roosevelt two blocks away. On the west side was the New Yorker, across from Pennsylvania Station, where trains bearing Washington Senators, Pittsburgh Pirates, and the Philadelphia A's and Phillies pulled in along steamy, gray platforms. Patrolling the Penn Station concourse, dressed top to toe in dismal browns, the meanest, most feared of railroad security cops, Fagan by name (how did we ever find that out?), made long strides toward effectively chasing harmless kid fans out of the ballplayers' paths. (These were, as it happened, the last years of train travel for the ball clubs; by 1955, most travel was by air.)

For raiding the hotels, off days were best, or afternoons before a night game. The objective then was to make it past the doormen and house detectives into the lobby where the players killed time—lounging, chatting, reading the sports pages, smoking cigars—in leather armchairs. Because the least likely stratagem was to slip unnoticed through the front door, one tried alternate routes—at the Commodore, for example, through the upper Grand Central ramp entrance, or the secret door at one end of the street-level bar and grill. One at a time, you might bound up some steps to a corner of the main lobby; tense, work up a sweat behind a pillar or potted palm; then walk wobbly-kneed to where some players clustered and whisper, "Would you sign my book for me?"

Some collected signatures on individual index cards, some on baseballs. On the high end were glossy photographs. Thanks to my father, who, as general manager of the Hearst wire service, gave me access to the photo morgue at the *Daily Mirror,* if there was an extra print of any picture in a file I could take it home. Under plastic, on black paper in a loose-leaf portfolio, I kept a small collection of such eight-by-ten-inch press glossies, action or portrait shots of the likes of Minnie Miñoso, Warren Spahn, Bobby Doerr, Luke "Old Aches and Pains" Appling, and Gil McDougald (whose eccentric batting stance, arms drawn back and stick horizontal, I rather pointlessly emulated). Because of them, I was able to make some of these player–fan encounters less anonymous. Presenting the players with these photographs to sign usually sparked some conversational opening, like, "Hey, where'd you get that?" with the follow-up, "Do you think you could get me one?"—which at least once, in the case of Dr. Bobby Brown, cardiologist, third baseman for the Yankees, and eventually president of the American League, was capped by a personal note of thanks on team stationery.

Spotting the players was easy. Like most fans, besides having seen teams on the field, we had spent hours studying photographs in magazines, season programs, and official guide books. We saw newsreels, collected trading cards, and as the early fifties progressed, watched more live action on TV. With or without a famous face, a ballplayer on a Manhattan thoroughfare was stylistically

Bill's signed photo
of Satchel Paige and
Bob Feller from his
autograph-hunting days

something else. The unorthodox fashion statement consisted of an open-collar, short-sleeved sport shirt, sometimes under a rayon jacket. Ballplayers wore saddle shoes or other two-tone items with mesh in the uppers. Mostly, though, these guys tended to be big—not football-lineman big, but with impressive fore-arms, broad shoulders. Some, pitchers especially, were tall; there were Johnny Mize–size bruisers from first or third and the outfield; stubby, rotund catchers; elsewise, you had the typical pepper pot infielder, the Nellie Foxes and Jerry Colemans, Marty Marion, "Scooter" Rizzuto, shortstop or second-baseman body efficiency plus, like an Aston Martin sports coupé. The rare established star might dress in citified dark suit, white shirt, and tie, an executive player like Stan Musial or Ralph Kiner (and DiMaggio too). But Kiner and Musial also distin-guished themselves by staying apart, taking their own suites further uptown, it was said, at the Plaza.

Chunks of raw power like Cincinnati's Ted Kluszewski or agile statuary like Ted Williams, the players occupied an Olympus we sought to approximate only by way of our pens and blank spaces on a page. None of our self-prospects, beyond merest childish fantasy, included becoming a professional athlete; there-fore, bonding even at the level of tutorial interest was eliminated. Most players responded both dutifully and distantly to our requests. Only an occasional story-book grouch—the powerful St. Louis Cardinal outfielder Enos Slaughter, who had jammed his Dixie spikes into the rookie Jackie Robinson's foot, would scoff and snarl. Sizes and styles of inscription varied. Commonest was "best wishes" over a looping, though always legible, name underscored with a decorative flour-ish (the curlicue or infinity sign with two vertical slashes adopted by schoolkids acting big-league in yearbooks).

Ultimately, something monastic informed the pursuit, although distinct social and survival skills were accumulated along the way. Collecting real hand-writing samples in ink from ballpoint pens—more actual than the stencil ver-sions burned into bats and mitts and printed over the players' images on baseball cards—wasn't the point. There were many other devices for gathering signatures by mail, among them, self-addressed penny postcards sent blank to the club's manager with a request, almost always granted, that they be circulated for sign-ing by the entire roster. (It was a point of pride to avoid those assembly-line autographed balls they sold over the counter at souvenir stands.) These items probably faded long ago from the glossy sheets of squarish, padded-leather col-lectors' books, the stiff card stocks and slick paper programs, and my prized photo albums (wherever they all went, since our mothers all dumped them in periodical cruise-by Salvation Army collection bins). Like attending the game itself, it was, as they say, a pastime.

1996

M. M.

Credit Tom Rogers with an assist. Once or twice a year, Tom, who was married to Ceil Chapman and managed her high-fashion dress design business, for which my mother did public relations, would invite me to share his season box on the third-base line at Yankee Stadium. On this particular day, however, there was no game, just an avuncular lunch with Tom and my eighth-grade classmate and fellow autograph hound Mason Hicks at Toots Shor's Restaurant in the west Fifties. Shor's was a meeting place for sports figures, writers, and assorted Hollywood and Broadway types. At the bar or hopping tables would be Max Baer, Gene Tunney, visiting ballplayers like Stan Musial, columnists Jimmy Cannon and Leonard Lyons, and perhaps a movie star or two, like Dinah Shore with her husband, the stalwart George Montgomery. Mason and I had club sandwiches and cokes with maraschino cherries and looked around while Tom made light with whoever came by the table. It was all vaguely glamorous but impeccable, thanks to Tom's gentle, boozy, blushful Irish cheer.

Come the moment of parting, Mason and I found ourselves outside on the unusually quiet, summery Midtown side street. We turned to walk east toward Fifth Avenue. About halfway up the block appeared a beige sack dress—this is about 1953—ivory pumps, and a flash of soft, blond permanent wave. There must have been other, more identifiable features, but somehow we made a rapid computation of this mirage. Plain as day: Marilyn Monroe. And we sprinted straight for her, our ever-ready autograph books in hand.

We saw her turn into a building, slackened our strides, and, taking deep preparatory breaths, followed through revolving doors. It was a narrow office building lobby, completely empty but for us and the woman waiting for the shiny brass door of the elevator to open. It was a time of wobbly knees and no second thoughts as Mason and I walked the length of the lobby, drew up, and, with respectful mutters, extended one blank page each of the little padded leather albums for her to sign her name—"Marilyn Monroe"—with ballpoint ink in a large, clear, barely slanting script. She smiled openly, as if appreciating the oddity of the situation from the angle of a couple of thirteen-year-olds with whom a dream had so suddenly become complicitous. Perhaps she enjoyed our company at that moment in a way neither of us was prepared to fathom. She made a little bounce, the elevator opened, and she withdrew from sight.

1996

Finding the Music

Extraordinary how potent cheap music is.
— NORMA SHEARER IN *Private Lives*

In the forties and fifties of my youth, the world was becoming full of recorded music. This was around the time that Muzak entered the workplace; elevators, hotel lobbies, and restaurants swayed with string arrangements; and radio and television introduced the latest pop hits (as well as now inconceivable hours of live symphony and opera broadcasts). A restaurant around the corner from our apartment building calling itself La Mer had Debussy and Ravel piped in non-stop. With my parents I went to Broadway shows, movie musicals, and an occasional concert, especially if, as was the case with Judy Garland, the performer was a family friend. I remember both her Carnegie Hall and Palace shows, and how, at our party after the latter, there was a piano in the apartment for the first and only time.

As for the music condoned in New York at the time, or at least my part of it, someone seemed to have pressed the pause button at around 1945—there was a big Glenn Miller revival along with the Jimmy Stewart biopic—or else Lindy hopped back to prewar modes. At fancy juvenile dances at the Plaza Hotel, Lester Lanin's Society Orchestra played Cole Porter and the Charleston with Dixieland breaks featuring the enormous trombonist Big Chief Russell Moore.

Music wasn't much of a factor in my parents' private lives. We had radios throughout the house and in the family Buick, and by 1947 or so, a television set, but these were usually tuned to shows that, if they featured any music at all, it was only the incidental kind. Mostly we were tuned to news, comedians like Edgar Bergen, Charlie McCarthy, Jack Benny, and Fred Allen, and the morning breakfast talk shows of Tex and Jinx or Dorothy and Dick. The one record player, a portable dolled up with a fabric cover to look like a small traveling case, somehow fell to me, along with whatever 78s or LPs arrived in the house—gifts from show-business friends or promo copies my father brought home from his work as a news service executive.

Alone in my room with my boxy phonograph, I entered this mysterious region of more or less organized sound, about which no one I knew spoke. It wasn't until I was in my teens that a friend confided a taste for the same catch-as-catch-can jazz recordings—Benny Goodman, say, to Chet Baker—that I had ferreted out for myself, just how I don't remember. As with most things, I had no taste but some burgeoning instinct; as with my first dalliances with poetry later, I was prepared to like just about anything. At around age eleven, I listened to— by this time, on 45s bought in a cramped store on Eighty-Sixth Street near

Third—Guy Mitchell, Louis Armstrong's "I Get Ideas," Teresa Brewer, the Four
Aces, Les Brown and His Band of Renown, Kay Starr and Vaughn Monroe's
"Riders in the Sky." Add just about any Broadway original cast album and
(because a girl I knew was taking ballet lessons) *Swan Lake.*

This was long before Thelonious Monk, Morton Feldman, Ornette Coleman,
Anton Webern, and John Cage entered the picture, and before the early sixties
nights my friends and I piled into my mother's Jaguar Mark VIII to drive the
outer river drives at Manhattan's edges, smoking god-awful, seedy marijuana
and nodding vigorously to classic jazz endearments intimated through the car
radio from Symphony Sid.

The point a lot of the music made was energy, an expansive declaration and
release that otherwise was absent—practically, it seemed, unmentionable—
amid the low-key assurances of an advantageous upper-middle-class childhood.
The greater energy release, I understood later—first with the R&B revelations
on Alan Freed's *Moondog* show, tuned into late one night by accident in the dark,
and then with my wandering unsuspectingly into the 1954 Birdland All-Stars
concert and witnessing the Count Basie band together with both Billie Holiday
(a wreck at the time) and Sarah Vaughan—was that of compensatory culture.

Apparently, my parents had no need for any of this. They went out to sup-
per clubs in groups with friends, and sometimes at home my father would do a
brief comic dance turn spontaneously to amuse me. I don't recall either of them
ever singing a note or referring in any way to a musical performance. The fash-
ion shows my mother produced always had stylish music, presumably with her
approval. When as a grown-up I finally asked her why she and my father never
listened to music she said, "I spent every day talking, talking to people, in the
office and on the phone. When I got home, all I wanted was quiet." Luckily, as the
music got louder, I was far away, down the long, long hall, in my music-charged
universe, so very rarely did I hear the exasperated cry, "Turn that thing down!"

2007 / 2016

From a Childhood #101

"You think the world
revolves around you."

I do.
Therefore, it does.

Had there been a piano in that room,
I would have studied it.

Fashion

Q: Did you rebel against your mother's fashion influence?

A: I had a sailor suit, then a Trinity School blazer with charcoal grays, then the preppy style at Lawrenceville—foulard and repp ties, tweed jackets with either khakis or gray trousers, charcoal-gray suits. My father took me to his tailor, Knize, near Rockefeller Center—not for me. When I was a junior beatnik, I got jeans and a fatigue jacket. My mother never tried to influence my wardrobe, but when I left off being a beatnik some of the fashion people and especially my friend Kenneth Lane showed me the pleasures and perils (the bills I ran up!) of bespoke English and Italian suits, shirts, shoes and accessories. Donaldson, Williams & G. Ward in Burlington Arcade, Turnbull & Asser, John Lobb. I was on the International Best-Dressed List once, through no effort of my mother's. When I reconnected with rock 'n' roll and the Lower East Side in the later sixties, the jeans returned, and then in California. Nowadays, in the era of overheated interiors and no one dressing for dinner or even the ballet, before going out Connie and I say to one another, "Jeans or higher?" About once every ten years I get my tuxedo out of storage, amazed that it still fits.

The trouble now is, I hate to buy anything "off the rack," except of course Levis. Even the Brooks Brothers button-downs are so poorly made. Once you have suits made for you, "to measure," as they say, there's no going back. What I like now are the French shirts and loose, lightweight, workingman's-style linen jackets made for a nice, slightly obscure Parisian boutique.

Alex Katz cutout of Bill, circa 1965

Artwork © Alex Katz

Belle Terre

The "float" where the kids congregated was in fact an old, gray, canvas-covered Navy pontoon raft anchored in the high water off the Belle Terre Club beach. I loved to dive and swim under the width of it. The water was mostly cool, sometimes around seventy-two degrees, or near body temperature. The beach at the tide line was broad and somewhat pebbly, but sandy farther back where the volleyball net hung, and around the dune grasses where chiggers bit. On one side of the steps was a line of brightly painted wood cabanas, each with a little porch. Ours was orange. In front, my parents and other grown-up neighbors arranged their folding beach chairs. The local summer aristocracy was the McAllister tugboat clan. Close-knit, Brooklyn Irish, the various family households occupied their part farther down the beach. A regular site at our end was Margaret Truman, a houseguest of the great soprano Eleanor Steber. Herself a would-be opera singer, Margaret eventually was praised for the biography she wrote of her father, President Harry S. Truman. (Margaret and Eleanor could be seen trudging across the sand to join the other grown-ups for a game of stylish backgammon.)

On yet another part of the beach, the world's most beautiful couple, tall, athletic Freddy Reiger and the extravagantly blond Susan Davidson, could be seen together, arms around each other's waists, in the waves.

Belle Terre, Port Jefferson, Long Island

If anything constituted my own private childhood idyll, it would be the house we had in Belle Terre on Arbutus Path. It was big and white, with fluted columns on the front porch, a flame tree on the front lawn, and a little downhill, bordering a smooth dirt path, a low boxwood hedge the dogs (two standard poodles, a Weimaraner, and a mutt named Snookie) liked to jump through. To one side, a dark wood summerhouse, and next to it, a cast-iron sundial. Beyond all that, cupped by the tree line between, was the harbor view and that part of the water where my father's fishing boats—worked up gradually from a dinghy with an outboard motor to a jaunty cabin cruiser—were moored.

Parts of the interior of the house had been designed by the original occupant to resemble staterooms on a ship; there were curving walls, lots of windows, and in my room, a sleeping alcove. Outdoors, on another side, were steps leading down to a small, rock-bordered pond where I sometimes saw turtles and frogs and an occasional garter snake, and where the first of the two brown poodles was buried.

On the upper lawn, my mother had a rose garden. Beyond that, in the trees, were a greenhouse and a strawberry patch. In the garage sat a red Willys army jeep with a fatigue-green canvas top.

I spent many summer weeks virtually alone in the house, watched over by the caretaker and his wife, Tom and Mary Keane, while my parents worked in town or traveled. Lonely and socially awkward, I had, despite my valiant efforts, few friends. (For a while, my best friends were a couple of older girls.) I went to the beach to see who was there. By myself, I rode my bike and wandered in the woods and along the mostly quiet side roads. If not on foot or bike, I might be taken to the beach or to the town of Port Jefferson proper in the jeep. At home,

Bill with Brownie at
Belle Terre, circa 1951

in one especially sunny room, I listened to music on the phonograph. (The EP that comes first to mind is *I Get Ideas* by Louis Armstrong.) I had a rich fantasy life. Again with friends, I went to movie matinees at either of the two theaters in town.

On cold winter weekends, when we went, it was usually after dinner in town and arriving late. I would fall asleep in the back of the family Buick, always waking at the same turn onto a small road curving about a quarter mile from the house. On arrival, I would go quickly with my father to the basement to haul a bag of coal into the furnace and then to the living-room fireplace to lay logs on kindling, narrow strips of newsprint over and crumpled sheets below, ready to ignite with long wooden matchsticks.

2016

Bill's father, Seymour Berkson, at Belle Terre, 1955

"How about Some Okra on Sands Street?":
An Impromptu Special to Larry Fagin about Jack Kerouac

In the summer of 1957 I was seventeen, a New York boy, out of prep school, college in the fall, with a job as a researcher in the sports department of *Newsweek*. The sports editor was Roger Kahn. Dick Schaap, who had just graduated from Cornell, was his assistant. The offices were on Forty-Second and Broadway, and because weekend work hours were long and late (the magazine was "put to bed" late Saturday nights), I got my initiation to that razzle-dazzle neighborhood as best a non–street person with little actual business there could. (Kerouac's Times Square sketch in *Lonesome Traveler,* published a few years later, synchronizes perfectly.) Catty-corner to sports was books, with Wilder Hobson, the jazz historian, in charge. The literacy rate of these men seemed incredible and so distinct from that of schoolteachers in its worldliness: Kahn and Schaap, for example, would likely be discussing across the metal desks some ethical implications of Kafka as applied to the latest exploit of Minnie Miñoso. My reading at the time consisted of Jean-Paul Sartre, smuggled Henry Miller, Graham Greene, and *The Outsider* by Colin Wilson, while as a beginning poet I wrote an odd klutzy amalgam of T. S. Eliot, Gertrude Stein, and the "camera eye" sections of John Dos Passos's *U.S.A.* Having been schooled in English, having chanced on some "modern," I was anxious to find out "who *now*?" I looked around among the desk piles of review copies. One of those, the big find midsummer, was *On the Road.* Whoever got to review it, it seems, did not take it home, so promptly afterward it fell to my possession. Looking at it today, the spine lettering shot, white stamp letters on the front's black cloth spell ON THE RO. The flyleaf has a blue ballpoint scrawl: "Bill Berkson 1957." No underlinings in this text. Those I saved up for *The Subterraneans* one year later, because of all the early Kerouac texts, that was the most exciting and pertinent—broad gray underlining from some kind of thick drawing pencil, a few marginal exclamation points, and on the outer-middle edge of page eight, an inscrutable eureka, "THAT'S IT!"

"They made matters where matters were there." *(Visions of Cody.)* Maybe the forties to fifties writing by Kerouac and some few others did uncannily predispose our teenage pivoting world-set. (Would that qualify for what Allen Ginsberg calls "prophetic"?) Thereby, upon access, the poems and stories arrived instantly recognizable, a distance between the vocabularies of literature and experience closed. Reading and writing became more talkative. "This *is* tradition," they confided, and so a classroom weight lifted off too. Kerouac and Ginsberg suggested whole areas of further study; just like *The Waste Land, Howl* contained its own reading list: William Blake, Christopher Smart, D. T. Suzuki, Wilhelm Reich, Edgar Allan Poe, Plotinus, Oswald Spengler, William Carlos Williams . . .

welcome to the club. It was more like meeting the music that spoke and the mov-
ies that seemed astonishingly real than that other literature, "magazine verse,"
which, maybe perfectly good, was dispiritingly sanctimonious. Elvis Presley, say,
then Thelonious Monk, James Dean, then *I Vitelloni*. There's an entire society of
oneself, slightly less isolated than before, in that swirl. Plus the hitherto unmen-
tionable conception of writing for one's own information, to find out what words
said, with pleasure ("The Origins of Joy in Poetry"). So, the feeling that these
writings had entered the world just as I had, unannounced; they actually *made*
that present time before anybody knew it. Perhaps such a retrospect of intoxica-
tion is fated to seem sociological, or some tedious nostalgia I don't for an instant
mean to indulge. Although "be true to the dreams of thy youth" is one real roost.
Presuming to know what I couldn't know then, I look to a certain Ground Zero
moment in 1957 when what I read and thought next made irrevocably straighter
the existence-arrangements between my meaning to write and how to live.
Straighter, clearer, not final. Before that, life was strange and writing had all been
written. I probably had all the thinking-type consciousness I could use. There
was identity and sex, and then there was this awkward goof who said, "Poetry."

Remember the Angry Young Men? The English version (Colin Wilson,
Kingsley Amis, John Osborne) was the immediate predecessor of beatniks in the
newspaper/publicists' mart. Being mostly proper dons, they weren't ideal copy,
too respectable for a standing joke. But Colin Wilson writing *The Outsider* in a
sleeping bag on Hampstead Heath made headlines! Osborne's play *Look Back in
Anger* was pretty good, something of a Broadway cousin to Frank O'Hara's *Try!
Try!*, a soft prelude to Lenny Bruce. Beatniks, though, presented a more fron-
tal challenge, like Jackson "Jack the Dripper" Pollock, so to them fell the royal
treatment—they got dismissed, that is, dumped on, royally.

I went to Brown. Found books by Kenneth Patchen and Lawrence
Ferlinghetti, the *Evergreen Review,* and the record album of readings from the
"San Francisco Scene" with "Howl" on it; "Howl," then the book *Howl*, then
Chicago Review (a "San Francisco" issue again), then *Gasoline*. An exact order, I
think. I reviewed *Gasoline, Pictures of the Gone World,* and Jack Micheline's *River
of Red Wine* for the *Brown Daily Herald* or else the literary magazine, *Brunonia.*
(Some of these articles were signed "Nicodemus" during a time my work for the
Herald was restricted because of cutting classes.) I wrote awful enraged poetry
condemning materialism and dullness. The next summer I took the grand tour—
London, Dublin, Paris, the Riviera, Rome, Venice, Munich, Paris—hitchhiking
most of the way. Ginsberg and Orlovsky were in Paris; I saw but didn't meet them.
Alex Campbell, a terrific Scottish folk singer who became my guide and teacher
in Paris, told me about a poetry reading Ginsberg had given naked in someone's
apartment. He introduced me to Alan Ansen and pointed out Gregory Corso in

a bar. (Corso was being obstreperous, yelling "Chicago . . . creep!" at some poor sharkskin-suited guy, so we didn't intrude.) I wrote a poem a day on that trip and called the set "Forty Dead Days"; pretentious, of course, nothing was dead. Bud Powell was playing at Le Chat Qui Pêche.

Back in New York and Providence, wearing my fatigue jacket, French suede shoes. Thanksgiving 1958, visited San Francisco with my parents and got interviewed for a summer job on the *Chronicle*. Went to North Beach, saw busloads of gawkers-at-beatniks. Wondered if Gary Snyder or Philip Whalen or Jack Kerouac were around. A nice Filipino I met at the Place identified Jack Spicer, frame hunched up towards his tiny head like the Heap, alone at 2:00 a.m. on the traffic island of Broadway/Columbus/Grant. Some "scene." My father died in January. I left Brown for New York permanently, enrolled at the New School, read aloud for the first time at the Seven Arts Coffee Gallery on Ninth Avenue. One of the first poems Kenneth Koch discussed in his New School workshop that spring was "Howl." He put it in a sane light, discussed as poem among poems, pros and cons, and proceeded on about André Breton and John Ashbery. That was a further initiation, more professional, and an important balance. I found it was all in my own backyard, so to speak, New York painting, the Five Spot, Frank O'Hara. From the perspective of New York, its working artists, "Beat" had less relevance, and the separate identities of writers, what their works were, got clarified.

"Who *are* these people?" being as pressing an issue then, and much less now, as "What does all this writing consist of?" Did I spend equal hours staring back at the engaging look in the photo (*Evergreen* no. 2) of Allen Ginsberg as I did rereading "Howl" at the back? Do I still discover a trace of stammer when in the same room with William S. Burroughs or Gregory Corso, even though I've been in that room with them, off and on, for twenty or more years? Never did meet Jack Kerouac, having apparently missed him by seconds when he'd been at Rivers's studio circa 1961 to meet Brendan Behan. Small matter. Now it's all the work.

Kerouac's books that mean the most to me these days are *Visions of Cody, Old Angel Midnight,* and the poems (in various editions, still scattered). More and more, *Maggie Cassidy* seems like a perfect novel, quintessence of heartbreak, adolescence-to-raw-youth pivot. Whole stretches of sound from "October in the Railroad Earth" and poems on the LP *Poetry for the Beat Generation* forever on my mind. I've written them back out to an extent in this year's prose. Likewise, the Mill Valley trees section of *Old Angel* has been a wonderful guide to this Northern California coastal landscape. Recently, I've wondered who, among writers, has dealt with the feel of street and sky in San Francisco or the East Bay; not many have approached that subject as Edwin Denby, Frank O'Hara, and James Schuyler have done with New York. Is it the incommodiousness of raw unsettled landscape ("that awful palette," as the painters say) that impedes? Or

the contrary of easy cottage lifestyles? J. K. was not fazed by either: "the clarity of Cal to break your heart ..."

It's more interesting to note that a decade has elapsed since *Visions of Cody* appeared than to mull over sociopersonal baggage attached to *On the Road*. Has anyone read *Cody* enough? All matters of sentence, block, notebook usage, observant vernacular and parti pris of things are there, including the dissolve of the pesky verse/prose conundrum. Just as in "Essentials of Spontaneous Prose"— "Don't think of words when you stop but to see the picture better"—I take it the "seeing" is of words among many materials. The poems are mysterious, freer, deeper, how composed? What were his margins? Hung on what? (That earliest lesson from, I think, "Origins of Joy": "Listen down deep ..." Yeah, but also watch how talk is mouthed and, like Shakespeare, adjust lines to their correlative shift.) I like *Vanity of Duluoz* for its awe-inspiring Dantean apologia task. I like never knowing where the writing will lead.

It seems the "legend" has come to equal back-to-base. Wha' hoppen? Homeless beatniks with outrageous manners are not this present self. Family living in the eighties, a "kick" (a joy) and concomitant *angst* to attention like any fifties street corner or bar. Alas, talk of history, romance, that nice man, religious principles, absent America, obfuscate the reality of what Kerouac built, the solid work we refer to as a source.

1982

October 17, 2008

Dear Molly Proust,

A funny idea: I'll tell you what I remember. It happens all the time.

I already told you when we met in Maine that during my first trip to Europe I stayed at the Hotel Alsace-Lorraine owned by your great-great-granduncle Marcel's former housekeeper and chauffeur, Céleste and Odilon Albaret.

Summer 1958, my college friend Gary Johnson and I arrived in Paris, the two of us having gone somehow first to Dublin after getting off the SS Liberté at which port in either England or France I can't recall, and checked into the polite hotel on the boulevard Raspail listed on the itinerary my parents had commissioned, courtesy of American Express, as part of my grand tour. That done, Gary and I set out wandering. By nightfall, still puzzling out the city we had read so much about but had only the barest clues—place names that dated back to earlier glory moments, like Saint-Germain (Existentialism) or Clichy (Henry Miller), which really had next to nothing to do with the present day—we found ourselves in a small, brightly lit bar on the rue Cujas, the Bar Morissette, with music resounding upward from the room below. The street-level bar itself was sparsely populated, the salient presence being the pretty, blond, and powerfully built barmaid wiping glasses behind the counter, but it was the sound of guitars and singing from the cave that drew us.

Downstairs, in dim candlelight, twenty or so people, most of them in their teens or twenties, sat on stools or benches fitted to the walls, listening to Alex Campbell and his sidekick Henry Pofferd. "If I had wings like Noah's dove / I'd fly up the river to the one I love . . ." Alex, slight of build, with curly auburn hair, trim beard, and mustache, then aged thirty-two, was an impassioned Scottish folk singer living in Paris; Henry, the somewhat younger, distinctly quieter one, was English and played beautiful backup guitar. When not holding forth in the Cujas club, they played the streets, sometimes with other, younger English musicians, most of whom lived in the cheap student hotels between the boulevard Saint-Michel and the Odéon. The repertoire was eclectic: Scottish ballads, American work songs, Lead Belly, Woody Guthrie, Pete Seeger, even an Elvis rockabilly tune or two. On the street, one or another companion would pass the hat, pour l'orchestre. Alex, a neckerchief knotted at his protruding Adam's apple, rocked every which way on his boot heels, head up, voice way up too. His dress style, come to think of it, with lanky jeans and dark solid-color cowboy shirts, resembled today's slim-fit look, though with Alex this had much to do with a lot of drinking and hashish on top of a poor diet and hereditary tubercular condition. (Make light then as he could of his very bad cough, I read recently that, with a throat cancer already in tow, he died of tuberculosis at age sixty-two in Denmark.)

This was for me. It was probably Alex who spoke first, where was I from and who was Gary, and so on, and Henry looked on, smiling both sweet and a little suspicious, the gay and also class-conscious one surveying Gary's and my plainly Ivy-league good looks. I stayed and stayed; Gary, uncomfortable, couldn't see or hear it, and, suddenly pale and cramped with horror, left. I never saw him again. Alex said, "Where are you living?" and then "Oh, come in with us, man!" and either that early morning—the bar stayed open until dawn—or the next night led me to the rue des Canettes and introduced me to the hotel manager. "She was Proust's housekeeper," Alex whispered as Céleste went off, my passport in hand, to write in a ledger. "A grrreat woman," he burred.

The room I got was on the first landing, diagonally opposite the office and apartment of Céleste and her ailing husband. Windowless with no amenities; a knee-high, blue-painted metal can in one corner served as the latrine. The ample bed was lumpy and squeaked. Lengthy groans issuing from Odilon's kidney condition ("albumin trouble," Céleste calls it in her memoir) or some other illness accumulated over time, punctuated every hour of the night, like out of a Beckett

Alex Campbell, 1958

play. (Ten years older than Céleste, Odilon would then have been in his late seventies.) The down-and-out setting—a good likeness of the possibility then of being, or seeming, gloriously poor—was perfect, an eighteen-year-old beginner poet's idea of Heaven, including Heaven's Queen, never unaccompanied by the aura of her late employer: "Monsieur Proust," she would say, whenever prompted, "such a gentleman."

A few nights later, I had a part-time roommate, Connie Cassidy from New York, a girl my age with big blue eyes and long stringy blond hair who, like Alex and Henry and many others who came to the rue Cujas, played and sang folk songs. We stayed together at the Alsace-Lorraine off and on before she, a New Yorker like myself, left for home, and I hitchhiked south with Peter Yarrow, then a Columbia student with prodigious guitar skills and an excellent singing voice to match.

"Everybody's invited to my room," Alex beamed, and so that dawn a crowd from the cave and some other hotel residents—among them the Australian artist Vali Meyers, aflame with painted eyes and her birds—piled onto Alex's bed. Hash rolled in a tobacco mix was passed around, and everyone sang and talked loudly and laughed until, suddenly, an operatic rapping at the door. Céleste appeared, flinging the door wide open and stepping forward, furious. "Je n'aime pas cette vie de bohème!" she barked, whereupon the beautiful scene dissolved, along with my naive assumption that Monsieur Proust and this sort of shaggy existence I had just encountered were somehow aligned.

What did I know of Proust, anyway? By those first weeks in Paris, I probably had read only smatterings—a sentence here, a whole page there—of Proust's writings: *Jean Santeuil* initially sniffed two years earlier in a teacher's room at Lawrenceville (the posthumously edited work having just recently appeared, in 1955); then, soon after, my own set of the Scott Moncrieff *Remembrance of Things Past*, which I still have in soiled gray buckram bindings that I occasionally pry open out of curiosity (and which I once raided to flesh out the word balloons in a comic-strip collaboration with Joe Brainard).

In the twentieth century, in a sense, no one read Proust, the culture just inhaled him. Inner life was "Proustian," the world out there "Kafkaesque," and the trump card, "I'm reading Proust in French" on a par with "Dante in the original." At the Bibliothèque Nationale in 1965, walking through the exhibition of Proust-related artifacts, I got a different whiff of the overall effect well beyond modernist critical clichés. Around the canopied bed of the Countess Greffulhe, her portrait ("Half-length in profile to the left, three-quarter face looking to the viewer, wearing a black gown, a black choker with a pearl pendant, drop pearl earrings, her left hand to her breast") and the vitrines full of letters, the maestro's corrected proofs (with the "paste-ons"—like today's Post-its—invented

and affixed by Céleste herself, to allow greater space for heavy revisions), people of every conceivable gender exchanged furtive glances. All eyes and subtle elbow brushes, the room was a heavy-breathing mass of flirts.

Je n'aime pas cette vie de bohème! Everyone starts with a peculiar fantasy of how much the life of a writer matches up with actually doing it. My sense at first was that it had to be wilder and far away from what was handed me. For a time I used to sport smooth yellow gloves in imitation of Robert de Montesquiou's aggressive dandyism. That was only a little later, on the next year's trip, after seeing at Cap-Ferrat the anchored hull of Jean Cocteau's bright blue yacht. As dear Marcel seems to have learned for himself, after much confusion and folderol, the work has its own arguable ideas of identity, for all it's worth, regardless.

Cheers, as ever,

for Molly Springfield, 2008

Garbo Talks

About Greta Garbo we could talk some time. I don't recall knowing her until I was eighteen and in Europe for the first time. Monte Carlo, the Grand Hotel, a dinner given by Elsa Maxwell. As other guests arrived, I sat with her outside the dining room alongside a row of potted palms. Garbo said, "Zeez pahms, zay used to be be so beeeg, you could hide behind zem!" Not bad for starters. A year later, at lunch on the Agnelli's patio, we were seated together. At the table was a famous heart surgeon who began, during the salad course, telling of the benefits of eating seaweed. Garbo looked with horror at her salad plate, then looked up and "Eez theese from zeh seeee???!" Dessert time, I got up and came back with dishes of ice cream for both of us. Garbo said, "Oh, you are my ice-cream man!"

There's the story Frank O'Hara liked to tell of how, when he was working as Cecil Beaton's secretary, Beaton gave a big party for Garbo at the suite he decorated for himself at the Plaza Hotel. Beaton was crazy for Garbo. When she decided it was time for her to leave, Beaton escorted her to the elevator. The elevator doors opened and Garbo got in, but before she could press the down button, Beaton cried out "Wait!" He rushed back into the party, gathered up all the roses from their vases, rushed back to where Garbo stood inside the elevator, and threw the roses at her feet. As the elevator door closed, Frank, who had been closely observing all of this, heard Garbo say, "Beaton! You fool!"

George Schlee, husband of the dress designer Valentina, who was one of my mother's first fashion clients, was Garbo's boyfriend. He was an old-fashioned roué. That same summer at Monte Carlo I sat with him in the hotel bar as he expounded in a godfatherly way on life and how to seduce women. I later went to his funeral at the Universal Funeral Chapel on Fifty-Second Street at Lexington: no Garbo, but lots of other women, most of them hidden behind long black veils.

for Robert Harris

History at Night

It happened in Roddy McDowall's New York apartment, the night he gave a party for Judy Garland and a few good friends. It was also the night of the Democratic Convention in Los Angeles. Central Park West, July 11, 1960. Myrna Loy fresh from her return to movie stardom in *From the Terrace*. Montgomery Clift recuperating apace. Adlai Stevenson was supposed to be a shoe-in as the Democrats' nominee for president of the United States. Lauren "Betty" Bacall, an avid Adlai fan, had gone off alone to Roddy's bedroom to watch the proceedings on TV. "Those sons of bitches," growled Betty, appearing nonplussed in the doorway to the living room. Judy was laughing and confiding, patting Monty's knees. Stephen Sondheim listened and lifted and lowered his chin. Carol Lawrence watched, starry-eyed, somewhat awestruck, and Larry Kert wondered. No one knew much about John F. Kennedy yet. All they could think was "Harvard" and "Boston Irish Catholic." Judy drank Blue Nun liebfraumilch poured from the tall, thin bottle she had brought in a black tote bag.

for Kevin Killian, 1999

A New York Beginner

The art world I entered in the waning years of the fifties was made up of about three hundred artists, writers, dancers, musicians, theater folk, and otherwise a few adventurous dealers and very few collectors and patrons. Likewise, the magazine critics were artists, poets, journalists, men of letters, or amateurs. In the mid-sixties, a group of young art historians made a full-time profession out of what had previously, and best, been a pastime. (The past having been largely exhausted for scholarly purposes—this was well in advance of the revisionist and multicultural eighties—contemporary art appeared as fair game for the enterprising PhD candidate.) Despite the academics' efforts, the most telling expository form of the sixties was the interview. Homeric forties/fifties art-speak took its grammar from working-class diners and cafeterias, as well as from Damon Runyon and bebop. Reviews could be parsed into variants of ultrahip sportswriting and obscurantist sci-fi or True Romance. Were the artists really that embroiled and dashing, their patter that entrancing? Often. Was the critical language accurate and sincere? A near miss. Art criticism since then, the criticism of career professionals, has been more methodical and more rarely inspired. Abstract expressionism was an art for urban professionals—the intellectuals, sociologists, lawyers, psychoanalysts, and literati who constituted the high end of bohemia. The first-generation New York School and their followers failed to charm café society in the way that the surrealists did. Pop brought about a merger of high fashion and the serious art scene.

> *Our best contemporary art critics are preoccupied with assessing, surveying, tallying, and rating—with history and the history of painters, less with the achievements of the paintings themselves and our responses to them.*
>
> —FRANK O'HARA, 1965

No one I knew believed that Clement Greenberg's idea of modernism, when it appeared around 1960, was especially pertinent. In *ARTnews,* Jack Kroll dismissed the chief critical premise of Greenberg's just-published *Art and Culture* as an "intellectual malted-milk-with-egg." To other critics and artists who had given their hearts to abstract expressionism, any but the most modest divergence was suspect. In that regard, Jasper Johns's articulated sense that Willem de Kooning did not need his help to make more de Koonings was salutary and true. Pursuit of the Great American Artwork—a novel, painting, or opera—informed midcentury art in this country (has it ever let up?), whereas by the early fifties Europe had said (and *then* they really meant it) good-bye to "art as art." If prewar Europe invented formalism, postwar Europe threw it over. Only in

England did Greenberg's fixed idea carry any serious weight. Postwar European art—art brut, lettrism, the situationists, COBRA, the Independent Group, and eventually Fluxus, arte povera, and the New Realists—anticipated the "anti-aesthetic," or anyway anti-formalist, art recognized twenty years ago as "post-modern." But you can search the pages of *ARTnews* in the fifties and sixties in vain for any mention of Guy Debord or even of Asger Jorn or Piero Manzoni. New Realists like Yves Klein and Jean Tinguely were acceptable to New York's sense of itself; indeed, they courted such acceptance. Meanwhile, for those old enough to care, criticism on the street carried on types of Depression-years name-calling: a spot of vermilion might be analyzed as "fascist," and all good gestalts were "Trotskyite."

In the early sixties, Marcel Duchamp could be perceived as a highly refined, neighborly, purse-lipped seventy-something who looked closely everywhere he appeared, whether at a small gallery show or a Happening. The American edition of the first big book on his work, with a text by Robert Lebel, appeared in 1959. Works that favored Duchampian playfulness and inclusion were labeled neo-Dada, which meant they were anti-art, not really serious. The 1961 *Art of Assemblage* show at MOMA institutionalized this phenomenon. During the opening, I wandered alone into a large gallery at the far end of which hung Rauschenberg's astonishing combine painting *Canyon*. I had been in the clutches of this complex image for a minute or so when a twangy voice in my ear, Rauschenberg's, said: "Pretty good, huh?" Without taking my eyes off the wing-span of the eagle on a tin box cantilevered near the bottom edge, I replied, "I was just thinking so myself." Rauschenberg lurched closer, snarled menacingly: "And it's no joke, either." Later that evening, in the King Cole Bar at the St. Regis, I confessed to Jasper Johns the notion just then dawning on me that Duchamp really was a great artist, whereupon Johns stated flatly, "Oh, I think Duchamp is as important as Picasso." As Picasso was the God of modern art, this was equal to John Lennon's quip a few years later that the Beatles had become "more popular than Jesus."

Edwin Denby, Rudy Burckhardt, and Alex and Ada Katz all lived in the Chelsea area of the West Twenties. Alex was, and remains, a kind of painting mentor for me. He has a way of saying interesting things that, upon later inspection, prove to be at least half right, and the remainder stays interesting nonetheless. In a lecture at the San Francisco Art Institute, he recalled the turn when he began to paint outdoors: "It violated my principles—and was more interesting than my principles." Early on, to clue me in and educate my taste, Alex took me to other artists' studios—most memorably, Tom Wesselmann's and Al Held's. The approach that Held and Katz shared with respect to their images' appearance put in abeyance the supposed rupture between figurative and abstract. Edwin

Denby interpreted the frontal flash of Alex's pictures by way of a question: "How can everything in a picture appear faster than thought and disappear slower than thought?"

The first Rudy Burckhardt films I saw were *East Side Summer* and *Millions in Business as Usual,* both made of New York footage that brought the city home in the poignancy of its details; its light, air, and irregular scale. Another night a few years later (1963), a couple of gawky brothers from the Bronx, George and Mike Kuchar, showed up at Rudy's with brightly colored, genre-type movies they made with friends, *Anita Needs Me* and *Lust for Ecstasy.* The Chelsea ethos, as I think of it, exemplified by Rudy's films and Edwin's poetry, was Manhattan mandarin, a nonaggressive, steady access to high style. Early on, in the thirties and forties, de Kooning, who lived around the corner, had set the attitudinal standard, and Edwin's later writings about him, as well as his dance writings with Balanchine as protagonist, communicated the importance of each in terms of an alert, unsettled classicism. The professional push was all in the work; after work, fronted by sociability, there was critical attitude, but promotion and the wider audience either followed or didn't as a matter of course. If the work was interesting, they'd come for it, was the idea—perfectly correct if "they" is a neighborhood of engaged parties, like the one that existed until the sixties boom demolished it.

Parties in the early sixties: Some of the best ones were at the Hazans (Eleventh Street between Fifth and Sixth), Fairfield Porter's nearby house, and around the block at Kenward Elmslie's (who soon moved westward to Cornelia Street), and Morris Golde's salons further west on Eleventh. Talk in groups of two, three, five; dancing to jazz records; impromptu theatrics. Kenneth Koch was good at improvising: someone—John Gruen, often—would play piano to back up his witty blues parodies. Another scene came together at Larry Rivers's parties in his house on West Fourth Street. The same crowd mixed with jazz musicians, and more women. Larry's parties were more frantic, frontal, beat, no less nuanced. Norman and Cary Bluhm and Mike and Patsy Goldberg had smaller places, so they gave smaller parties. Morris Golde had the prominent theater and music people—Edward Albee, Richard Barr, Clinton Wilder, Virgil Thomson, Aaron Copland, Ned Rorem, Tommy Flanagan—mixed with poets and painters. Later, in the mid-sixties, I went to more art parties at Bob Motherwell and Helen Frankenthaler's on East Ninety-Fourth, a very different crowd: Mark Rothko, Frank Stella and Barbara Rose, Clement Greenberg, Ralph Ellison, Hannah Arendt, Walker Evans, Philip Rahv, David Smith, Barney and Annalee Newman—interesting but not much fun, except when Helen, who loved to dance, put on some music and rolled back the carpet. Summers in the

Hamptons, the party givers were the Gruens, the Hazans, Larry Rivers, Wilfrid and Marta Zogbaum, Conrad Marca-Relli, and one time, Willem de Kooning.

If in the forties and fifties the basic design elements of fine art were dictated by the cubism that Picasso and others enlarged upon in the twenties, the ambitious artists coming of age within the past thirty years have taken theirs from minimalism and its subcategory, pop art. Early pop maintained the sportive look of action painting, the perversely messy-looking, wide, overflowing artisanal mark that by then certified whatever it was applied to as Art. Once the technological facet perceived as style could be taken for a readymade thing, portable, disposable, or up for grabs, the historic sixties had begun.

> The Brillo boxes are also close to nothing. They aren't the real thing; Warhol had the basic wooden boxes made by an anonymous commercial cabinet maker, he ordered silk screens for reproducing the labels and he used assistants even for the painting and silk-screening of the boxes. They are not very interesting as art, and might look best in an artificial museum-like plastic case with a little brass plate that reads, "Brillo Box, Souvenir of an Exhibition by Andy Warhol, 1964."
> —GENE SWENSON, The Other Tradition, 1966

In a late-eighties museum exhibition recapitulating the history of design-oriented sixties art, the Brillo—and Kellogg's and Campbell's—boxes were shown encased in snug-fitting Plexiglas cubes, which suggested that they were both far from nothing and fragile. The boxes are now big-time souvenirs, collector's items shielded from the wear and tear they originally seemed to cry out for. Swenson was right about the boxes' afterlives in a museum context but wrong about their nonreliquary existence in everyday life. A single Brillo box never looked better than in the cramped living room of a Lower East Side apartment—Ted Berrigan's, as it happened—where it accommodated scuffs and Pepsi stains and, like the rest of the furniture (there was more art than furniture), multiple stacks of reading matter.

April 1966: outside the Castelli Gallery after the opening, the breeze took three of Andy Warhol's silver pillows into the air above Seventy-Seventh Street. Up they went, past Madison Avenue, between the apartment buildings, the water towers and roof terraces, heading east but coated with the late-afternoon light from across the Hudson. That July Frank O'Hara died, and my world for a few years afterward became more fragmented.

2001

"Europe" and So On

In his workshop at the New School for Social Research, when I took it, in 1959, Kenneth Koch read and talked about John Ashbery with his customary sense of modern poetry as a play of associations. The surface of a poem was analogous to the expanse of a sensibility's intensities and diffusions. Ashbery's poem "Europe," which appeared that same year, had a surface like none other.

However Ashbery himself decided to feel about it, "Europe" has been an important poem for me and many others who began writing around the time it was first published. You can see it in the early poems of Clark Coolidge, Dick Gallup, Ron Padgett, Bernadette Mayer, Lewis Warsh, Ted Greenwald, and me, and behind Ted Berrigan's *Sonnets,* too, and some of Frank O'Hara's late poems as well. "Europe" and the other similarly desyntaxed works that eventually found their way into *The Tennis Court Oath* constituted a permission. One aspect was the way of arranging by phrase, or sometimes just a single word: "I moved up / glove / the field." Writing by phrase derives partly from William Carlos Williams. The intervals in "Europe" are unique. A couple of years ago, a group of young San Francisco poets read it aloud, round-robin fashion, at David Highsmith's Books & Bookshelves. What with all the different voices, one aspect that came through strongly was the poem's consistent pacing, its pulse, and the gathering of phrase and interval accordingly.

At twenty, aflame with new senses of what poetry could be, I wrote poems mixing up Ashbery's insouciant rhetoric with O'Hara's passion and irritability. (I brought my own distress.) In the process, I discovered that Ashbery is a kind of Paganini, his demonic quality no less pervasive (and persuasive) in "Europe" than in his other work.

In Ashbery, it's discrete lines that are memorable, not so much, as with O'Hara, whole poems. (There are exceptions: one is "A Blessing in Disguise," which is built almost entirely of memorable lines.) It's the rhetoric, how Ashbery fits his lines together, how they ring from one to the next, that is irresistible, that makes for the acceptance of his work "across the board." Whatever else his poems are or aren't, they carry the unmistakable ring of poetry.

Sometimes it seems the world could get along well enough retrieving one Ashbery blip daily for sustenance. Samplings from the dish, an imaginable national pastime of Sortes Ashberianae:

> And sudden day unbuttoned her blouse

> The lake a lilac cube

> She is under heavy sedation / Seeing the world

And the fried bats they sell there

The constellations are rising / In perfect order

"you" in the plural

And then I start getting this feeling of exaltation

young love, married love, and the love of an aged mother for her son

Heh? Eh?

Or:

cannot understand / feels deeply

For my part, I heard "Europe" as a texture of interferences and interruptions analogous to those in John Cage's "mixes," but even there, the impulses were so clearly distinct. (Note that Ashbery was twice rescued from an impasse in his work by hearing new music in concert, first by Cage's *Music of Changes* and next by a vocal piece by Luciano Berio, *Thema (Omaggio a Joyce)*. In any case, "Europe" has Anton Webern written all over it.)

What if Ashbery had conceived of a poem in 111 sections covering twenty or so pages and let it go at that? The idea is beautiful in itself. The poem doesn't need to be written.

The demonic inside and out is irony. With irony, as W. H. Auden wrote, "The limitations of the situation . . . loom larger than the situation itself."

> *I call people of this sort "ironists" because their realization that anything can be made to look good or bad by being redescribed, and their renunciation of the attempt to formulate criteria of choice between final vocabularies, puts them in the position which Sartre called "meta-stable": never quite able to take themselves seriously because always aware that the terms in which they describe themselves are subject to change, always aware of the contingency and fragility of their final vocabularies, and thus of their selves.*
>
> —RICHARD RORTY "PRIVATE IRONY AND LIBERAL HOPE"
> IN *Contingency, Irony, and Solidarity,* 1989

Of such deep irony and its urtext of pratfalling disappointment, the poems achieve sublimity.

2014

Variations on a Theme (Warfare)

> There is no love interest in these modern wars.
> —GERTRUDE STEIN, 1945

It's said that the more examples you show of suffering the smaller the impact. One sad case is tops. The casualty list looks blank unless you're searching for a name. In Gertrude Stein's *Brewsie and Willie,* Willie says, "If you fight a war good enough everybody ought to get killed." A little later Brewsie says, "Oh dear, I guess you boys better go away, I might just begin to cry and I'd better be alone. I am a G.I. and perhaps we better all cry, it might do us good crying sometimes does."

Ted Berrigan said he heard a gunshot in the night in Korea, outside the base. Kenneth Koch lost his glasses in a foxhole somewhere in the Pacific, bullets whizzing. "Killer Kenneth." Frank O'Hara stood on the deck of the USS Nicholas, spotting enemy planes, horrified that he might be the cause of the next great Japanese composer's going down in flames. Robert Creeley drove an ambulance through Burma. What happens when poets go to war, as they will, but nowadays rarely? (Some mystery in that.) "War is shit," Ted wrote in one of his Vietnam-vintage poems. Some of us are just perpetual observers, like Tolstoy's Pierre threading through the aftermath at Borodino.

For those who were in it, varying degrees of persistent horror seem inexorable: "war-torn," "battle fatigue," "shell shock," and the now clinically approved "PTSD." (A bellyful of scare quotes there.) O'Hara went on to Harvard and wrote an attempted exorcism, "Lament and Chastisement," its finale choir screeching like out of a bad dream.

Poets and painters have a high command. Few of my friends have ever been in any army, nor have I. Fat chance of that. Our love interests lie elsewhere.

Nevertheless, we have rage, aggression, defense mechanisms, a taste for revenge, inordinate cruelty, appalling as all those may be, as well as resentment, pride, and shame. I remember a poet friend in 1967 or so telling me he was going to join the army—because, he said, "I need to kill someone."

Is that a real soldier? Do we fuck or fight? The professional—commander or hoplite—is one thing. My uncle Kent, the career cavalryman, rode horses in World War I and tanks in World War II. In the latter, on George Patton's staff in North Africa, Sicily, and onward—a disreputable association that left him shunted at war's end, his last years as colonel commandant of the dress post on Governors Island. His daughter, my ninety-three-year-old cousin, says he was generally "naughty." Lean, elegant, persuasive, sporting a neatly trimmed mustache, a lightning-bolt-shaped Armored Division patch on one sleeve of his uniform jacket, he was the closest I ever got to a military life.

Fuck or fight? Walter Reed is closing, the troops may well be pulling out, but the drones keep flying. John Keegan's *A History of Warfare* reads like a biosketch of collateral humankind. But strangely omitted is the sense of how soldiering fits with the everyday economy. At the selective service induction center in Lower Manhattan, 1960, I overheard people my age eager to get in, get the job. "Hope he doesn't spot my trick knee." Growing up absurd, with no higher prospect. I, on the other hand, wanted out, ambitious to avoid, certified 4-F by a picture-perfect Viennese émigré camp psychiatrist, psyched, watching my hands shake when he told me to hold them out. The desk sergeant handed me a lunch ticket for the mess hall; an hour later I sat drinking vodka in Frank O'Hara's parlor, wondering if I had missed out on some crucial experience.

2011

Engagements 1961

March 27: Alex Katz lunch 1 p.m.
...

May 12: Party for *Second Coming* magazine
13: Dinner Ellie & Alfred Frankfurter
14: Norman & Cary's wedding
15: Party for Norman & Cary
22: With Frank to see *Destry Rides Again* and *My Little Chickadee*
24: Dinner Barbara Guest
...

September 9: Royal Ballet opening at Met, *Sleeping Beauty*
13: Royal Ballet, *Fille mal gardée*
21: *Ondine* w/ Margot Fonteyn
24: Registration NYU Institute of Fine Arts
 Roscoe Lee Browne reads Yeats/cocktails Geoffrey Gates
27: Party at 124 E. 57

October 26–28: Frank O'Hara wrote this:
 "Shirley G. made it with Frank. I cried all night because I was
 worried and cold. Jenkins locked up his electric blanket and
 I can't speak French."
29: Arrive Paris 8:30 p.m.
30: John Ashbery drinks/*Tête d'un homme* at Cinematheque
 (Duvivier)
31: Hallowe'en. Joan Mitchell lunch/Roy Leaf & JA at Deux
 Magots
Note/October 31: During lunch at Joan's, Frank pronounces
Ashbery "the foremost poet in English today." Joan Mitchell
says, "God! How I worked over that poem!" (meaning "Europe").
I grunt. Jean-Paul fixes the camera.

November 1: *L'année dernière à Marienbad*/Joan Mitchell's lunch
2: Lunch w/ JA and go to shows of Ste. Phalle, Frankenthaler,
 Lebel, Munford/Dinner David Budd
3: Sent postcards
4: Lunch w/ Marcelin Pleynet in Sceaux. Meet Julien Alvard.
 Returning from Sceaux, get off métro w/ Frank at pont
 Mirabeau. Meet JA at Gare de Luxembourg, 1 p.m. Mother
 arrives/will call.

5: Dinner Mother *("Missed Papa"* – F O'H)

6: Dinner Joan & Jean-Paul & JA *("Partousie"* –F O'H)

7: Ossorio show at Galerie Staedler

8: Ilse Getz drinks, 6:30

9: Riopelle's studio lunch

10: Leave for Rome. Hotel d'Inghilterra, Via Bocca di Leone 14

11: Fabiani's drinks

12: Meet Bill Weaver. Weaver gives party. Monica Vitti invited but doesn't come. Meet Hans Werner Henze, etc. Meet John and Ginny Becker (patrons of Edwin Denby and Bill de Kooning), go to their house for puppet shows.

16–18: Frank: *"Go see Pope."*

19–25: Frank: NY skyscrapers
> Cocktails
> Joan
> white-tie

> Missing Paris
> and Rosa Luxemburg
> and Picabia
> (J. missing my perfume)

26: *Zazie dans le métro*/Drinks Ken Sawyer

27: Dinner at home w/Frank, Joe, Norman, and Cary, *Sensations of 1945* on TV

28: Drinks w/ Frank/tropical garden and Jazz Gallery with Connie Ullman

29: Ann Miller drinks

30: Frank lunch/opening of *Daughter of Silence,* 7:30 p.m.

December 1: Lunch w/ Earl McGrath 12:30 p.m./drinks with Fairbanks, 6:30 p.m.

4: Jacques Sarlie party after 10:30 p.m., 550 Park Ave

6: Lansners' party

7: NYC Ballet (opening of *Raymonda Variations, Episodes, Fanfare, Interplay*)

8. *The Hustler*

9. Ballet?

12: Selective service exam 7:30 a.m./ R&R at Frank's

13: McGraths' party

16: Call Ken Lane

December 18: Ken Lane drinks/Virgil Thomson concert w/ Frank
 19: Ballet?
 20: NYC Ballet "All Stravinsky"/lunch Waldo Rasmussen
 22: *Nutcracker* 5:30 p.m./Morris Golde party for Virgil Thomson
 birthday
 23: Party at home. Norman lunch.
 24: George Schlee/Valentina party
 25: Mary Lasker lunch
 28: Party for Bill Weaver at Tiber Press
 30: *La Fanciulla del West*

Avenue de la Bourdonnais

"We call it a one-and-a-half," said the bright old Russian lady, gesturing at the bed that just fit in the alcove of the one-room apartment, the top of a duplex, the lower half of which she and her husband occupied on avenue de la Bourdonnais, between the Eiffel Tower and the École Militaire. "You know," and here she smiled at Maxine and me together, although we were not a couple in that way, "You put one leg *over* the other person." Maxine had found the place that summer, 1963, while I was traveling in the South of France with a side trip to Venice. It was perfect, otherwise roomy, with a large desk by windows giving onto the broad avenue and an enormous bathroom featuring a deep tub and two big sinks. The previous tenants, I soon found out, had been Helmut Newton and his beautiful wife, June (on whom, when they came to collect things left behind, I developed an instant crush). I stayed there for about eight months, from August 1963 into the following March. Very few poems, if any, resulted. Frank O'Hara visited, as did my mother. When, in November, John F. Kennedy was killed, the French press went straight to conspiracy theory. David Budd gave me a Nat King Cole LP called *Love Is the Thing*. I went out dancing a lot and lived much of the time with a Welsh-born, raven-haired fashion model named Morfa Mansi. But the best was that apartment. My Russian landlady was a painter whose husband served in the merchant marine and also in the French Resistance; his memoirs, which had just been published, included an account of how, during World War II, she had crossed the channel from England to help rescue him from a German prison. Both of them were short. He was stocky and shuffled around in a tough-guy manner like Jean Gabin, *un vrai mec*. She was very thin and smoked Gauloises in a black, vintage cigarette holder, periodically relighting to take a few short puffs until she got the cigarette down to its tiny, final nub. What her paintings looked like I never found out. In her youth she had known all the avant-garde artists of Moscow. "I went with Mayakovsky," she confided one afternoon. "He invited me. We were together all night in a private room. I knew it meant my family would be furious and they would punish me, but it was worth it."

Spoleto 1965

Frank O'Hara was asked by Gian Carlo Menotti to select the American poets for Settimana della Poesia at the Spoleto Festival of Two Worlds, June 26 through July 2, 1965. He chose Barbara Guest, Tony Towle, John Ashbery, Allen Ginsberg, Gregory Corso, Lawrence Ferlinghetti, Robert Lowell, Charles Olson, John Wieners, me, and, I think, Kenneth Koch and Frank Lima as well. Menotti refused to invite Allen and Gregory because of the scandal they'd caused at the festival a year or two before. (This was during Allen's phase of getting naked in public every chance he got.) Robert declined. Tony couldn't go for lack of travel money. Menotti and company added Allen Tate and Ezra Pound. Then Frank himself couldn't go because of his curatorial obligations at the Museum of Modern Art (which may also have been why he was absent from the Berkeley Poetry Conference later that same summer). Nonetheless, Frank was there in spirit, having organized a tidy MOMA show of recent landscape painting that featured Alex Katz, Allan d'Arcangelo, Roy Lichtenstein, Jane Freilicher, Richard Diebenkorn, Robert Dash, Christopher Lane, Jane Wilson, and Aristodimos Kaldis.

Among the European and Latin American poets, some of them selected by Stephen Spender, were André Frénaud, Yevgeny Yevtushenko, Ted Hughes, Miroslav Holub, Pablo Neruda, Pier Paolo Pasolini, Salvatore Quasimodo, Lino Curci, Rafael Alberti, Johannes Edfelt, Ingeborg Bachmann, José Hierro, Murilo Monteiro Mendes, and Desmond O'Grady. Spender acted as master of ceremonies for most of the week, with John Ashbery replacing him on one occasion.

Amiri Baraka's ritual drama *Dutchman,* which had opened at the Cherry Lane in New York the year before, was performed during the festival with the original cast of Jennifer West and Robert Hooks. ("Tremendous," said Pound to Olson when the latter asked what he thought of Amiri's play.) Other people who weren't directly involved but showed up during the week were: Joe Brainard, Kenward Elmslie, Maxine Groffsky, Lewis MacAdams, D. D. Ryan, Waldo Rasmussen (representing MOMA), George Schneeman, and Peter Schjeldahl. I read later that Pound's group included R. Buckminster Fuller and Isamu Noguchi, but no one seems to have been aware of them being there at the time.

"That's no epiphany, it's a wet dream!" said Maxine, as we saw from a slight rise above the Teatro Caio Melisso parking lot a young poet marking, with eyes riveted and arms spread wide, in a posture of near genuflection, the arrival of Charles Olson. Moments later, I joined the group. John Wieners, also there to greet Olson, brought me over to introduce me, and Olson gave me a surprise bear hug. This display of instant affection puzzled me until John explained that the woman with whom he and I once shared an afternoon at the Cedar Bar was

Charles's wife Betty, who had since died—I hadn't caught her name—and John had told Charles about how she and I happily clicked in that one casual meeting.

Inside the theater that afternoon, the first reader was Barbara Guest. By way of a pointedly undiplomatic curtain-raiser, Stephen Spender rose to introduce the proceedings and, for the edification of the international audience, singled out Barbara as "a member of the New York School of poets, whose main distinction would seem to be that they all write about painting." So Settimana was off

The Festival of Two Worlds, Spoleto, Italy, 1965: *left to right,* Charles Olson, Bill, [unknown], and Pier Paolo Pasolini

The Festival of Two Worlds, Spoleto, Italy, 1965: *from left, around the table,* Bill, John Ashbery, John Wieners, [unknown], Desmond O'Grady, Ezra Pound, Charles Olson, Olga Rudge, and Caresse Crosby

and running. Yevtushenko read at length, one arm raised to the heavens, the other keeping time behind. ("The discus thrower from Smolensk," Ferlinghetti called him). Allen Tate read what must have been the entirety of his "Ode to the Confederate Dead." Neruda also read for a long time—all of his *The Heights of Macchu Picchu* cantos—but thrillingly.

In the order of things, Ezra Pound's reading was scheduled for the morning of the next to last day, July 1, with John Ashbery, John Wieners, and Johannes Edfelt from Sweden before him, then, in the afternoon, the roster was Charles Olson, Pier Paolo Pasolini, me, and Murilo Mendes, with John Ashbery introducing. Pound, nearing eighty, in a loose-fitting linen suit, read from the royal box, deep in the rear of the theater. Even with a microphone he was almost inaudible, and he read not his own work but Marianne Moore's translation of "The Grasshopper and the Ant" from La Fontaine, Robert Lowell's Dante "imitations," his translations with Noel Stock of ancient Egyptian love poems, and solo renderings of the "Confucian Odes" and the little-known Italian modern poet Saturno Montanari. All of us in the orchestra rows below stood up, turned, and strained to hear him. The advance word had gone out that he was frail and silent, and that was pretty much the case. Olson wanted to engage him in some big-time, earthshaking confab, but no soap; Pound wasn't up for confabbing in those days.

About Pound, Joe Brainard wrote in his diary:

Ezra Pound arrived two days ago in Spoleto. I heard him read. I could not understand a single word he said. When you meet him he does not say a word: he rolls his eyeballs around and does not look real. He looks like he belongs on a coin.

In the afternoon, Olson read, with great heaves, "The Song of Ullikummi," his "fucking the mountain" poem. Pasolini addressed his Italian poems to a great claque of boys in pastel-toned, fuzzy angora sweaters, filling the front two rows. When Pasolini had finished, John went to the podium and began, "Next is a young American poet . . .," meaning me, at which utterance the two Pasolini rows emptied out: Pier Paolo's boys, described in the press as a Communist youth group, had gotten up en masse and darted up the center aisle with great commotion. Once John managed to complete his brief introduction, I approached the podium totally shaken. Somehow, though, I managed to direct my opening poem upward, to where Pound and his entourage were sitting, again in their box, and because the poem I read was clearly in line with some of Pound's early writings—I had in fact, at about that time, fallen all over again for his authoritative manner—it seemed to go over with the grand old poet. I saw that he was clapping

and others had followed. That initial applause steadied me somewhat and I was able to go on. (Renée Neu, Frank's assistant at MOMA, had done the translations of my poems into Italian for the bilingual audience handout sheets.)

Afterwards at the Tric Trac, Pound sat with Olga Rudge and Caresse Crosby, more or less guarded by the relentless Desmond O'Grady. John Wieners and I went up to Pound with copies we had each just bought of a slim, red-bound Italian edition of his poems, which Pound inscribed (mistaking my last name as "Bergson"), followed by a greeting, "Salut," and his signature.

The next morning I returned to the Tric Trac and, wanting a rest from the festival folderol, decided to have breakfast alone in the café's backroom. But the backroom wasn't empty. No sooner had I settled at a little table just inside than I saw that there was a large company at the long table beside me, with Pound and Rudge at the near end and a film crew at the other. Gulp. I had accidentally sat myself down about two paces to one side of Ezra Pound. Trying my best to remain invisible, I picked up a glossy magazine from the small table next to me, and no sooner had I begun flipping through its pages than I saw it contained an article on Pound's old friend, the sculptor Henri Gaudier-Brzeska, who had died at age twenty-three in the trenches during World War I. No escape. I got up, approached the table and showed the magazine spread to Rudge, who, gesturing

Bill reading at the festival in Spoleto, Italy, 1965

to E. P., said "Well, show it to him!" As I shoved the magazine under Pound's chin, I said to him, "I imagine you'd enjoy seeing this." (*Connaissance des Arts*, I think it was.) Pound took it, and I went back to my seat; minutes passed while he looked long and hard at the text and pictures, then he looked back at me and offered to return the magazine. "You keep it," I said, and he nodded. Silence. By then my breakfast had arrived. I picked up a newspaper and, thinking to resume my measure of anonymity, began to concentrate on the day's news. Suddenly the room was full of the fullness of Pound's voice, "And then went down to the ship / set keel to breakers, forth on the godly sea . . ." He read through all of "Canto I" and a couple of others, all frailty for the moment gone away, while the cameras rolled.

One other event involving Pound was Max Neuhaus's account on another day of Morton Feldman's percussion piece "The King of Denmark." As required, Max played this extremely sotto voce Feldman composition in the theater lobby with a small group of listeners standing in a semicircle around him and his elaborate setup of bells, gongs, pipes, triangles, cymbals, and so on. Pound, the only one sitting, placed himself a little forward from the rest and watched intently every one of Max's moves, taking in the delicate and widely spaced sounds for the duration of the work, about seven minutes all told.

2016

Andy Warhol

October 8, 1965, opening of the Andy Warhol retrospective at the Institute of Contemporary Art, Philadelphia. At Sam Green's invitation, D. D. Ryan and I took an early train down and got a preview of the show before the crowds piled in. It was a shock. Even though I had been impressed a few years earlier by the Elvises and other works shown at the Stable Gallery, especially the big, silver double one, I stayed generally indifferent to Warhol's work and kept a distance from his scene, including the *Screen Tests*, hanging out at the Factory, and so on. But seeing the paintings in the big, airy ICA galleries knocked me for a loop. I said as much when, that night, amid all the hubbub of the actually opening, a TV reporter stuck a microphone in my face and asked what I thought. Gerard Malanga told me later that Andy was pleased by my remarks, probably because he knew that I wasn't sure about him before.

My childhood friend Brigid Berlin (a.k.a "Polk") was my only real contact with the Factory scene. One night at Ondine, she asked me how Rauschenberg made his solvent transfer drawings, and I invited her back to my place for a demonstration. Who knows how, but I had learned that technique of placing a newspaper or magazine image face down then squirting the back of it with lighter fluid and rubbing with a pencil or some other instrument to make the image appear—presto!—on a sheet below. Brigid stayed up all night making her own, leaving me a big Jackie Kennedy image (from *Life*, I think) on the desk.

The one Factory party I went to was Judy Garland's idea. I think by that time her daughter Liza was living at my mother's and beginning to break into show business. All I recall is the big sofa and Judy on it, wide-eyed, a bit nonplussed at all the goings-on, but nonetheless "Judy."

Another connection was Sam Green himself. One time Sam invited me along with John Giorno and Taylor Mead for an overnight at his distant cousin Henry McIlhenny's house on Rittenhouse Square in Philadelphia. The idea was for Sam to screen a set of underground films for Henry's edification, including Andy's *Tarzan and Jane Regained . . . Sort Of,* with Taylor and Naomi Levine in the title roles. The house was large enough for every one of us to have a separate room. I remember the Renoir and Bonnard in mine, two small still lifes. I also recall Taylor, in his relentlessly outspoken way, having a mad crush on Henry McIlhenny's butler, though not whether anything came of it.

I think it was Gerry Malanga who encouraged Andy to be at Ruth Kligman's Washington Square Gallery for John Ashbery's reading of "The Skaters." As far as I can determine, Andy's feelings for poetry were practically nil, but he liked to be where the action was, and that day the action was definitely all John's.

2015

Teaching in the Sixties

The New School for Social Research

> *1672 Poetry: Reading and Writing*
> *Tuesdays 8:10–9:30 p.m., beginning February 1. $60. (Reg. fee: p. 6).*
> *William C. Berkson*
> *For those who have had some experience in writing poetry. Students'*
> *poems are read and discussed in class and seen in relation to issues raised*
> *by a few well-known poems read closely during the term. The purpose*
> *is to increase awareness of the possibilities and problems involved in*
> *writing contemporary poetry. Some of the poems read are: Williams's*
> Asphodel, *Pound's* Cantos, *Wyatt's sonnets, Joyce's* Finnegans Wake.
> *Some of the issues: The Personality of the Poet, Speech and Typing, Poetry*
> *as Narration, Poetry as Ethics, Group Composition. Guest poets join in*
> *certain discussions.*

<div align="right">—THE NEW SCHOOL BULLETIN, SPRING 1966</div>

I taught at the New School for five years, 1964 to 1969. The reading list changed over that time, as did I. Arthur Rimbaud, Frank O'Hara, John Wieners, W. H. Auden, John Keats, Alexander Pope, John Ashbery, Gertrude Stein, Allen Ginsberg, William Blake, and Federico García Lorca put in appearances, but the basic format of the class stayed pretty much the same. In the process of those initial years as a teacher, I went from being a protégé of the older generation of New York poets to knowing poets my own age—from the odd angle of posing as their teacher—and eventually finding something of my own place among them.

The New School in those years was bubbling. For spring 1959, the semester that I took Kenneth Koch's workshop, the bulletin listed John Cage's courses in experimental composition and mushroom identification (the latter categorized under "Recreation"), Rollo May on Zen and Existentialism, and other offerings taught by Erich Fromm, William Troy, Alfred Kazin, and Louise Varese. Frank O'Hara taught a workshop there in spring 1963. By 1966, the writing faculty had included, besides Kenneth and me, Amiri Baraka, Arnold Weinstein, José Garcia Villa, Marguerite Young, Robert Phelps, Diane Wakoski, David Ignatow, and Michael Rumaker. Henry Cowell and Martin Williams taught music; Joseph Chaikin, theater; and William K. Everson, a course on film. September to November 1966 featured a series of "readings by young poets in the vanguard tradition," with Ted Berrigan, Ed Sanders, Ron Padgett, Dick Gallup, Aram Saroyan, David Antin, Joseph Ceravolo, Jim Brodey, and others. That last list is telling: none of the poets who read in what must have been a remarkably exciting

series showed up in my classes—Ted Berrigan had his own workshop across town at the Poetry Project—but they were part of the buzz I was then becoming privy to. The New School credit rolls for my workshop in the fall 1965 and spring 1966 semesters included (names here as registered) Michael Brownstein, Bernadette F. Mayer, and Peter C. Schjeldahl. Through the years, other such notables as Lee Crabtree, Frances LeFevre, Jean Boudin, Myra Klahr, Annette Hayn, Charles North, Musa McKim, Miriam Solan, Carter Ratcliff, Rebecca Wright, Mary Ferrari, Hannah Weiner, and Patti Smith came and went. Among the early contingent, Peter Schjeldahl, for one, was taking both Ted Berrigan's and my classes, and Bernadette may well have followed suit.

At Yale, with Jean Genet

In early 1969, while teaching at the Yale School of Drama, Arnold Weinstein met Susan Holahan, who was teaching writing to undergraduates. The two of them hatched a plot. Agreeing that Yale students should know about contemporary poetry, for which the regular curriculum provided not at all, they saw advantage in the newly conceived program of seminars in the residential university colleges, whereby courses in any subject could bypass departmental strictures. They chose Ezra Stiles and Branford colleges as the testing grounds and invited students interested in taking poetry courses taught by live poets to gather one afternoon to meet some candidates and vote on which ones would teach the initial seminars in each college, two in the fall, two in the spring.

The poets invited were Ron Padgett, Dick Gallup, Ted Berrigan, Peter Schjeldahl, Michael Brownstein, Anne Waldman, and me. The students at Branford voted for Ted and Peter; the Ezra Stiles votes went to Ron and me. Ron wasn't interested, so the two semesters at Stiles fell to me alone.

Once a week for the fall 1969 and spring 1970 semesters, I took the train to New Haven, taught an afternoon class in Stiles, and stayed overnight in the academic suite with its ingeniously heated slate floors. (Eero Saarinen had designed the college, which was built in 1961, to mimic the towers of San Gimignano in the Tuscan hills.) My first day, I was accosted by a student wanting to interview me for the school newspaper; that student was Kit Robinson, who was a Branford resident but nonetheless became a good friend, along with his fellows in Branford, Steve Benson, Alex Smith, Rodger Kamenetz, and Alan Bernheimer, some of whom eventually moved to San Francisco and became identified with the Language school there.

In the spring, events around the trial of Bobby Seale and other Black Panthers stirred talk of a "Yale Revolution," diffused by way of shrewd compromise on the part of the Yale president Kingman Brewster Jr. (Brewster's was the kind of paternalistic, liberal compromise that, for many American colleges and universities, spelled the end of higher education's balance of powers in that, when the smoke cleared, all institutional power would be ceded not to students or faculty but to corporate trustees or regents—one cause of today's curricular mess.) Meanwhile, among those who arrived to speak in support of Bobby Seale was Jean Genet. Genet, in his customary brown windbreaker, took the stage in a student lounge and spoke passionately, and often obscenely, in French, flanked by a kind of honor guard of David Hilliard and other Panthers in full regalia. Translating for Genet was a dark-haired girl, presumably a graduate student, in black beret and leotard, whom Genet admonished every so often for not conveying his words, especially the obscene ones,

accurately. The girl blushed, Genet resumed, same thing again until they too arrived at a compromise.

As far I can recall, the poetry classes continued unfazed by such events. Guest poets I invited to read in the evening after my classes included Ron Padgett and Jim Carroll. The students in Stiles were good company but not as interested in poetry as the Branford ones. I don't think any of them became poets, though one of them seems to have become a critic. I remember asking during the first class which poets they had been reading, and the consensus was Richard Brautigan.

Poets in the Schools

Poets in the Schools (PITS), Teachers & Writers Collaborative, and other such programs for teaching children to write poetry developed because it had become evident by the mid-sixties that teachers in the U.S. were incapable, through either inexperience or sheer embarrassment, of standing up before a classroom of students and discussing poetry, much less suggesting that the students write some of it. In New York, and perhaps everywhere else, Kenneth Koch was among the first to go into a public school and encourage children at any age to write poems. Kenneth famously developed a lot of techniques for doing this. He read great poetry aloud to them—by Shakespeare, William Blake, Arthur Rimbaud, William Carlos Williams, John Ashbery, and others—and then suggested ways that they could write, inspired by the poem they had just heard. He also developed "poetry ideas"—forms, themes, and other devices—to spark their imaginations. Because of Kenneth, teaching in the schools became a typical thing to do for poets across the country.

My first assignment with PITS was in 1968, at Benjamin Franklin High School, 260 Pleasant Avenue in East Harlem, a classroom of mostly Latino students. That was tough: the class was Remedial Reading and Writing, which meant that passing out poems for the students to read was unlikely, and so was asking them to write anything down on paper. I did a lot of writing on the blackboard and backtracked constantly to get conversation going. I played music, Jimi Hendrix's version of Bob Dylan's "All Along the Watchtower." Many of the students were half or fully asleep because they came to class more or less directly from night jobs. Some were above normal high-school age, struggling to catch up, to get their diplomas. One, who worked nights in a bar, came up at

Bill at a San Francisco Art Institute seminar, 1985

the end of class and said, "What about Helen?" "Helen of Troy?" I said. "Yeah,"
he said. It happened that he had been attending breakfast programs at the Black
Panthers headquarters, and had gotten some gist of the Homeric sagas there,
enough to stir his imagination.

To this day, even though I seldom get the opportunity, teaching little kids
to write poetry is my favorite form of teaching. When I was living in Bolinas, I
taught so regularly in the Bolinas-Stinson schools that I became known there as
"Mr. Poetry." (Nervous in my first session with fourth graders, I paced back and
forth in front of the class so much that a girl in the second row passed me a note
that read, "Please stop pacing—you're making me seasick!") I went on to teach
poetry and memoir writing (or a combination of both) to older people at the
Redwoods, a retirement community in Mill Valley, and later on came full circle
to holding workshops at the San Francisco Art Institute. I've found that the same
aptitudes, along with the same inhibitions, obtain at all levels. The poetry ideas I
communicate to college students and elders are the same for fourth graders.

2015

Frank Sinatra

Everybody who has a taste for Sinatra's singing—and the ones who don't have particularly good reasons—is forced to contend with the unhappy facts of his personality. An instance where the two are damagingly at odds is the recording of Sinatra and Count Basie at the Sands, on which the impeccable vocals have to wait out the singer's repellent interstitial remarks and one prolonged, even more insufferable monologue.

New Year's Eve 1962, I was staying with my mother in Cuernavaca at the house of Merle Oberon and her husband Bruno Pagliai. The house itself was rumored to have been built by Cortés's forces to serve as a women's prison. (It's across the street from the Palace of Cortés, with Diego Rivera's murals in homage to Emiliano Zapata.) New Year's party guests included plenty of Hollywood notables—besides Merle herself, there were Dana Wynter and Greg Bautzer, Bill and Edie Goetz, Irene Selznick, and the man himself, Frank Sinatra. "Come meet Frank," said Merle, leading me by the hand to where he stood in the middle of the patio. It was mercifully brief. She said my name, he extended his right hand to pat my left elbow and, before turning away, flicked me a one-liner: "Good luck to you, kid."

The next night Merle, Bruno, my mother, and I went to the home of a wealthy Mexican couple. On one dining-room wall was the portrait of a man with a large swathe of discoloration across the canvas at the level of the man's neck. Asked about it, the woman said it was her grandfather, an important landowner in the years before the revolution. "Zapata came to this house," she said, "and when he saw the portrait, he recognized my grandfather and slashed his image with a machete." What Emiliano would have made of Old Blue Eyes is anyone's guess.

2012

My Generation

I am almost certainly the only person who was at both the Woodstock Music
Festival in 1969 and Truman Capote's Black and White Masked Ball at the Plaza
Hotel in 1966. About the ball, which I attended as my mother's escort, I have little
recollection. I had a basic black domino and my mother a slightly more elabo-
rate white creation. A newspaper photograph shows us entering the ballroom
right behind Mia Farrow and Frank Sinatra. Otherwise, I recall watching Arthur
Schlesinger Jr. on the dance floor with Lauren Bacall and thinking the timing for
this whole event, billed as "the Party of the Century," was way off. The upshot
was, aside from Capote's hard work inviting every celebrity he could get his
hands on, very little of any interest happened.

Woodstock was something else. I went because John Giorno called up, said
there was a concert, and asked if I would I like to ride there, to White Lake, with
him in a friend's car. By the time we got there it was dark and Joan Baez was
warbling on about Joe Hill from the bandstand to a huge crowd. En route, I had
taken a healthy dose of Orange Sunshine acid, the orange-barrel variety com-
mon at the end of the sixties. John and I soon drifted apart. We didn't see each
other again until the festival was over and together we found a ride back to New
York. The rest of that first night is a blank. The next day was gorgeous, the hal-
lucinogen still thrumming, people and music performing in kind. In between, it

Bill, behind Frank Sinatra and Mia Farrow, at Capote's Black and White Ball, 1966

had rained. Then the mud—I recall threading my way through bodies lying on the slope stretching up and away from the stage and picturing myself as Tolstoy's Pierre among the wounded at Borodino, curious, detached, and not a little lost. Many years later, looking at a picture in the *New York Times,* I spotted myself in a cross section of the crowd: more solitary than the rest, eyes closed, head resting on one hand, listening hard, or so it seems, and smiling along with the music.

2013

Bill, *circled,* at Woodstock, 1969

The Phenomenology of Everyday Life

The Phenomenology of Everyday Life, the unbranded brand of impromptu activity, proto-YouTube, beginning around 1960, of documenting anything and everything, the more seemingly inconsequential the better, extended from a disposition toward collecting oddments (from baseball cards to bottle caps) gathered before, in the fifties, and likewise had a lot to do with recording devices. Somehow the record keepers have never gathered the strands—and no one yet knows the full import—of the sundry manifestations, in visual art, writing, and general culture, of this passion to look, listen, and record. Doubtless, drug culture played a part, the attention seduced by some active ingredient to rivet on any cosmic morsel happening to waft by. (A paradigm was William S. Burroughs's account of sitting in a room in Tangier for weeks on end, "staring at the toe of [his] foot.") Be that as it may, the baseline technology developed by the mid-sixties consisted of newly available hardware: the portable cassette recorder and the Sony Portapak joined the Gestetner mimeograph printer, Thermofax and Xerox photocopiers, the Super 8 movie camera, the Kodak Instamatic, and advanced versions of the Polaroid Land Camera.

Beginning around 1965, prosody often took on the look and sound of inventory; poems were lists. Lecterns at poetry readings were jammed with differently shaped plastic microphones; chitchat at the after-parties got summarily tape recorded, an open-mic ethic closely parallel to the one that resulted in Andy Warhol's *a: A Novel*. Brigid Polk lined the walls of her tiny room at the Hotel Thomas Jefferson floor-to-ceiling with cassette tapes of her life with others on the telephone. At the same time, Brigid was compiling theme books using ink pads to print from people's bodies, one of penises, another of scars, mine from scratching a chicken-pox sore included. One-of-a-kind or anyway limited-edition books using Xeroxed found images abounded, as did deadpan photographs of anything that looked photographable. Ed Ruscha's series of books of obvious imagery was the prototype. (As Ed must have intuited, with the photograph, the world in all its manifestations became photogenic.) Bernadette Mayer's *Memory* was nearly twelve hundred color snapshots and seven hours of taped narration, recording the incidentals of every day in the month of July 1971. The TV in Robert Rauschenberg's Lafayette Street studio was on all day every day, with the sound muted. All this ran parallel, and to some extent still does, to reality television (the Loud family in *An American Family,* filmed in 1971), cinema verité, and the official streams of video, performance, and conceptual art, but closer to home, more literally psychedelic, in the sense of increased alertness to average particulars.

Bolinas

Bolinas and San Francisco have in common their disappointing close-ups, ameliorated by distant views that take your breath away. For me, the sublimity of the coastal landscape—the excitement of living in the midst of it, at least—lasted nine years, after which I got tired of what Fairfield Porter called the "characterless" greenery, the dust, mud, and, when the rains come, the cabin fever of it all. Then, too, I gave up on the pretense, the struggle, of being, what Willem de Kooning would call "a country dumpling." I remember sitting in the East Hampton movie theater, watching John Carpenter's *The Fog*, filmed as it was in nearby Point Reyes, alongside Lynn and Chou-Chou, both of them homesick, but I, for my part, recoiling.

How Bolinas was in the seventies: some look back in horror, some in tears. Ted Berrigan's "Things to Do in Bolinas" begins, or maybe ends, with "Watch the natives suffer." Which is certainly a consideration, in retrospect. I myself can hardly bear to go there anymore, but for visiting Joanne Kyger and Donald Guravich and Chou-Chou and my granddaughters Lolo and Estella, all of whom persist (or else find themselves stuck) in what I still see as a parallel world like that of Brigadoon.

First impressions of Bolinas, the idyllic: young girls on horseback, dog running free on dirt roads, single mothers with baby strollers.

What Jim Carroll said after his first twenty hours in Bolinas: "It's too *white* here, man."

This nice little village has a way of reflecting the changes in America. There was the general back-to-the-land (or anyway exurban) zeitgeist. For those who are basically city people like myself, Bolinas, being only about forty-five minutes outside San Francisco, was perfect. (Today, they say, the new billionaire class of property owners finds it equally convenient.)

The Organization of the Petroleum Exporting Countries (OPEC), 1973, together with fallout from Vietnam, spelled the End of the Affluent Society, a.k.a. the American Empire. The end, too, of the era when people could be gloriously poor. The dog days of getting by on what funds one had or taking odd jobs were kaput. In Bolinas, you could do tree work, plumbing, carpentry, construction, gardening, surfboard design; be a short-order cook, waiter, bartender, auto mechanic, fisherman; or grow a tidy patch of marijuana for sale at a modest cost to friends. Without such skills, go figure. Some left town and went to Hollywood to get rich as screenwriters. The movies resurged in that decade, but none of our crowd made it. Well into the eighties, I tried to make do by teaching little kids to write poetry in the schools and doing some copyediting beside. Generally, it took until about 1985 for the scene to empty out.

But Bolinas stays unique, largely due to the water meter moratorium insti-
tuted in the seventies by the so-called hippie-fascist water board (Bolinas
Community Public Utilities District) with Lewis MacAdams, Peter Warshall,
and company in charge. (Even so, fighting off the Pacific Legal Foundation's
attempt to end the moratorium still costs the homeowners big tax payments on
the legal-fund bond.) Publishing in the seventies, including my small press, Big
Sky, as well as alternative spaces that hosted poetry events, benefited from lav-
ish funding from the NEA and the Coordinating Council of Literary Magazines,
the only drawback being that such funding encouraged higher-than-normal pro-
duction values and larger print runs (hence the closets full, for decades after, of
unsold copies).

Another phenomenon, key to the ethos (or chaos, as the case may be) was
the Poets Orchestra initiated by Tom Veitch and the multi-instrumentalist
Darrell DeVore and featuring Tom Clark, John Clark, David Meltzer, Bobbie
Louise Hawkins, Lewis MacAdams, me, and anyone else ready to join in. The
scheme was total unfettered improvisation on whatever instruments came to
hand. Thanks to Darrell, I had a C-melody saxophone, which I never learned to
play in any conventional fashion, but for which I had some instinctive affinity.
(I went about noodling on it before passing it on to another more musically adept
neighbor.) Beginning in 1971, with wall-of-sound performances at the Bolinas
Community Center and the swank Hansen-Fuller Gallery in San Francisco, gui-
tars were the primary standard instruments, but Darrell liked to invent new ones
out of unusual materials, like kelp. Joanne Kyger remembers how Madga Cregg
"played" a refrigerator rack by repeatedly raising it high, then slamming it on the
floor "with tremendous gusto."

Poets Orchestra, 1971

Three Visions of Dame Kind

As the Cecil Taylor/Steve Lacy album spins, Lynn asks the title of the cut. "Things Ain't What They Used to Be," I say and sit down next to her on the settee. Thoughts in my head have turned to solid rock, through which another part of my mind is drilling, drilling. Eyes closed, teeth clenched; bits, flakes, chunks, shards of "thought" fly off in all directions as the drill whirls deeper. After several minutes of this, snapping out of it, I look at Lynn beside me and tell her, "You are Sparkle Plenty."

Sitting with Lewis Warsh on Francisco Mesa, in view of the Bolinas lagoon and Mount Tamalpais ridge. Across the estuary, the ridge jiggles wildly, enormous folds of flesh expand and contract—a sprawling Bacchus. The whole of the external world, so to speak, pulsating. But inside, at the exact center of my skull, a tiny pea bursts open, flooding downward, its warm wash the node of all Beauty, whereupon I am "reduced to tears."

A few years earlier, 1969, in the dark, lying on the floor of the Connecticut shoreline home of one of my Yale students, watching images of the history of modern art—Piet Mondrian, Fernand Léger, Pablo Picasso, Arshile Gorky, Henri Matisse, Joan Miró, et alia—a mnemonic slide show projected mentally onto her living-room wall. Afterward, the nice young girl and I go for a walk along the rocks under a bright blue moon.

2013

Las Vegas

Connie and I went to Las Vegas to see what was there. We planned a three-day trip. By the end of the first day, each of us had exhausted our self-imposed fifty-dollar limit on gambling. We had played the slots mostly and watched the action at the high-rolling tables, which left, for day two, the architectural amusements of Caesars Palace, New York-New York, and whatever else of note was left on the Strip. Europeans go crazy over this nutcase sublime. We thought of going to see Siegfried and Roy in their white-tigers act at the Mirage—somebody's steal at ninety dollars a pop—but learned that one tiger had mauled the other, who was convalescing, so no show that night. By mid-afternoon, stepping out of New York-New York, we had had it. Typically, whenever at a loss for what's next, we consider going to the movies. Connie checked the local listings, we asked a doorman to call a cab, and, once it arrived, told the driver the name of a theater near the edge of town. About two minutes en route, the driver called in to his supervisor: "Guess where my fare's going—" he chortled, "the movies!" We saw *The Portrait of a Lady* with Nicole Kidman then came out and called another cab to take us back to our hotel. "What'd you see?" the second cabbie asked. "*Portrait of a Lady*," I said. Obviously this drew a blank. "Nicole Kidman," I put in. "Oh, yeah," the cabbie brightened, "I was married to a woman looked like her once—but she had a better body." The third morning the Strip looked point-less. After dipping conscientiously into the Liberace Museum, we rented a white car and drove to Red Rock Canyon, the sublimity of which blew all of outsized Vegas away.

2001

With Landis Everson

Ben Mazer had arranged for Landis Everson and me to read together in the Woodberry Poetry Room at Harvard, but when I arrived in Cambridge, Ben told me that Landis, whom I had never met, had had a stroke that morning and was at the Massachusetts General Hospital and clearly would be in no shape to read that evening. When Ben and I got to Landis's hospital room, Landis was obviously very disoriented but managed to greet me cordially, in fact, with a surprisingly large measure of warmth. I gave him the book I had brought to give him on the occasion of our reading: *Fugue State*. Landis held the book before him for a minute or so, looking in silence at the front cover. Then he slowly looked up at me and said very deliberately, "Hugo Flake."

Out in the sunlit hallway, Ben and I stood while Landis sat in his wheelchair, looking around him, obviously puzzled by the hospital environment. At last, when a doctor and nurse stopped to ask him a question, Landis gathered his strength to ask them the question that probably had occurred to him many times over the past few hours: "Are all of you in some kind of play?"

That evening Ben substituted, leading off to read Landis's poems beautifully and with great intensity. I followed, very aware of the surroundings, the famous Poetry Room at Harvard, with its furniture, including the lectern I was standing at, designed by the great Finnish architect Alvar Aalto. At the end, our host Don Share told me that indeed it had fallen to me, by coincidence or not, to be the last reader in this room. The Poetry Room was slated to vacate its old quarters and the fate of the Aalto array of furniture was uncertain at best. "You are the last," Don Share said. "The first was T. S. Eliot."

2013

Ageism

There's always a pretty girl in the plot,
but nowadays she calls me "Sir."

Aging has its twists—consecutive wrinkles in space-time, so to speak. In youth, the differences can be sharp: between twelve and sixteen, big; between sixteen and twenty, even bigger. "Now you're a teenager," said Sheila Knapp, a few years older in her one-piece, yellow swimsuit, in the sand trap during ring-a-levio on the night of my thirteenth birthday, as she gave me my first big kiss.

As time goes by, the differences tend to even out. At forty, memories that have been inaccessible for decades come flooding into consciousness. After fifty-five, everyone still standing "of a certain age" seems to be in the same boat.

2016

Love Without Fear

When do we get to write our sexoirs?

—ANNE WALDMAN

In my teens and twenties, sex to me was what now is called "open": I was girl crazy and sex crazed. I had started early, and, as in most things when I was very young, I took on more than I knew what to do with. Protective in my uncertainty about what might happen next, I affected nonchalance. Certainly there were cruelties on my part, forgivable only if inadvertent. (For penance, as it were, I've read and reread Jack Kerouac's record of his own youthful misadventure, *Maggie Cassidy*.) If my affection waned or didn't develop, or another attraction intervened, I would disappear without a word. But the main fact, in no way tantamount to an excuse, was that I was more naive than I let on to myself or anyone else. Wildly sophisticated and just as naive, a near-lethal combination. There was, for instance, a serious gap in my understanding of female anatomy—the clitoris (or pleasure point, so to speak), on the topic of which I must have missed a passage or two in *Love Without Fear*, the sex manual people my age read in adolescence. This ignorance persisted long enough for a number of embarrassing episodes, including one particularly laughable dalliance, fumbling around nervously in bed with T. L., the well-known movie and TV actress, far out of my league.

Although from time to time obsessively attached to one person, especially in the early sixties, I was always ready for more; in fact, I was really a hunter, on the prowl, or else just available, in the sense that if someone wanted to, I was usually game. This continued into my thirties, after I moved to Bolinas, but then, in 1972, I began living with Lynn (age thirty-three), and we married three years later, had Moses, and stayed monogamous until things began to break apart in the early nineties. By then I was in my fifties, in love with Connie, and disinclined to get involved, even casually, with anyone else.

I have dreams but no outlandish fantasies. I was fairly carefree during my New School teaching years. But as a teacher at the Art Institute I established a firm rule not to "mess around" with any students. I saw the troubles some of my colleagues and their students tumbled into as their relationships escalated, and I wanted no part of such duress. Plus, I had learned the grown-up pleasures of lust for lust's sake, and the influx of appetition, to be alive with that: enjoy, and hold it right there.

Feeling that sexual momentum, my eyes go everywhere in the street, in a room, but it is just that, or else "the purring of the invisible antennae" that Pound wrote of. (Although the mixed metaphor—kitten plus bug equals what?—is weird.) Flirtation never fails—"calculated production of uncertainty," as Adam

Phillips calls it. But there is a dangerous logic—a syllogistic "If *a* says *x*, then *b* will follow with *y*"—by which uncertainty is replaced with a kind of spiraling obedience to the script of which neither party has advance notice. By saying the next thing, as if it were required of all concerned, "falling in love" happens, and both of you are set to moving in a maelstrom or on some slope, tumbling presumably to some conclusion. What comes next, the perfect marriage or a horror show?

I am monogamous, "closed," because why not? At seventy-five, I am nobody's sex machine, though I love what's left of that to do. For years I've puzzled over, even when understanding its basic premise, that passage in William Carlos Williams's original prologue to *Kora in Hell* that begins, "I have discovered that the thrill of first love passes!" and then the assertion, "I have been reasonably frank about my erotics with my wife," whereupon the good doctor more or less concludes, "I have discovered by scrupulous attention to this detail and by certain allied experiments that we can continue from time to time to elaborate relationships quite equal in quality, if not greatly superior, to that surrounding our wedding." It seems that what Williams and I both had to confront was our own and other people's capacity for duplicitousness, and what Freud called the "polymorphously perverse." (I remember the fury of the professor of French literature at Columbia when I said yes to his asking, "Can one be in love with two people at the same time?")

Bill in Paris, 2011

To backtrack: a few years ago, I wrote a "kissing" poem about how the movies taught monogamous love as an ideal life story, seconded by my parents' almost unbelievable (I saw and still believe it, nonetheless) devotion to each other. So as a little kid I daydreamed and agonized over the girl I would love, who would love me totally and marry me "happily ever after." All that was mixed up with religion, too, my conversations with divine being, which were mostly demands for gratification.

However, had I gotten any of the wishes I had then, like about my high-school sweetheart or about the married woman I was crazy about when I was in my twenties, it would have been disastrous. Sharp as Cupid's arrow is made to be and deep as it goes, its truth (the mark) can be absolutely separate, on another plane, from the truth of who one is also made to live with, without going berserk or being continually at odds. Perhaps this is why, looking back on my early days, the best was what is now called "friends with benefits," unencumbered by any demands but the occasional mutual pleasure.

Friends are loveable in ways that lovers aren't but that a wife can be, though that can take some time. Connie and I were friends—just friends—for a long time before loving. Maybe that was the key. But anyway, it seems miraculous how attuned we are and continue to be.

I know the difference in me came in my thirties, with waking up from the dream of love as being a matter of getting carried away by my imagination of another person as a love object to realize that love is something you go out and do vis-à-vis someone for real, shaping the space between, consciously, though happily not always in control. There is fate, and the occasional shock of appreciating one another in turn for exactly who each of us feels the other to be.

2015

Identity: Kevin Ramsay Interviews Bill Berkson

As you're growing up, you keep finding yourself cast in a certain way, maybe even told who you are, as in Gertrude Stein's "I am I because my little dog knows me." My parents told me who I was, my teachers, my schoolmates. I was a child who wanted to find my place. There was the question looming of wanting to belong to something. When I was at Trinity School, there were sports, and there were the other boys, including the older ones I tried, however comically, to emulate, and soon enough, earlier than most of my male friends, there were girls.

My leaving Trinity was an identity crisis. I remember discussing it with a couple of friends there and the feeling we all felt: that having been at Trinity for ten years, we so identified with the school that you could say we owned the place. I wanted a change of scene.

I went to Lawrenceville School, the famous boarding school in New Jersey. I was crazy about a particular girl who had been going out with these older guys who went there. She made it seem so glamorous, and of course I was jealous. I thought that going there would give me more power. Maybe it did, but it also threw me, because the girl was going to Dalton—suddenly, she was still in New York, and I wasn't. I realized that there is really a lot of desperation in finding a place to be.

I had had my phase of thinking I could be a crooner like Frank Sinatra, a basketball player like George Mikan or Marques Haynes. There were movie star fantasies. All that stuff affected me. You get a certain awareness of who you are by what you're not or how the world impinges upon you. Your limitations define you, to a large extent.

People of my generation were having a very difficult time finding anything worth doing. Eventually finding that I could write and that writing poetry was a mode of Being, all the other propositions, like going into business, constituted Nothingness.

There was a degree of identity in being a poet, or at least in being a writer. I know now that if the poems aren't there, in me, so speak, to be written, I'm prepared to say, well, that's something I did, but I'm not doing that now. Insofar as that goes, I guess I don't rely on it as an identity. I never have called myself an art critic, either.

If I'm writing a poem I'm writing a poem, and whatever comes into that comes into that, and what may come out of that is something—it has a voice, or is readable and has a tone in it—but I don't usually think of it as me. I think of it as some sort of presence that comes through the words as they're strung together. The poem ends up with its own identity, in that way, and its own language. Some

people will say it's me talking, but that doesn't interest me too much. The sense of identity as style is similar to identity as person.

The poem itself may have this multiplicity: asked by a French translator if I intended a certain amount of polysemy (multiple meanings) in a particular poem, I answered that the poem should have as much polysemy as it can bear.

In terms of style in writing and that kind of identity, I worried for a long time that I didn't have any. My impulses were multiple. But somehow or other I shrugged off my worries and said, well, there's nothing I can do about it. I decided to go with what I had. But what did I have? Good luck or some sort of instinct. I'm as surprised as anybody else by what I might do next, so I just sort of follow it. I liken it to the times when I'm driving a car, and either I have or somebody else has made a momentary mistake, like driving in the wrong lane. The truck is coming right at me, I don't have time to think, and a flick of the wrist turns the wheel just enough, just right, to make that correction. I've had that happen enough times, and not just while driving, where I think, O.K., either it's just my own reflexes, or I've got a guardian angel. Somehow or other, just let me trust it.

I'm the last to know what I add up to as a person. There are people who invent characters for themselves—fixed characters—and then they determine to be that person. I can't do that. Other people tell me they see me certain ways, or tell me they read my poems in particular ways, and so they see something, allowing for the fact that they, too, recognize that there's this diversity if not total scatter. Then, when I put my book *Portrait and Dream* together, I had fifty years of work to look through and decide what was in and what was out. I began to see these, I don't know if they would be themes, but I saw things that seemed characteristic or consistent, and that surprised me, that I did have continuities in my work.

In the poem called "The Position," I'm allowing the sense of self a lot of play. I contain multitudes, as Walt Whitman would say, and this poem is meant to contain some of those multitudes. Does "tending to go to all places" apply to me, Bill Berkson? I can throw myself there. "I don't really have to work for a living" is largely true and refers to the safety net of middle-class America. Some feel they have to escape their middle-class identity, and I'm sure I felt that way at a certain point too.

The man-about-town was what I was in my youth. The town was New York, and, in a certain way, that never stopped being *the* town. "Family man" is what I was right then, when I wrote this poem, in California. My son had just been born. I was doing this "family living" thing, and so were most of the people around me in Bolinas, the little town I was in at the time. The "clairvoyant" is the poet, a seer, somebody who sees through all, and sees all three persons as one. It's a kind of performance, being that person, those persons, but who's doing it is always open to question.

EJ's Luncheonette, New York, September 17, 2012
Trinity Per Saecula, 2012–13

Polyphony: All in One

When he's painted himself out of it / De Kooning says his picture's finished
—EDWIN DENBY

The most beautiful dream is that moment in *Purgatorio* when first Virgil rejoins the four shades of ancient poets "on the enamelled green," and after a while they invite Dante in, "so that I was sixth amid so much wisdom"—the gist being there's room for more.

The teachers are always there, in mind, in acquired gestures, voice, things casually said that become markers. Older men who keep teaching me new things are Kenneth Koch, Alex Katz, and Frank O'Hara, two of whom are dead, but I hear them constantly.

Did I learn more from them than from the outnumbering ones my own age, or now, from much younger poets and artists?

A teacher is not necessarily a hero or role model. "Always meet your heroes," Robert Creeley once said. That way, you see that everyone is in the same boat.

I don't feel that art or personality is a contest about exclusivity. Maneuvering for identity in art seems to make artists ill at ease with themselves and others.

Style, at best, is something you can't help. Most people think it's an achievement, but it mostly comes from flaws and limitations. People borrow other people's glitches.

Funny, I'm hearing Creeley again here, whom I resisted mightily at first because he made such a struggle about his own continuity—"trying to be in my life," as I once heard him say. But he had this joke: "*X* says, Who am I? and a voice comes back, Who's asking?" like out of one of those Magic 8-Ball toys.

Or the old, oft-quoted story—was it John Cage or Philip Guston who told it?— about how as you work, the room is full of other artists, but as you keep at it, one by one they all leave, and then the work is you. Nonsense—nobody leaves. You are just the same old material for the work, and perhaps at a certain point the work begins to talk back.

I have an unfixed, relatively unstable character, or anyway my poetry seems to reflect that.

As far as personality is concerned, for a long time I was confused. Then, at a certain point, I decided to go with what I had.

Pasternak's *Doctor Zhivago* told us something about polyphony: "You in others—this is your soul." I think the other way around is true, too, to some extent.

I like my poems to have good company.

for Jarrett Earnest
The Brooklyn Rail, *2015*

Bill at the Kröller-Müller Museum and Sculpture Garden in Otterlo, the Netherlands, 2005

Some Books

Shining Leaves

The poems in *Shining Leaves* I wrote entirely at Yaddo, the wondrous, disastrous summer of 1968. Two months or so in a room "haunted" for writing: I could do nothing else; every time I began to read or just look out the window, the Poetry Fiend would grab and catapult me to the big desk in the middle of the room. Who could complain? But eventually it would get to be too much, and I'd leave for the Saratoga Performing Arts Center or the Broadway Bar or the Chicken Shack or to see a new friend at Skidmore. Others at Yaddo that season were William Gass, Joy Williams, and Carl Rakosi, who had just returned to poetry after many years as a social psychologist in Minneapolis. Allen Ginsberg was in and out of Cherry Valley that summer. When I returned from visiting him, Elizabeth Ames, the venerable Yaddo abbess, would ask "What news of the revolution?" intrigued by the dire happenings at the Chicago Democratic National Convention, and so on. On the first visit, I brought Allen and Peter a sunflower. Allen asked: "What would Frank [O'Hara] think of the revolution?" I replied: "He would consider Mark Rudd awfully cute." Allen played the harmonium and sang his settings of William Blake. There is little overt reference in the poems to such events, though undoubtedly they are there. The title struck me one night out of nowhere sitting in Anne Waldman and Lewis Warsh's apartment on St. Mark's Place. In the cover drawing, Alex Katz got a good likeness for the time, or so I hypothesize.

The World of Leon

The Leon poems were written collaboratively from 1968 through 1970 in New York and Port Jefferson, Long Island. *The World of Leon* (*Big Sky* no. 7, with an introduction by Donald Hall) contains all of them. "Participants" is a good word for those involved in these collaborations. The participants included Larry Fagin, Ron Padgett, Michael Brownstein, me, and possibly Anne Waldman, Joan Inglis (Fagin), Jim Carroll, and others. The series in order of appearance: *Pictures of Leon, Eternal Quest* (anonymous, but just Padgett and Fagin), *Portable Leon, More Pictures of Leon* (cover by Joe Brainard), and *The World of Leon* (*Big Sky* no. 7). All but the last were published by Larry Fagin. All the material was published anonymously, except for "Waves of Particles" by Padgett, Brownstein, and me, and "Variations on a Theme by William Carlos Williams" by Padgett, Fagin, and me.

As to the process of "Leon" creation, Michael Brownstein held the pad on which "Waves of Particles" was composed; Michael put down lines as he heard them suggested by Ron and me and perhaps others who were present that time in my mother's house in Port Jefferson, 1968 or 1969. "The Secret of Jane Bowles"

was written during the same session, but in that case the pad was passed around from person to person. (I think Anne Waldman was there, Pat Padgett, and maybe some others.) "I Feel Free" is another written at Port Jeff, the house also known as "Brenda" (so named by Ron after the hurricane that passed through the weekend of the first two mentioned collaborations), though I am not sure of the participants. Some, as I recall, were written as solo performances: "If things are," for instance, by Michael, and others by Ron alone. Beside "Waves of Particles," the ones I know I participated in are: "Variations on a Theme by William Carlos Williams," "The Saint Takes a Holiday," "Leon's Tune," "The Banana Boat," "Beautiful Music," "The Funny Typewriter," "A Pardonable Crime," "The Infinity of Always," and "Requiem for a Paperweight."

Recent Visitors

I always liked the title of that section at the back of *Poetry: A Magazine of Verse*. When the section began I have no idea, but I think of it as Henry Rago's idea to list the names of people who had visited the magazine offices over the past month or so. I decided to take and use "recent visitors" first as the working title for a book-in-process, the one that Angel Hair published eventually in 1973; in the interim, I took it for the name of Joe Brainard's and my comic, starring the comic strip characters Nancy and Henry, done as a souvenir handout for our San Francisco reading when Joe visited in 1971. The book's title was meant to refer somewhat lightly to the poems themselves as "visitors" and, as the collection was of, as they say, recent work, the whole phrase made a good fit.

Ants

Greg Irons was living on one of the calles in Stinson Beach, around the lagoon from Bolinas. I met him through Tom Veitch, with whom he primarily collaborated in those years, or else with Lewis Warsh, who lived close by in Stinson for a time. Greg did the cover for the first issue of *Big Sky*, which was fitting because I had wanted to do the whole issue in a comic-book format printed by Rip Off Press (which was not to be because the run was too small for Rip Off's web press). Greg and Tom did a mock horror strip, too, for the magazine *The Creature from the Bolinas Lagoon*. In any case, "Ants" I wrote on my own. Of how it got to Greg and then to Wesley Tanner, who published it, I haven't a clue, but Wesley, whom I saw not long ago in Detroit, probably does. When I saw him, he slipped me a pristine copy of that same beautiful little book.

Lush Life

Sometime in 1982, Kenward Elmslie wrote to ask to see the poems I had been writing lately. I sent him just about everything I had, not a book manuscript,

just a stack of poems. A few months later as we were sitting at a table at his place on Greenwich Avenue, Kenward pushed a sheet of paper across to me and said, "What would you think of this?" It was a table of contents. Kenward had carefully edited—indeed, had fashioned the makings of a book—from what I had sent. It's still the best editing job anyone has done for my poetry. I called the book *Lush Life* after the Billy Strayhorn song and something a New York friend had said about the "lushness" of Bolinas. Kenward published it as a Z Press book with nicely hand-set type in a square format, with a cover design by Joe Brainard. Couldn't have been better. On the front cover was Lynn's photograph of me, the "Jolly Green Giant" by dint of Joe's verdant overlay, in front of the generous spread of our backyard willow tree.

Three Collaborations

Gloria is a book that was made to order to be printed in glorious hand-set type by Andrew Hoyem's Arion Press: Andrew invited me to submit a manuscript, and once he had that in hand, after agreeing that Alex Katz was the man for the job, Andrew invited Alex to do a set of prints to accompany the poems. Although very nice about the poems, Alex left the arrangement of the prints—which print to go with which poem—up for grabs. Andrew made a mock-up for me to see; I suggested switching two matchups, and the thing went to press, very elegant, super deluxe.

The book called *BILL* emerged from a time warp. The words and title were taken from a juvenile detective novel Tom Veitch gave me around 1980, Astrid Lindgren's *Bill Bergson, Master Detective*. Just flipping through this illustrated kids' book immediately occasioned an emergency, and what might be called the editorial imagination went to work. Having typed a sequence of short paragraphs and stray phrases at the bottoms of unusually thin sheets of 8½" × 11" stationery, I set the twenty or so pages aside and thought no more about them. Many years later, in 2005, I came across the typescript, which, it occurred to me, might arrive at another kind of completion if the areas left blank on the sheets were filled by drawings. Mac McGinnes, who had keyed *BILL* into a computer file, suggested that Colter Jacobsen, an artist Mac and I both admired, would be the perfect choice of someone to supply the images. Colter agreed, and *BILL* eventually reemerged in its present splendor, with Colter's drawings, many of them from photographs on old postcards and in the Jacobsen family archives, exquisitely setting their own timeline in relation to the spotty narrative sequence below.

How different it is when the handoff is just down the street and the artist's part is a unilateral positioning of image in response to text. Over a year or so, taking a combine of poetry and prose worked up from a computer-desktop notebook, the San Francisco artist Léonie Guyer set her delicate glyphs to the parts

that most appealed to her of this extended work called *Not an Exit*. Like *Gloria*, the book, done by Marie Dern at Jungle Garden Press, is printed in letterpress, but otherwise it's entirely handmade—handmade paper, hand-cranked press, hand-bound, in an even more limited run. Contrariwise, it's a sign of the times that although Léonie lives about ten minutes away from me by car, most of our discussions of this project occurred by email.

After seeing Léonie's and my book, John Zurier proposed that we do something together. I said yes, nice, but who is to publish it? But then I gave him a set of sixteen poems with the title *Repeat After Me*, and he came to my house one day soon after that with a portfolio of the same number of watercolors to match. He had some ideas about how the images should interact with the poems. We spread poems and watercolors out on the dining table, discussed and made a few changes to the order he had devised. John went away and within a month or so showed me the final order, to which I agreed. John offered the book to his New York dealer, but the dealer wasn't interested. I figured it was John's idea and up to him to find a publisher. Eventually, he showed it to his San Francisco gallerist, Paule Anglim, who is a good friend of mine, too, and who loves poetry. I never thought she would want to publish a book of poems—but there it is; she did it. Generous as ever, she gave away practically the whole edition of five hundred copies as gifts to museum people and artist friends.

Memory Snippets

Navy-blue coat, leggings, earmuffs—riding my tricycle like Genghis Khan astride his mount.

Kindergarten was at the Church of the Heavenly Rest, three blocks up from 1060 Fifth Avenue, where we lived. Later on, I played basketball there in the basement gym and stoopball with Mason Hicks and Bill Scully, bouncing a pink Spaldeen off the steps and ledges on the Ninetieth-Street side. Among young communicants the place was wittily nicknamed the "Church of Celestial Slumber." It's a beautiful building, actually, built in 1929 (the same year as 1060) in an odd combination of neo-Gothic and art deco and with arts and crafts stained-glass windows by the great English glassworks Whitefriars. I recently learned that the ashes of Gloria Swanson are interred there, along with those of Lillian and Dorothy Gish, and that it was also the venue for the funeral of Chester A. Arthur. This jibes with piquant memories of trying to see through the little window of the door marked "The Crypt," opposite the smelly locker room. Inside you could barely make out the flickers of the eternal flame.

When music came with stories: Prokofiev's *Peter and the Wolf, Tubby the Tuba, The Jungle Book* (with Sabu Dastagir as Mowgli). A little later, recordings of dramas, mostly movie soundtracks like the soliloquies from Laurence Olivier's *Hamlet,* with overdramatic orchestrations.

At Rumpelmayer's restaurant in the Hotel St. Moritz on Central Park South, the amazement of seeing in person the bellhop, the uniformed, diminutive Johnny Roventini, whose "Call for Phil-lip Mor-ris" decorated cigarette ads on radio and TV.

School lunches were creamed chipped beef on toast (often called, despite that I loved it, "shit on a shingle"), endless mashed potatoes, Mello-Rolls. In a tone of blatant disgust, a boy asked the teacher at the head of the table, "What's that *you're* eating?" The teacher had the student put his hand on the lunch table then whacked his knuckles with the back of the knife blade. Supper at home, on the other hand, on nights when my parents went out, consisted of clear or jellied consommé madrilène topped with sour cream, creamed spinach, and lamb chops, then Jell-O or tapioca with something or other on TV.

One afternoon in 1948, during baseball practice on the yard behind Trinity known as "the Dust Bowl," I noticed for the first time the American flag on a tall pole at the girls' school across Ninety-Second Street displayed at half-mast.

Somehow the news went around that the secretary of defense, James Forrestal, had committed suicide by jumping out a hospital window.

One school punishment I'll never forget: cleaning gum spots off two flights of marble stairs with my fellow miscreant Billy Rapp.

Among my father's more inexcusable sayings: "If he was smarter, he wouldn't be an elevator man."

The sneaking suspicion that everybody else knows what I'm thinking. Not God, but the people around me. And that further, everyone can do this, read other people's minds, if they know where to go, how to throw the switch, as it were, in their own.

Meanwhile, not being "in on the secret" is scary. Who knows if I ever got over it?

"Craig"—my middle name, and the surname of various forebears going back to, as my mother always liked to imagine, the Irish kings—carried the meaning of "one who lives near a precipitous rock."

Caribbean impressions, 1947: It must have been Easter vacation. I flew with my parents first to Cuba for a day, then Jamaica, so different from going to Florida or Mexico. Of Cuba, generally I recall only the big green leaves on hillsides as we drove on the outskirts, and of both Havana and Montego Bay, the deep blue-black skin of people everywhere. Apparently, unattended for my first outing on the beach at Casa Bianca in Montego Bay, I acquired a fierce, blistering sunburn and spent most of the remainder of the trip alone in my dark bungalow bedroom. There is home-movie footage of this trip. My father was an excellent cameraman. A series of particularly striking shots show a Jamaican boatman singing as he rows his boat then diving and surfacing. Later, from my father's dispatches on the state of Caribbean affairs, I learned that this boatman was a local hero, Luthan "Broadway Bill" Thompson, the unofficial mayor of Montego Bay.

1949: I was in St. Petersburg, Florida, for spring training with the Yankees, accompanied by my mother's secretary, Kay Salsano. A photograph now lost showed me on the bench—batboy for a day—with Casey Stengel, Yogi Berra, Bill Dickey, and my guide Hugh Gaddis, sports reporter for the *New York Journal-American*. Thrill of a lifetime. (Which is to say, after thrills comes the lifetime.)

I learned to "lead with a strong right arm" in Miss Bloss's dancing school, classes held in a small ballroom at the Plaza. I wore a navy-blue suit and white gloves,

doing the regimental box step with girls in black patent leather shoes, velvet dresses, and the occasional mystery crinolines beneath.

My favorite Christmas vacation involved driving with my parents down the east coast of Florida to Key West and then back up the west as far as Tampa. This must have been 1948, winter of my ninth year. Highlights included stopping at the prison in Saint Augustine where Geronimo's band of Apaches were shipped after their capture in New Mexico. (Geronimo himself was soon transferred to Fort Pickens in Pensacola.) After the Everglades, a visit to Silver Springs with its glass-bottom boat and a sad, dilapidated Seminole village where, as we crossed a little wooden bridge to get back in the rental car, I jumped, horrified at my first sight of an actual rattlesnake. (As portrayed in B Westerns, snakes—especially rattlers—were terror incarnate.) Further along, in Miami, the big thrill was seeing Lena Horne perform at the Fontainebleau. But what I remember best is Key West and meeting a girl my age there, with whom I concocted a kind of dance drama of sheikh and slave girl played out daily across the Key West sands. As she was also from New York, our mini-romance continued after we both got home. Somehow she convinced me to join in the tap-dancing classes she was taking in a studio in the same theater where *The Ed Sullivan Show* was staged. There was also a vague intimation that attending these classes might lead to a spot on the show. I guess I was willing because of being dazzled by the feats performed by male dancers in the movies, like Fred Astaire, Gene Kelly, and Donald O'Connor, but the reality of the classes was that I was just thrown into a line of student dancers, some of them far more adept than I would ever be, and expected to pick up on the moves, from time step to paradiddle, on my own, with little or no pointers. Finally, one day I was told that I was wanted in the manager's office. Getting there, I found that my (so-to-speak) girlfriend had told the manager about our Arabian Nights beach routine, and the manager was intrigued enough about it to suggest that we audition on the spot. Intimacy betrayed. What had been a fairly innocent mutual ruse to kiss and touch one another a lot, as awkwardly as our ages demanded, was suddenly thrust into the spotlight, rudely exposed. In a moment straight out of old-time comedy, with a sense of deep betrayal, I looked at the girl, the manager, the door, through which I went, and never saw either of them again.

Getting out of a taxi at the corner of Madison and Seventy-Sixth Street for an ophthalmology appointment with Doctor Guy. A little old lady landed smack on the sidewalk at my feet. She was so little that I thought at first it was a child my own age (ten), except for the old-lady black of her dress. I found out she had had an asthma attack and fallen from six stories up in the medical building. For weeks I wondered why there was no mention of her in the newspapers.

Kissing games in closets. Talking to friends who had sisters about how their sisters looked when naked. Nudist magazines with all the interesting parts airbrushed out. *Playboy* and the Playmate of the Month foldout. When I was fourteen, an older boy known to his classmates as "the Count" pulled a packet of "rubbers" from his blazer pocket. "Don't tell the headmaster," he smirked.

How I became Jewish on fifties TV: Jack Benny, Eddie Cantor, Phil Silvers, Milton Berle, Sid Caesar, Groucho Marx, Red "Strange things are happening!" Buttons, George Burns—and even more so in the sixties with Lenny Bruce.

All forms of mathematics, or what today are called "computational skills," were hard for me, but in Mr. Ballentine's Plane Geometry class, I discovered how making receding parallel lines, if you extended them from any angle and connected the pencil strokes, would magically produce a box, a brick, or a room-like setting. Or in a rapture of perpendicularity, stack box over box, add several parallelograms worth of doorways, and—presto!—a city, ancient or modern as you like, ready for occupancy. Or so it seemed, from sixth grade onward. I found for those sovereign moments at my school desk a literal elbow room; indeed, the importance of learning to draw simple shapes now seems on a par with learning to dance or throwing a ball clean through a hoop.

At eighth-grade graduation, just as my name was called, Adam Dribben, a classmate in the same row, had an epileptic seizure. Teachers rushed to carry him out of the hall as I clambered over to get to the aisle, the stage, to get my diploma.

I wanted to have a place in something outside my own self-consciousness. I had no idea, so I followed others' leads. Grown-up conversation seemed easy, relations with boys my own age less so. For a while, my closest friends were the best friends of whoever was my girlfriend of the moment.

Westerns, gunfighter movies—ancient thrill phantasms of homeless chivalry and a weird carrier of instinctive rage. "The fastest gun in the West." I just wanted to kill my pillow or whatever it was. Revenge, get the bad guys. Such is Nature, tooth and claw, so to speak, but horrific how it will still flare up, unbidden. Road rage, Anne Waldman's "strangle Rumsfeld" poem, Ted Berrigan's "How'd you like a broken head, kid?" All that violence subsumed somewhat in a later talent for verbal assault.

Naming myself: On December 8, 1939, a little over four months after I was born, I was christened William Craig Berkson. The "William" came from my father's

father and the "Craig" from my mother's mother, Helen Houghton Craig, of whom I have no memories even though she may have visited from Iowa, where she lived until her death in 1942, at age eighty. As a small boy I was "Billy," a diminutive favored by my mother and her friends well into my adulthood. Once I began writing, the question loomed large of how to identify the author of what I had written. For a time, under the spell of T. S. Eliot, I tried "W. C." but soon discovered its British connotation—W.C. equals water closet or flush toilet—and went back to "William." It wasn't until I was in Kenneth Koch's New School workshop that I settled on "Bill," encouraged somewhat by the growing number of artists and writers—Jack, Frank, Larry, Ed, Al, and so on—who had started signing their works with the short form or nickname, the names they went by among friends. All the same, in those days few magazines or schools would recognize "Bill" as a suitable first name for a contributor or faculty member. Frustratingly, at *ARTnews, Arts,* and the New School, I was always "William Berkson" or, if signing a short review, "W. B." But the poetry magazines didn't mind one way or the other, so my first appearances in print, in *Big Table* and *Poetry: A Magazine of Verse,* carried the byline "Bill Berkson."

For a while, thoughts of sex and love and God became inextricable. In Episcopal liturgy, communion is spoken of as "an outward and visible sign of an inward and spiritual grace." Dancing, said Paul Groebli, the upper-form math teacher at Trinity, was "a vertical expression of a horizontal idea." Bonnie Kilstein was attracted to me, at first, because I was an Episcopalian (even though already lapsed), and she wanted to join the church. At Bob Glauber's party for those who had just been confirmed at Temple Emmanuel, she crossed the room and, without saying a word, sat down on my lap. When she got deeper into Christianity, and eventually into the Martin Luther King part of the civil rights movement, I thought (wrongly) that I had lost her. I became jealous of this "God."

In the fifties, a secret that Bonnie and I held dear was Mabel Mercer, listening to her sets with either Cy Walter or Cy Coleman on piano at the Ruban Bleu. Mabel had entered her later years and her musicality rested largely on her impeccable diction, that phrasing that had everybody from Billie Holiday to Frank Sinatra in thrall. Going to hear her at the Ruban Bleu became such a habit that I talked it up to my parents, who agreed to join us one night, thinking to introduce them to my big find. And so we went, and when the first set ended, Mabel Mercer surprised us—surprised Bonnie and me, that is—by making a beeline for our table. "Seymour Berkson!" she said and, wrapping her big arms around my father's neck, planted a kiss on his cheek. They had known each other in the old days, the twenties, at Bricktop's in Paris. The revelation was all mine.

I wrote my very early poems on yellow second sheets from my father's office at INS or on Eaton's onionskin Corrosable Bond, rolled into such protolaptop portables as the Hermes Rocket and Olivetti Lettera 32.

For a long time, from high school through my years at Brown, my politics were based on the shaky foundation of trying to reconcile the meanings of two books, Niccolò Machiavelli's *The Prince* and *Essays on Freedom and Power* by Lord Acton. At Brown, these were augmented by George Orwell's essay "Inside the Whale."

The head of the Music Corporation of America, Jules Stein, and his wife, Doris, were family friends. At parties at our house, Doris Stein would always get another woman to join her in the bathroom, to sit on the edge of the tub while Doris sat on the toilet and gossiped. At one party, it must have been 1955, I met Jules and Doris's daughter, Jean Stein. Jean was then an editor at the *Paris Review,* and having heard that I had begun to write, she kindly told me of "a young writer we've discovered, and we're printing a story by him in the next issue." The story was "The Mexican Girl" by Jack Kerouac.

Sharing a compartment on the Orient Express, Munich to Paris, 1958, with two French women, mother and daughter. The mother had been out shopping when the Gestapo came; now they have gone to see where the daughter was taken: Auschwitz, which has become a museum with a catalogue bound in black paper, which the daughter hands me. When I make to return it, she says, "You should have this." All presented as matter-of-factly as the numerals tattooed on the younger woman's arm, unfaded.

During my brief matriculation at Columbia from 1959 to 1960, I was lucky enough to be in Edward Le Comte's classes on seventeenth-century English literature and the history of England. At the end of almost every class session, there were ten minutes or so remaining for Le Comte to unlock his treasury of famous last words, the utterances of dying, mostly literary, notables. These he parceled out each time with fiendish glee, the surge of which was infectious; the class loved these moments. Le Comte had collected such anecdotes over many years and compiled them in at least one book, *Dictionary of Last Words,* which, along with others such as *A Dictionary of Puns in Milton's English Poetry* and *Milton and Sex,* is still available.

Ten Books That Changed the World

T. S. Eliot, *The Complete Poems and Plays: 1909–1950*
John Dos Passos, *1919*
Jack Kerouac, *The Subterraneans* and *Old Angel Midnight* in *Big Table*
Alfred North Whitehead, *Modes of Thought*
Charles Reznikoff, *Testimony: The United States, 1885–1915*
John Ashbery, *The Tennis Court Oath*
Frank O'Hara, *Meditations in an Emergency*
John Wieners, *The Hotel Wentley Poems*
Thomas Wyatt, *The Complete Poems*

Changes (After Alex Katz)

John Ford's *She Wore a Yellow Ribbon,* Benny Goodman's *Trio and Quartet Sessions,* R&B on Alan Freed's *Moondog* show, Mabel Mercer, Ida Lupino, Henry Miller, Elvis Presley's "Heartbreak Hotel," Thelonious Monk, Morton Feldman, Ornette Coleman, Willem de Kooning's landscape abstractions, William Carlos Williams's *Spring and All,* John Cage's *Fontana Mix,* Robert Rauschenberg, Jasper Johns, Allen Ginsberg, Gertrude Stein's *Four Saints in Three Acts* and *Stanzas in Meditation,* Wittgenstein's *Philosophical Investigations,* Otis Redding, Michelangelo Antonioni, Yasujirō Ozu, Stravinsky/Balanchine, Yvonne Rainer, Philip Guston, Alex Katz, Edwin Denby, Rudy Burckhardt, Blind Willie McTell, Bob Dylan 1967–70 and his *Blood on the Tracks,* Samuel Beckett's *Happy Days,* Eva Hesse, Philip Whalen, the Kinks, Neil Young, the Velvet Underground, Clark Coolidge, Bernadette Mayer, Chantal Akerman, Jackson Pollock's *One: Number 31, 1950,* Kuchar brothers' *Lust for Ecstasy,* Robert Smithson, John McPhee . . .

In 1961 I became the movie critic for *Kulchur,* the little magazine of criticism published by Lita Hornick. The other editors were Frank O'Hara (art), Joe LeSueur (theater), Amiri Baraka (music), and Gilbert Sorrentino (books). Editorial lunches at Lita and Morty Hornick's apartment on upper Park Avenue usually consisted of lobster salad. As the magazine, and with it, Lita's involvement with the New York art scene, got more elaborate, the Hornicks began to throw bigger and bigger parties. There would be big paintings by Alex Katz and others on the walls and musical accompaniment provided, on at least one occasion, by the drone improvisations of La Monte Young and Marian Zazeela. (About his portrait of Lita, Alex told me, "I couldn't see the face, so I painted the makeup.") At one of these affairs, I chided Ted Berrigan for calling Harold Rosenberg a dunce in his, Ted's, Art Chronicle in *Kulchur.* As I walked away, having said my piece, I overheard Linda O'Brien (Mrs. Peter Schjeldahl), who must have seen that something had been going on between Ted and me, say to Ted, "Not serious enough, eh?" as if she knew (she was right) that that would be my (and a few others') charge against him, though of course Ted was serious in the most serious way.

Harold Rosenberg may not have been a dunce, but he was the worst kind of intellectual bully. During my brief tenure as managing editor for *Location,* the magazine he and Tom Hess produced in the mid-sixties, Hess, Rosenberg, and I lunched at the Smorgasbord on West Fifty-Seventh Street to discuss the third issue, which, in fact, never appeared. Harold, a disappointed poet become a fifties version of what is now called a public intellectual, continually goaded me about what poets I would invite to contribute. "Charles Olson!" I ventured in

some desperation (I hardly knew Olson's work at the time). Rosenberg, who had worked with Olson during the forties in the Office of War Information, obviously had a case against him. "That fascist!" he roared.

They called me "Varsity Bill." That was at Lawrenceville, another case of acting out, above my station. There were right turns and wrong ones, and my sense of self swerved with them. At Brown, Steve Oberbeck accused me of "living the life of a poet without doing the work." (It turned out he opted for neither.) Many years later, at Naropa in 1978, Gregory Corso accurately assessed my progress to date. Gregory said: "You're into maintenance, still in the bud." If a bloom came, I would estimate its occurring two or three years later, with the poems that went into *Lush Life* (1983).

My roaring twenties, when "everything was possible and nothing made sense" (Stephen Sondheim, "Waiting for the Girls Upstairs").

Isaiah Berlin, lecturing on Alexander Herzen at Columbia in 1965, starts at noon, speaking in perfect sentences without notes, puts the period to the last one at one o'clock sharp. Something about Oxford-educated Slavs—Leo Steinberg was another—who contain this otherwise lost mode of civilization.

Virgil Thomson modeling the brocade vests he inherited from Gertrude Stein and calling everybody "baby" and "puss."

Nights in and out of my place at 107 East Tenth Street: normal hours were roughly noon to four or five in the morning, an open-door policy there and at Lewis Warsh and Anne Waldman's and George and Katie Schneemans', both on St. Mark's Place. Hours collaborating with George and others, or else poker games around the dining table. The back room at Max's Kansas City was open late, too, with the red laser hitting the rear wall. In the wee hours, by twos and threes, off to Ratner's for figs, nuts, and raisins.

Fall 1971, back in New York for the first time since moving to California, I stay in the Hotel Chelsea and write in a notebook "Strange to feel like a visitor here, which is what I am." I see Manhattan in *sections* as never before. Fiscally at risk, New York is now what Edwin Denby years earlier called a "sunk city," the people walking with their customary gestures but as if swimming through heavy gas.

Tom Luddy, when he was director of the Pacific Film Archive, used to bring movies out to Bolinas and show them at Tommy Goodwin's house on the

mesa, close to the cliffs. One day Tom showed up, accompanied by a familiar-looking Frenchman, at the house I was sharing with Joanne Kyger and others, the so-called Grand Hotel. The Frenchman was Jean-Pierre Léaud, star of many François Truffaut movies. The astonishing thing was that he immediately began making faces and poking his nose around the house exactly like Jean-Pierre Léaud as Antoine Doinel!

1973, Chou-Chou accompanies Lynn and me after a lengthy road trip to New York across the USA: Rock Springs, Davenport, Chicago, and so on. Having checked into the upstairs at Kenward Elmslie's on Greenwich Avenue, we take to the streets. On the other side of Seventh Avenue, Chou-Chou is stunned to see a very old lady, her first. Lynn and I discuss how Bolinas is devoid of such old people. Funny, too, that the only person in California that Edwin Denby asks about is Eleanor Antin, "the lady who takes photographs of her boots."

Philosophical aperçus of the early seventies:
Q: "What's the sound of one hand clapping, Chou-Chou?"
Chou-Chou: "Patty cake!"

In the long division of life, it's time over pleasure. (This "hedonist" maxim written by Larry Fagin and me in the back room of Max's Kansas City winter of 1969–70.)

Two notes:
You're at the edge of the crowd, trying to see what's happening to you, start moving through, toward the center, the event, and everyone turns, adjusts—you're the center. Everyone else is "distracted" by your presence.

 Only now, in my early thirties, do I realize the incomprehensible pain of living, the inevitability of death, and the endless necessity for total illumination, be that as it may.

January 16, 1991: Flying to Rome to be at the American Academy, on in-flight television we watch negotiations deteriorate between George Bush and Saddam Hussein. By the time we land in Rome the next morning, the Gulf War has begun.

 As a visiting artist-scholar at the Academy with Lynn and Moses during the winter of 1991, I discovered my true vocation: getting up in the morning to take a walk and get lost in the city. And the cardinal rule: when in Rome, if you see an open doorway, go through it—there's always something to see. A year later, Lynn and I return to Rome together and take train trips to Umbria and Tuscany, mainly to see again the work of Piero della Francesca, whose paintings have come to spell sublimity for me. The photograph Lynn took of me on the train

back from Perugia tells the tale: me gazing out at the Umbrian hillsides, a picture of unalloyed bliss.

It was in Bolinas, with time on my hands, that I learned to read different kinds of prose writings, novels mostly, that I had previously ignored: the then-new procedural and psychological mysteries of post-Simenon Europeans like Maj Sjöwall, Per Wahlöö, Nicolas Freeling, and Janwillem van de Wetering, as well as novels by Elmore Leonard, Larry McMurtry, Gabriel García Márquez, and the stories of John Cheever.

How my mother in her last year asked me for the first time ever to read her some of my poems, and at the end of one bedside reading said: "You take ordinary things and make something beautiful out of them." Another time, very late in the

American Academy in Rome, 2001

Bill and his mother, Eleanor, 1962

Bill and Eleanor,
circa 1962

getting-to-know-me game, imbued with all the futility she seemingly felt, in what seemed a despairing sense of ever understanding what I was about, said: "Well, you've had an interesting life."

Acer platanoides, Norway maple: tree on a patch of Central Park (the Arthur Ross Pinetum) near the Great Lawn, a favorite play spot of my childhood, where Moses and I unceremoniously and illegally—I in Eleanor's wheelchair, he pushing the handles this way and that—put (just about literally dumped) the mixture of Eleanor and Seymour's ashes in the dire winter of 2004.

Later, resplendent on an April day, 2009, with yellow-green petals, the trunk divided in two, stretching up and out against an achingly clear blue sky. Across the path, little girls in school uniforms screeched under cherry blossoms.

"The spirit leaves the body," said the ever flat-on Alex Katz when I told him how my mother's last breath was taken, then just went.

June 23, 2002: Leave Richard and Jane Wentworth's house, Oxford, in rental car. Decide not to go to Hay-on-Wye book fair as it is Sunday, no stalls will be open, but the general direction looks good. Gloucester (lunch, then Cathedral). Connie drives, I navigate, mind the hedgerows! We head west on A40 through Monmouth to Ross-on-Wye and turn on Wye Road, hitting a high curb near Coleford (more or less), and the torn tire goes flat. The turnout is directly beside the River Wye, a meadow, fishermen, some sheep promptly scared off by Connie's approach. Most pleasant idyll, sitting on the bank, waiting for the Triple A man to arrive, as an hour later he does, to change the tire. Onward to Chepstow, and en route, unawares, we run smack into Tintern Abbey!

At a conference on translation, Jacques Roubaud told of how at age sixty, the saddest thing imaginable happened to him: he lost his taste for chocolate. *Quelle horreur.* My sympathies, cher Jacques!

I recently discovered that my mother wrote love letters to my father for twenty years after he died. Most of them she left sealed. One says, "Bill, like us, believes in Romantic love." Another, undated, contains these words: "My Beloved, I have been thinking all day about the dignity and beauty which never deserted you for one instant even to your last soft breath. Through the years my darling I learned your faults as you learned mine—I quibbled over your demand for detail, I railed at you for wasting our time with ridiculous jealousy, I sulked if you sulked, and so on. But never once did I see you mean or ugly or fawning, dishonest, cowardly, or cruel. You never demeaned yourself, me, or our love, and you must know now that I never failed in the same standards." When, late in her life, people urged her

to write her memoirs of her work as a fashion publicist, she said, "I don't think of my life that way, I think of it as a love story."

One night in 2002, after lights out, I was practicing some diaphragmatic breathing before sleep when I became aware of the emergence of first Joe Brainard, then Ted Berrigan, and a short succession of other dead friends, each one ascending on my exhalation, starting at heart level on my left side (I was lying on my right) and rising to my face (whence the breath whooshes outward), whereupon each took on a bodily presence, not tangible but amazingly full in present character: that person was there, although not one could stay when another appeared, so no "party," no gathering like that. Later it seemed sensible that this phenomenon could be repeated at will. And yet the residual effect was that I felt those presences, especially Joe's, to have lingered about me, to inform my movements, so that calling upon them, for the time being anyway, seemed redundant.

The shock, shortly after my sixtieth birthday, of realizing that I had slipped over a line and had spent more than half my life in California, all the while maintaining my New York credentials. Nearly ten years later, I see Diane di Prima installed as San Francisco poet laureate. On the stage of the public library auditorium, she settles into a big armchair and begins reading poems and talking—tearfully, as she continues—about how the human face of the city she had come to in the sixties had deteriorated. Deep in cushions, she looks like a perkier Queen Victoria, but the voice is Brooklynese. Seeing her at the reception after, I remark, "The longer we stay out here, the more 'New York' we sound." That natural habitat we carry in and around us is so telling.

70 Years by George Schneeman and Bill, 2008

100 WOMEN

Page Neville
Gail Mitton
Betty Spiegel
Edith Schiffer
Bonnie Kilstein
Jan Smith
Sheila Knapp
Susan Kratka
Ellen Oppenheim
Cynthia O'Neal

Barbara Pollack
Kay Salsano
Saundra Nelson
Miss T
Barbara Berkson
Brooke Edzel
Ellen McAllister
Ellen Davidson
Susan Davidson
Joyce Ann Reed

Ronnie La Roche
Karen Kennerly
Joan Fagin
Peggy Katz
Maritza
Marie
Maxine Groffsky
Judy Garland
Connie Cassidy
Susan Burke

Patsy Southgate
Leonora Corbett
Marilyn Ezer
Tina Louise
Anne Waldman
Tessie Mitchell
Pamela Blank
Kitty Hawks
Mimsy Morgan
Bianca Perez de Macias

Ruth Kligman
D. D. Ryan
Pat Padgett
Dana Wynter
Maureen O'Hara Granville-Smith
Valentina Schlee
Amy Green
Stephanie Gordon
Morfa Mansi
Denise Minnelli

Eleanor Lambert Berkson
Grace Lambert
Leon Bing
Betsy Dworkin
Betsy Baker
Judi Wellons
Alix Lukin
Ann Troxell
Susan Uris
Elizabeth Rae

Ellie Munro Frankfurter
Helen Frankenthaler
Peggy Hitchcock
Maggie Paley
Pris Kaufman
Margo Margolis
Greta Garbo
Katie Schneeman
Diane di Prima
Joy Bang

Bernadette Mayer
Devereaux Carson
Janice Koch
Anita Pallenberg
Ruth Ford
Shelley Lustig
Ultra Violet
Phoebe MacAdams
Diane Sweeney
Bobbie Kapp

Lucy Barnett
Anne Feller
Carol Lindemann
Connie Ullman
Sue Blum
June Newton
Phyllis Newman
Niki de Saint Phalle
Françoise Sagan
Ada Katz

Clarice Rivers
Brigid Berlin
Merle Oberon
Jane Hyman
Ann Miller
Sondra Lee
Faith Solinger
Joanne Kyger
Rose Weil
Eve Rand

1972

JOURNAL SNIPPETS

NEW YORK 1961–70

1961–62

March 11, 1961

Went to Philip Guston's show at Janis. Guston: "I hope each one is a self-portrait. It really comes down to what you feel like, so the portrait isn't enough or what you see isn't. So you start destroying or elaborating, trying to get the whole story. Why should a shape which has had a lot of experience (a personality, so to speak) come out looking, pretending it's just been born, fresh as an acrobat appearing in the ring? It's got to be a little battered, a little used or scarred."

Larry Rivers: "Well, I guess I'm just young enough to ignore that."

Guston (later): "It's like the fable of some last judgment. You want to say this is what I've done, good and bad, do you get it? But the line is so long you'll never get to be judged anyway."

At Alex Katz's show at Stable Gallery, Lee Gatch introduced himself to Alex: "I'm Gatch!" (Old West Sam Bass gunman figure.) Then: "Stick with those landscapes and away from all those multiple Elizabeth Taylors." (Meaning the six Adas in one picture.) "You got a sense of form, too raw though . . ." This got very tiresome, like some dumb nightmare, and just the opposite of what I think.

"When something is good it distracts you from your problem." —Henri Michaux

May 4, 1961

Frank O'Hara was startled last night by a strange man who appeared at his door and asked for a drink. Then the man asked to use Frank's toilet. He apparently upset everyone in the apartment so much that Mario and Marc offered to stay all night to "protect" Frank and Joe in the event of the stranger's return. They did, and everyone stayed up talking until 8 a.m. I had lunch today with Frank at Larré's. He said he was very tied and irritated, mostly at the fact that he had allowed the man to cross the threshold in the first place.

Fireworks tonight on the Hudson.

"typist poems"

May 5, 1961

What can this journal be? Certainly it is not inspired by André Gide.

Thought, reasoning that is, without inspiration of talk is very difficult for me— and I want to stop depending on other people for impetus to thought or inspiration. I always feel like such a cheap imitation. My life.

"Leonardo said there are only two things worth painting—battle scenes and the Deluge. You may as well go the whole route." (Mike Goldberg)

Frank said, "Because you do not throw it away it is a poem!"

"strange island thinking after you"

Sunny today. I went to the zoo for lunch. Closed my eyes in the sun and enjoyed it.

(Undated) 1962
In a Bowery bar after Jane Romero's funeral, an old woman talking about Marilyn Monroe: "You wouldn't believe it, but she could sing too . . . She was such a doll!"

1966
July 7
A week ago, Helen Franc suggested that notes be kept on the preparations for the Pollock exhibition to be held at MOMA next March. She & FOH & I discussed the quarrels and controversies we'll be revitalizing: Peggy Guggenheim–Lee Pollock; Barney Newman (who claims his blood is literally "in" *Blue Poles*); the de Kooning–Pollock rivalry (between avatars & critics). . .

Yesterday at lunch with FOH & Helen Frankenthaler, Frank was visibly nervous, hands shook lifting his first negroni to his lips. In fact, he couldn't get it there at first & Helen shot me a look as we both thought "What?!" DTs perhaps, but later he said he always feels extreme nervousness before such important shows. He had met with Bill Lieberman who now insists F. be director of the whole show with Lieberman just supplying his half of the drawings. Frank said the promises he had made to Lieberman made him nervous because now he wasn't sure he could meet them.

The deadline for catalogue material is October 1. I will write the biographical outline & assist in research.

Frank says Ossorio has promised to lend not only *Lavender Mist* but 5 other paintings.

Willem de Kooning has agreed to a retrospective at the museum—with FOH directing—1968. "If *you* do it, O.K.!" is what the master said to Frank on the beach at East Hampton last weekend.

July 13
Lunch with Frank. He talked of Lee Pollock, that perhaps she & I should talk soon. I suggested that I not meet her until I have studied the Pollock background

material more thoroughly. He tells me she is pleased I am doing the biographical outline. Some attractive paintings by her at Marlborough in a summer show.

Frank still seems distracted. Noticed a slight tremble in one hand at lunch, at which notice he gave me a little, bemused side glance.

Helen Franc is not editing the catalogue material. (How come?)

Lee Pollock has vetoed the inclusion of appreciations by former colleagues—Newman, Tony Smith, de Kooning, etc.—in the catalogue.

I suggested we include quotes from reviews & articles pro & con & sensational in biographical outline. Frank likes notion, but Lee P. to be consulted.

1967

February 25

Waking up with Bianca (she's been living here about a month now, mostly nights, since her clothes & other gear are at a friend's place on upper Fifth Avenue). Bianca has a lunch date. She takes a bath & looks in the mirror for a couple of hours. I kid you not, but I kid her about it, & she says, "Mais j'ai à peine fait le maquillage aujourd'hui!"

I go to Diane di Prima's room in the Hotel Albert for early dinner, with her, Alan Marlow, Jeannie, Tara, Alex, Minnie & Jimmy Waring, who asks me to write a ballet for his company. Jimmy reads his lecture "100 Questions About Dance." I suggest John Blow's setting of Dryden's "An Ode on the Death of Henry Purcell" as suitable dance music. But Jimmy says he's only interested in music between 1830 & 1930, so then I suggest Poulenc's "Rhapsodie Nègre." Diane asks if I'd like to read with Frank Lima in the hotel's George Washington Room. I say, "Sure."

February 25

Finished reading *The Vanity of Duluoz* by Jack Kerouac. What nerve—in the best way!

March 17

Dick Kollmar talking about his family home: "The place is full of bad Karma." The Palace at 4 a.m.?

March 19

I go hear John Berryman, Robert Lowell, and others read poems by their dead friends Jarrell, Schwartz, and Roethke, all of whom had died recently. Berryman dramatizes his account of how Delmore Schwartz had, in some disoriented state, awakened other residents of his, Schwartz's, hotel, gasping for what would be his last breaths. Unbelievably depressing, so I forget everything that (didn't)

happen there & quick. (Kenneth Koch told me that Delmore Schwartz was the best talker he had ever known; I wish I'd heard him instead of those other guys.)

March 25

Read collaborations written with Frank O'Hara yesterday (Sunday afternoon) in the George Washington Room of the Hotel Albert. Everyone sitting on suitcases & trunks, which filled the room—unclaimed baggage of twenty years (!) to be auctioned off. John Wieners was there & Lewis MacAdams, Kenneth Koch, Duncan McNaughton, Charles Henri Ford, Ron Padgett, David Shapiro, etc. Finished by reading Jimmy Schuyler's beautiful "Buried at Springs."

March 25

With Ted Berrigan at the Byrds concert, Fillmore East. Ted tells me that John Wieners once dressed up in his mother's clothes and makeup. John's father came, took one look, and left the house. Ten minutes later, he called John from a phone booth and said, "Now, John, you be a good boy."

April 17

Giving a guest lecture on Pierre Reverdy in my modern poetry class at the New School, Ron Padgett said: "Nothing extraordinary ever happens in a Reverdy poem."

"Crime or Miracle: The Complete Man."

May 2

Nice dinner at Ron & Pat Padgett's. Ron played a record (sort of French cultural anthology) of Apollinaire reading "Le Pont Mirabeau," Briant declaiming, Valéry, Debussy playing . . . Together we correct Ron's Dada article for *ARTnews*. Showed Ron new poems of mine, which he said he found "surprising." Stayed late to watch *Dames* by Busby Berkeley on TV. Really funny dialogue but numbers not so hot. One character named Ezra Ounce and another named Hemingway—who wrote this thing? A moment when one of them says, "We must gird our loins for the battle," followed by, "And those loins will roar!"

Imagine a wildly rhapsodic & moving poem (involving, of course, "the full of life, its passions and its pleasures") & ending with the line "It is the divine music of Erik Satie!"

May 14

At Merce Cunningham's opening night, the after-performance party in the lobby of Brooklyn Academy. I sit down to dinner next to Jasper Johns and across from

Maxine Groffsky, John Cage, and Marian Javits. Dessert is a dubious-looking honey pudding served in little cups. Johns tastes it first, then gives Cage some from his spoon. I offer some to Marian Javits, who says, "No, thank you." Then Johns offers some to Marian Javits and she takes it. Laughter. I offer some to Maxine and she declines. Johns offers and she accepts. I offer some to David—same thing again. Cage returns to the table. "John," I say, "will you have some of my pudding?" "No, thanks, I've had some." Johns offers him some from his spoon and he takes it. Marian tells me that there is a very simple reason for all this, something she learned from feeding her babies: "You withdraw it," she says, "you don't really give it to them." What Jasper was doing was putting the spoonful to their lips and making the offer in one complete gesture.

Well, about the performance (Merce). The new dances are very pleasant. Carolyn Brown is the greatest female dancer alive, & Merce is the most commanding dancer on stage anywhere. The choreography is refined now, & recognizable, but never tired. There is lots of drama. This & then this & then & then & then.

1968
March 26
Introduced by John McKendry to Marcel Duchamp outside the Museum of Modern Art. Dada-surrealism show there. 10:04 p.m. Duchamp has the first room to himself. He beams broadly—"Go! Go see the show!"

Everything has its slot in the date-&-address book of this world.

May 2
Herman Cherry to David Smith (1/23/58, found among David Smith's papers): "Helen Frankenthaler and Motherwell have found each other—I think it is the most perfect match from any angle. For one thing, they are both gentlemen."

May 7
Two "political" readings: today with Allen Ginsberg, Kenneth Koch, Harry Mathews, David Shapiro, Dick Gallup, and Peter Schjeldahl for students in lounge during riots at Columbia, last night for Eugene McCarthy's presidential candidacy, with Ron, Ted, and Kenneth at a bar called "Eugene's."

May 20
A Few Moral Essays
"Here we are walking in the rain & you ask do I like it!"

A woman said she hated her husband. Someone asked her, "Why don't you leave him?" She said, "He's my husband."

"Do you always blush when someone tries to kill you?"

I had liked Alex Katz's painting of a nude girl in the woods called *Cathy*. One day, Alex said I could have it if I liked. I said I thought it might be too difficult to look at all the time. He said, "Try it for a while." And since he didn't say it in an uneasy way, I took it. Six months later, too disconcerting—I gave it back.

May 23
At Gotham Book Mart, a party for Kenward Elmslie and Joe Brainard's book *The Champ*. Joe's drawings on the walls of the upstairs gallery. I buy the drawing of the baseball player wearing uniform number "53" partly because I like it and partly because of the blond English (like Julie Christie) girl behind the counter.

Ron Padgett and I go to a dinner for Charles Reznikoff at his niece's house on Riverside Drive. CR talking, using his necktie as worry beads—fidgeting. Quotes from *Hamlet:* "'Tis bitter cold. And I am sick at heart." He has "double" the *Testimony* already published, unpublished. Vachel Lindsay, "the one who could read" (aloud, he meant). Dylan Thomas, "a druid." He said he looked through Zukofsky's *A Test of Poetry* and found a poem he liked (not signed); he looked it up in the index and discovered it was by him. "It's nice to know you had it right all along," he said.

June 12
Reading with Joe Brainard at St. Mark's Church. Afterward, when Joel Oppenheimer was complaining that any worker but not a poet could have a house in Queens, Kenneth Koch rejoined, "But a successful poet can have queens in his house."

Kenneth also said "too bad the lesser lights of the New York School" weren't invited to the Stony Brook poetry festival; then he was embarrassed thinking he might have offended me as a "lesser light." He didn't, though; I thought it was funny.

The old effort: to live effortlessly.

August 11 (Saratoga Springs)
Monteverdi—what a pretty name he has! (Even in translation: "Greenberg.")

Carl Rakosi, here at Yaddo, walks into the music room while I'm listening to Satie, *Messe des pauvres,* and says, "He must have been insane!" Rakosi roomed early on with Kenneth Fearing who, he says, "died senselessly of lung cancer—he never had a cigarette away from his lips!" And: "I once saw Ravel play, his arms like matchsticks."

August 15

Finished compiling the David Smith chronological outline for MOMA book. At "1963" I realized I was getting near the end, happily, but getting there meant David (May 23, 1965) had to die.

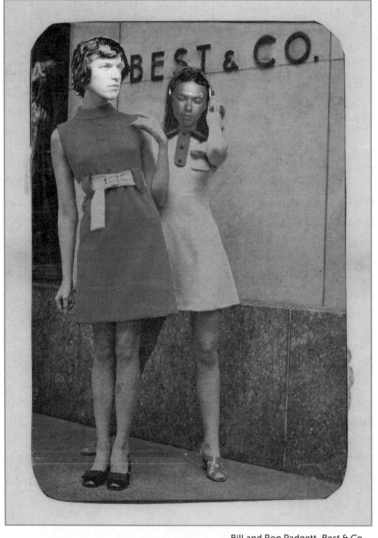

Bill and Ron Padgett, *Best & Co.*

August 20
Shakespeare's first poem, written while drunk under an apple tree at Stratford:
Piping Pebworth, Dancing Marston,
Haunted Hillborough, Hungry Grafton,
Dodging Exhall, Papist Wixford,
Beggarly Broom and Drunken Bidford.

Trotsky: "Lenin is dead. The words are like great rocks falling into the sea."

September 19
Visiting Allen Ginsberg in Cherry Valley, a Saratoga sunflower for Allen and Peter. "White magic." Huncke is there. Peter tries teaching me how to milk Bessie the cow. No soap. Jeep ride to Drummond Hadley's house in Cooperstown. Cliff faces en route like out of *The Last of the Mohicans.* As we approach the family estate, a vision of someone in a cowboy hat astride a shiny tractor atop the hill, none other than Drummond Hadley. His wife, none other than the very lovely Diane Kress. Out by a pond above the main house, "What would Frank think of the Revolution?" Allen asks. I say Frank would have found Mark Rudd very cute. Sitting on the grass looking at the starry night; Polaris, Orion, Cancer . . . Allen (ever the egoist!) says, "If we all disappeared, they wouldn't even notice." Drummond Hadley's baby daughter opines: "It smells goofy."

MISTER EYE

October 16
Lunch with Monroe Wheeler at the Dorset. "French sophisticates used to say, 'Don't read Proust in French, the English is far superior.'"

 Things Monroe Wheeler said about Marcel Duchamp: "He was going to organize the Stettheimer show (at MOMA) but then went to Paris and wouldn't come back in time." Mary Reynolds: "Duchamp had a long romance with her. She had a long nose and chin. But she had a voice that was very light and beautiful. She said Marcel was a cunnilinguist. On the other hand, Duchamp said he used to go see her because she lived near the Eiffel Tower." Did Duchamp know Gertrude Stein? "Yes, but he was too raffiné for her."

October 20
Paradise Now (The Living Theater) at Brooklyn Academy.
"Margin of credibility"

1969

December 30 (Bolinas)

I take the *Whole Earth Catalogue* with me to the Sharons' sauna. I'm sitting in the box, heating up, when Mr. Sharon, aged about 55, pokes his head in & says, "Take it easy." Puzzled at this, I go to the door & look out. Mr. Sharon sees me & says "Oh, I thought you were Ernest."

Shower, dress, shave, start cleaning up around the apartment. Lewis arrives. Coffee. We start writing poems together. Three of those. Then Tom arrives in time to read them. MM is the most "together," he says. Michael Bernsohn comes in with news of a lady—Mary Coleman—who wants to have the Bolinas Poets read in her house. We drive to see her. It's a large redwood house on the hill behind Sharons'—a road . . . The house first belonged to a Shakespearean actress named Locke—a friend of Ellen Terry & Isadora Duncan. Walnuts. Sunlight on this blond woman's face. Her chubby, attractive daughter. The polished wood of two coffee tables. Tom & Lewis like the idea of reading there. I don't know. I'm pretty stoned, & to me it's a little eerie.

Now we go visit Joanne in "the little red house" she's moved into. On a pad of Joanne's I write a poem beginning "Do you traffic in heroin?" & Tom adds to it, it's a collaboration. Then Lewis writes an "Elizabeth Bishop" poem called "A Wino from Rio." It's great & awful. Tom has to go return the stroller he borrowed for Juliet. We put it in the trunk & drive off. Down the road is a large puddle. The day before, we decided to back away from that puddle. Too deep. But now I decide it's O.K. to go ahead. We move thru & get stuck. Just then a man with a pickup truck appears. He has a chain & drags the car out. He says, "Next time drive on the other side."

December 31

The PLAN is to drive to San Francisco (Lewis & I) & pick up Ted & Alice, then see the aquarium & the Brundage Collection at the de Young. When we get to the Coolidge's where T & A are staying, Fred Neil is singing "Dolphins in the Sea." Ted & Lewis go on an errand. Alice packs & I read *Look* magazine on the 70s. I call Don Allen, who says "Come right over." So, when Ted & Lewis return, we load the car & drive to Don's on Jones Street. There we drink sherry & talk about New York painting—the show at the Met, Alfred Leslie, Mike Goldberg, Kline. Suddenly it seems everyone is drunk on sherry. Don's a very attentive host. We talk about Frank, who looks out from a photograph. Don gives me a copy of a book he's just published, *The Charm* by Robert Creeley. Off to the aquarium. But first, Alice is hungry, so we go have chili dogs in the aquarium basement. Lewis wanders off. So does Ted. Alice & I look at snakes and fish. We are standing in

front of the porpoise tank when Ted appears. "I don't dig it," he says. Anyway, the aquarium is closing. It's 4:30. The de Young is already closed. We leave San Francisco. By the time we arrive in Bolinas it's dark, New Year's Eve. At Tom's, Ted & Tom embrace. Everyone takes acid. Back at Gordon Baldwin's, I make dinner, as much as will allow me not to think too much about it once the acid rush comes on. The rush comes on. Very much happens. I play the host. Crazy looking people arrive. They take acid and look perfectly sane, though a bit quieter than before. There's a knock at the door—kids off the beach—they've walked around from Stinson Beach, they say, looking for a match and a bathroom. I don't feel like talking, but I show them the bathroom. Ted does the talking & practically informs these kids of his entire history, travels, reasons for being in Bolinas, etc. Ted is suddenly about 4 feet high & wearing the aspect of a demented leprechaun. Other people are dancing. There is wine. I need some air—it's a little after midnight now—so Jack Boyce, Tom Field & I walk out onto the ramp that leads to the beach. The tide is very high, up to the ramp, so no beach, but we linger there a time watching the waves come in, go out. Waves of breathing. Waves of one's life. The wave (which is Time?) of one's life. Back inside & the phone rings, it's Anne Waldman "What's happening?!!" I tell her who's here & "Happy New Year." "Let me talk to EVERYBODY!" she says. I walk into the living room & say, "It's Anne," & Lewis shoots from his seat on the couch to the other room where the phone is. A little later, Lewis, Tom, Angelica, Ted & Alice leave. That leaves Joanne, Jack, some people I don't know, & Pat Haines. They go. I walk Pat Haines home then go see Lewis. We talk but can't really get a conversation together, tired. Long walk home in cold spray.

1970

January 2
Poetry Reading at Mary Coleman's House (in order of appearance):
Lewis Warsh
Ebbe Borregaard
Joanne Kyger
Bill Berkson
Ted Berrigan
Tom Clark
John Thorpe
 Bill Beckman – M.C.

March 6
An all-nighter with Ted and Jim Carroll. At dawn we walk across town and have breakfast in a diner on the far west end of Greenwich Avenue. Returning

eastward on Eleventh Street between Fifth and Sixth we see rubble we later learn is that from the explosion in an old townhouse, 18 West Eleventh, where members of the Weather Underground, including Kathy Boudin, the daughter of our poet friend Jean Boudin and her lawyer husband Leonard, had accidentally set off a bomb they were in the process of making. Kathy was wounded but survived; three of the group were killed in the blast. The street was a mess. A bookcase hanging at a forty-five-degree angle from the next-door house turned out to be Dustin Hoffman's.

April 4

Went with Joe to see Edwin. Joe brings sketch pads, paints, etc. so Edwin can display them & prove to the rent commissioners he's a painter. Otherwise, he gets evicted from this loft he's lived in since the 1930s. We set up an old easel & put the canvas board on it. Edwin performs a little painter dance. Then he gets out some old pictures stored in a metal valise. Paintings by him, others by his friend Valdes, including a portrait of Edwin, Rudy & John Becker in Florida in the late 30s. Edwin gives Joe & me each a gingerbread Easter Bunny and to me, a blue & yellow ribbon which he ties on my arm.

April 17

I'll Tell You What I'm Thinking
Of the small blue star tattooed on the inside of my mother's ankle.

Bill at George Schneeman's show, Poets House, New York, 2014

Ted Greenwald Interviews Bill Berkson

What does it feel like to be a poet in the "postmodern" era?
I think that the era is two-ply. Poetry exists on thin paper. Personally, in one's late forties—a poet continuing after some time, in a period where poetry as an item doesn't seem to be going anywhere, as a public item—I wonder what it must be like for a twenty-year-old or twenty-eight-year-old coming into it, what with this void. A few years ago Ron Padgett said, "We'll see who has the courage to continue." About the same time I thought Ron was right. I noticed those I was in touch with were really enjoying it. All the business (publication, etc.) had to take care of itself or be ignored for a while.

What does love have to do with it?
You've got to ask Bernadette Mayer questions like that. That's really a two-ply question. There's a lot of museless poetry, which has nothing to do with my "love" ethos. Unless you can identify an eleventh or twelfth muse, which is the muse of theory, which we haven't heard from yet.

There's the "love" that grows from fascination with writing. The rest is like the poetry of private life—doesn't seem to have very much pressure in it right now.

What are some of the differences between visual artists and poets?
Most visual artists nowadays consider themselves public actors. Few of the poets of our age have found any consistent access to that role, or necessarily even wanted it.

Why didn't they want it?
Because it seemed to require convertible meanings: what you actually wrote, to be taken publicly, would have to be continually paraphrased.

Visual artists are behind in literature. They tend to read top-forty "serious" literature. They didn't catch the sixties-seventies-eighties wave of poetry. There's no mixed community of poets and visual artists anymore. They're not interested in one another right now—except for the few poets who are still writing art criticism.

There seems to be a difference in mental set. The visual artists don't read the right books.

Do you think poetry will ever develop an economy?
Poetry has an economy: of energy. It may be doing nothing more now than seeping into the general culture. Strictly speaking in economic terms—poetry and the life of the poet are out of it.

Why has the media characterized everything but poetry as "poetic"?
Well, "poetic" means soft. In media, "poetic" means soft-focus and harmless, euphemistic. That has nothing to do with the poetics of the best writing in America for the last thirty years, which has been characterized by a hard, factual surface—not vague, "poetic," at all. In art criticism, "poetic" now is what was called "lyrical" in the fifties. And it usually triggers an uneducated use of the word "ambiguous" (which means "uncertain," not "multiple meanings").

Do you have any sense of what direction poetry will take as we enter the twenty-first century?
No. Really, no.

What's your favorite movie of the eighties?
After *Blue Velvet, Three Men and a Baby.*

Who does the dishes?
Tom Selleck does the dishes. In *my* house everybody does the dishes. And the dishes get done. There's a certain time in family life when you decide whether or not the dishes get done.

Where do you place your work in today's poetry?
The hard part of this question is where do I place today's poetry. Because I see less of other people's work. There isn't the little magazine and small-press dissemination that there was ten years ago. That's an economic fact.

Not energy?
The forty-and-over poets don't have the time and the money to continue. The younger poets haven't picked up the obligation. The only way I have of "placing" my poetry is in relation to what I know I'm doing and in relation to my ideals.

Which ideals?
They're complicated. They have to do with surface. A poetry whose surface is factual and inclusive and has zing. But that description is just a set of words that I keep alongside whatever it is that turns out to be the next poem. I don't necessarily expect that ideals and practice will match up.

What advice would you give to a young writer coming on the scene today?
I wouldn't. I never got any advice from anybody. I got examples—and from time to time somebody tells me to do more, rather than less. And that's always useful.

Poetry Project Newsletter #127, February–March 1988

Twenty Questions with Bill Berkson

1. Who has been the biggest influence on your life and writing?
Kenneth Koch, then Frank O'Hara.

2. If you were stuck on a deserted island and could take only one book what would it be?
Kenneth Koch's *New Addresses*.

3. Is process as important as what you produce?
Process is the pits. But I love writing.

4. Do you try to be accessible or even worry much about it?
Never, ever.

5. What city has been most conducive to your work?
New York, in fact, at heart.

6. Is locale important to you?
No.

7. What color is your imagination?
White or gray, depending.

8. What's the first thing you do in the morning?
Sex is best in the morning, if possible. Then I stretch, and inspect the big window.

9. Do you use a computer, typewriter, word processor, or longhand?
Longhand journals, computer, notepads. Although I find the computer presents too little tactile feedback for writing poetry, I am getting used to it.

10. Do you find yourself writing differently when using different writing methods?
Not that I notice.

11. What are you working on now? Is it available?
New book of poetry, *Fugue State*, is available. I am working on a book of autobiographical writings.

12. Is there a certain memorable line that sums it up?
"Dove sta memoria"? No, that's too fancy. How about, "Roses are red, violets are blue," or, "Hold it right there"?

13. What or who started it all for you?
(I'm losing the thread here.) It was a dark and stormy night.

14. How do you feel about interviews?
Stop that.

15. Do you feel that belonging to a group helps focus one's talent?
I never have done either.

16. What, if any, short advice would you have for would-be poets?
If you are would-be, don't do it.

17. Do you feel like you're a part of any tradition?
Yes, but it would require another lifetime to define.

18. What would you like to be remembered for?
My penetration, and salad dressing.

19. Are you getting tired of all the questions?
Yes, I am afraid so.

20. Do you think it's about time to end this?
Oh, o.k.

Larry Sawyer, Milk, *vol. 3, 2001*

Sophie Calle/Grégoire Bouillier Questionnaire

When did you last die?
Some deaths may go by unnoticed, but in Madrid, end of December 1995, with a high fever, I felt launched out of this life.

What gets you out of bed in the morning?
Morning itself, personified—and curiosity.

What became of your childhood dreams?
They follow me everywhere, minus the one of being incinerated by a Russian A-bomb.

What sets you apart from everyone else?
My sense that everyone knows the secret but me.

What is missing from your life?
Dead friends.

Do you think that everyone can be an artist?
Why not? Nor should that be an issue.

Where do you come from?
New York, New York.

Do you find your lot an enviable one?
I wouldn't encourage envy in anyone, but I am often astonished by my own good luck.

What have you given up?
Cigarettes, and trying to be anyone in particular.

What do you do with your money?
Give it to people for things.

What household task gives you the most trouble?
Calling the plumber, "straightening" my desk.

What are your favorite pleasures?
One can't have a "favorite" pleasure because every pleasure must contain its own continual element of surprise.

What would you like to receive for your birthday?
Love and admiration—the proofs thereof.

Cite three living artists whom you detest.
Cite them for what? I'm not a traffic cop!

What do you stick up for?
Guilty pleasures.

What are you capable of refusing?
Fish for supper, bores, solicitations.

What is the most fragile part of your body?
My transplanted lungs.

What has love made you capable of doing?
Believing in love.

What do other people reproach you for?
Silliness, snobbery, ordinariness.

What does art do for you?
Keeps me looking.

Write your epitaph.
"Just look at this mess."

In what form would you like to return?
A door.*
 *As in "Come, let us 'a door' him . . ."

2011

Questions translated by Bill Berkson, with thanks
to Constance Lewallen and Harry Mathews

Eden

after W. H. Auden and for Jarrett Earnest, in reply

Landscape
Woods—clearing—woods. Assorted bodies of water, including a falls.
Mountains far off, to one side, snow-capped.

Climate
Normally mild, changing to snow, wind and enough rain to keep water flowing.

Ethnic Origin of Inhabitants
Thoroughly mixed, leaving room for blond and blue-eyed folk.

Language
Highly inflected.* Lots of shades of nouns and verbs (obviating excess of modifiers).
 *I decided on this before checking Auden's list, where he says the same thing.

Weights & Measures
Non-standardized, but taken seriously.

Religion
Appeasement and complaint; deities for most occasions. Open-air liturgy.

Size of Capitol
Not much. (I think Auden's category is written "capital.")

Form of Government
A tough one: one that changes monthly?

Sources of Natural Power
Physical (wind, sun) and mental (telekinesis) combined in good proportion.

Economic Activities
"In America you'll get food to eat / Won't have to run through the jungle & scuff
up your feet." (Randy Newman, "Sail Away") Otherwise, high-fashion, low-cost
housing.

Means of Transport
Walking and boating.

Architecture
Borromini.

Domestic: Furniture and Equipment
Sofas, round tables, comfortable straight-backed chair, self-sorting desk. Out-
houses with starry-sky views, easily interiorized as needed in bad weather. Good
spatulas and coffee maker.

Formal Dress
Formal nudity (weather permitting) and/or New York and Hollywood 1930s.

Sources of Public Information
Chinese whispers, poetry readings, scoreboards.

Public Statues
Neighborhood deities and figures of fun (mostly ex-presidents who served the
people badly).

Public Entertainments
Movies, dancing, track and field.

March 21, 2009

Jane Nakagawa Interviews Bill Berkson

You've been to Japan twice now, is that correct? What brought you here, in the main?
My wife Connie Lewallen had been seven times to Kyoto as supervisor of the Crown Point Press woodblock project, taking American artists to work with Crown Point's resident woodblock master. I myself had always been curious about Japan—about Japan proper, the place, the people, and Japanese culture generally—and then the temples and gardens associated with Zen Buddhism, because early on I felt connected to that ethos. We visited in 2006—Kyoto, Nara, Tokyo— my notebook of which is available online at *Nowhere* magazine, issue one (later published in facsimile by Cuneiform Press). Going to Kyoto first and then Tokyo was probably a mistake: I loved the calm of Kyoto, a calm I experienced this time all over again, so going from that to the noise and flash of Tokyo, I reacted negatively, just didn't care, in fact.

Connie and I just wanted to return. We had a very grandiose plan at first—Hokkaido, maybe the south, or traveling around the inland sea. But primarily, to revisit Kyoto, and then we decided to go to Naoshima for the museum "experience" there, and also Osaka because Trane DeVore, with whom Joanne Kyger put us in touch, is there. Joanne also connected us with Daniel Bratton and his wife Carol Williams, and then, too, you and I connected—so it worked out marvelously for us.

As someone originally from the U.S. but now a resident of Japan, I'd love to hear more about which Japanese artists, writers, etc., or more generally "things Japanese," catch your attention and perhaps even influence your own work? Any relevant comments about other travel or other cultures would be welcome, of course, too ... as far as they may relate to poetry or art ...
When I was at Lawrenceville, around 1955 or '56, I wandered into a bookstore near the Princeton campus, just down the highway, and found books by D. T. Suzuki and R. H. Blyth. Somehow, instinctively, I knew these books, this information, was for me. Then the same thing happened when Allen Ginsberg's and Jack Kerouac's writings appeared, just after that—and the Zen connection with them was fairly clear. My informal Buddhism remains fairly constant, even though I have no regular identifiable practice.

On the artistic side—which is consistent with all that I just mentioned—I love Ozu's films, the writings of Kawabata and Tanizaki, and I've always been curious about the works of the Gutai artists (of whom so pitifully little is known in the U.S.), especially Shiraga and Motonaga. I don't know enough about old Japanese art, even though I took a course in it with Professor Warner at NYU, but of course the early ceramics and paintings are wonderful. The big hit this

time was going to Shisendo, the house of the poetry immortals (the immortals are all Chinese poets, of course, admired by the Japanese poet Jōzan). I guess this is an instance of how one feels in relation to "other culture": in the Shisendo garden there's a little spot, a kind of niche in the grass bordered by short loops of bamboo fencing, that leads to the edge of a little ravine; I walked into it and looked—nothing special. It might have been that at some time of year there is an event, something extraordinary to see, but not when I was there. So I got the idea that the idea was, *Just look*. It reminded me of my impatience with the special value put on the rocks at Ryōan-ji—when I turned from looking at them, at the formal rock garden, I noticed some other rocks and stones just accumulated by the boardwalk and thought, *What's so negligible about these?*

At your reading and lecture in Kyoto this year for the Japan International Poetry Society, you mentioned education as at least in part responsible for the rejection of difficult or unconventional poetry by many (as opposed to poems that are readily grasped without effort). Would you care to comment a bit more on this?

When I went to school, every piece of poetry and imaginative literature generally was approached with an eye to symbol and metaphor; nothing was as-is, nothing real in itself. I wanted, still want, the words to be real, enough in themselves, and the characters in the story to be themselves, thoroughly, before they are stand-ins for big ideas. Big ideas are generally useless or, in fact, toxic. Most schoolkids have no sense—are disallowed the sense, literally, of reading actively and directly what is there to be read, heard, felt, and thought about. Everyone is taught methodologies, or so-called critical thinking. They don't confront the poem. In 1953, Saul Bellow complained that reviewers of his first novel, which is

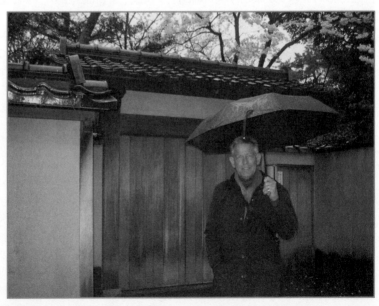

Bill in Japan,
2010

a very funny book, would use the term "picaresque," but, Bellow said, "they don't laugh." The gist being, how do they know it's picaresque, or a funny book, if they don't laugh along with it? The answer is that laughter in school is "a trope" you can identify without getting near the effect of it.

A strange question perhaps but I wondered what Connie was writing in her notebook during your Kyoto reading . . . !
Connie often draws during events. In this instance, she was drawing my hat and glasses.

Over your long career as a poet, art critic, and curator, which frustrations and successes particularly stand out for you at this juncture? And what plans or projects do you have now in the works?
The prevalence of bad, melodramatic poetry is an irritant, but perennial, and there isn't much to be done about it except fill up the air with more good poetry—there is a lot of that, but it doesn't penetrate official culture, it seeps out where the people who can enjoy it find it and they multiply, one hopes, enough to affect things. Meanwhile, our official language is a mess, right where strong doses of good poetry could help. Academic culture is simply part of the official mess, its pretense at being other just makes it worse. And that goes for most of the visual arts culture, too, the museum and magazine parts anyway. You would think that the commercial parts would be worst, but they at least do an honest job of it. As do most artists, really. It's all professionalized. I complain about professionalization, but the world is such that these people must seek income-producing work—high-income, at that—and who can complain if that's the way it is?

I have enough projects to keep me busy for the next twenty years: a new book of poems in the works, one section of that coming out as a limited, deluxe book with pictures by my friend Léonie Guyer; a new collection of art writings; a book of autobiographical writings; a book of uncollected poems and some drawings and collaborations with artists from the 1970s and '80s. And more long-term projects—I'd like to put together notes and memories about Frank O'Hara and his poetry, and a libretto on how my parents met during the 1934 Venice Biennale, which was the same one where Hitler came to meet Mussolini.

Do you have any advice for the current generation of young poets?
At the reading, Kiyoko Ogawa, somewhat miraculously, it seemed to me, brought up a passage in Goethe's conversation with Eckermann of September 18, 1823, in which Goethe, trying to dissuade his young poet friend from taking on too-ambitious projects, talks of how what Kiyoko translated as "the poetry of opportunity" is constantly available. "Opportunity" here is usually translated

as "occasion." Goethe says, "All my poems are occasional poems," but he means, rather than birthday poems or elegies or odes to famous athletes, that the occasion for poetry is omnipresent—one just has to stop, look, and listen, or even (although Goethe has a caution about this) just start writing. Anyway, I recommend that entry in *Conversations with Eckermann* to anyone who's interested in writing poetry. In fact, the whole book should be in anyone's library. The important thing is attitude, and with that, a sense of artistic manners—the last thing taught in poetry classes nowadays. So I guess the next piece of advice is, get out of those classes, but that brings us back to making a living, and how.

Fedora, *May 2010*

Acknowledgments

Versions of some of these pieces first appeared in *Art Journal, The Hall of Fame Hall of Fame, Adventures in Poetry, Sal Mimeo, ZYZZYVA, Modern Painters, Best Minds: A Tribute to Allen Ginsberg, Nice to See You: Homage to Ted Berrigan, That Various Field for James Schuyler, Continuous Flame: A Tribute to Philip Whalen, Dorado, A Painter and His Poets: The Art of George Schneeman, Ted Berrigan, Perpetual Motion: Michael Goldberg, What's Your Idea of a Good Time?* (with Bernadette Mayer), Harriet: The Blog (Poetry Foundation), *Philip Guston: Drawings for Poets, Big Bridge,* the *Battersea Review, Artforum, 1st of the Month, AMERARCANA,* the *Delineator, Trinity Per Saecula.*

The original version of the autobiographical essay "Since When" was commissioned by the Gale Group and first appeared in *Contemporary Authors,* volume 180 (Gale Research Company, 2000).

Some of "John Wieners" first appeared as "Afterword" in *A New Book from Rome* by John Wieners (Bootstrap Press, 2010).

Another version of "Variations on a Theme (Warfare)" appeared as the foreword to Anne Waldman and Noah Saterstrom's book, *Soldatesque / Soldiering: With Dreams of Wartime.*

Thanks to the following editors and publishers: Peter Anderson, Lisa Berman, Bill Corbett, Steve Dickison, James Dunn, Larry Fagin, Derek Fenner, Lyn Hejinian, Howard Junker, Ben Mazer, David Meltzer, Bill Morgan, Prudence Peiffer, Kevin Ramsay, Bob Rosenthal, Michael Rothenberg, Anne Waldman, Nicholas Whittington, Suzi Winson, and Karen Wright.

More thanks to Lewis Warsh, Tom Clark, Duncan McNaughton, Joanne Kyger, and, as ever, to Connie Lewallen.

Special thanks to Chris Fishbach at Coffee House Press for making this book as real as possible. And in fond memory, to Allan Kornblum.

LITERATURE
is not the same thing as
PUBLISHING

Coffee House Press began as a small letterpress operation in 1972 and has grown into an internationally renowned nonprofit publisher of literary fiction, essay, poetry, and other work that doesn't fit neatly into genre categories.

Coffee House is both a publisher and an arts organization. Through our *Books in Action* program and publications, we've become interdisciplinary collaborators and incubators for new work and audience experiences. Our vision for the future is one where a publisher is a catalyst and connector.

Funder Acknowledgments

Coffee House Press is an internationally renowned independent book publisher and arts nonprofit based in Minneapolis, MN; through its literary publications and *Books in Action* program, Coffee House acts as a catalyst and connector— between authors and readers, ideas and resources, creativity and community, inspiration and action.

Coffee House Press books are made possible through the generous support of grants and donations from corporations, state and federal grant programs, family foundations, and the many individuals who believe in the transformational power of literature. This activity is made possible by the voters of Minnesota through a Minnesota State Arts Board Operating Support grant, thanks to the legislative appropriation from the arts and cultural heritage fund. Coffee House also receives major operating support from the Amazon Literary Partnership, the Jerome Foundation, McKnight Foundation, Target Foundation, and the National Endowment for the Arts (NEA). To find out more about how NEA grants impact individuals and communities, visit www.arts.gov.

Coffee House Press receives additional support from the Elmer L. & Eleanor J. Andersen Foundation; the David & Mary Anderson Family Foundation; Bookmobile; the Buuck Family Foundation; Fredrikson & Byron, P.A.; Dorsey & Whitney LLP; the Fringe Foundation; Kenneth Koch Literary Estate; the Knight Foundation; the Matching Grant Program Fund of the Minneapolis Foundation; Mr. Pancks' Fund in memory of Graham Kimpton; the Schwab Charitable Fund; Schwegman, Lundberg & Woessner, P.A.; the U.S. Bank Foundation; and VSA Minnesota for the Metropolitan Regional Arts Council.

The Publisher's Circle of Coffee House Press

Publisher's Circle members make significant contributions to Coffee House Press's annual giving campaign. Understanding that a strong financial base is necessary for the press to meet the challenges and opportunities that arise each year, this group plays a crucial part in the success of Coffee House's mission.

Recent Publisher's Circle members include many anonymous donors, Suzanne Allen, Patricia A. Beithon, the E. Thomas Binger & Rebecca Rand Fund of the Minneapolis Foundation, Andrew Brantingham, Robert & Gail Buuck, Louise Copeland, Jane Dalrymple-Hollo, Mary Ebert & Paul Stembler, Kaywin Feldman & Jim Lutz, Chris Fischbach & Katie Dublinski, Sally French, Jocelyn Hale & Glenn Miller, the Rehael Fund-Roger Hale/Nor Hall of the Minneapolis Foundation, Randy Hartten & Ron Lotz, Dylan Hicks & Nina Hale, William Hardacker, Randall Heath, Jeffrey Hom, Carl & Heidi Horsch, the Amy L. Hubbard & Geoffrey J. Kehoe Fund, Kenneth Kahn & Susan Dicker, Stephen & Isabel Keating, Kenneth Koch Literary Estate, Cinda Kornblum, Jennifer Kwon Dobbs & Stefan Liess, Lambert Family Foundation, Lenfestey Family Foundation, Sarah Lutman & Rob Rudolph, the Carol & Aaron Mack Charitable Fund of the Minneapolis Foundation, George & Olga Mack, Joshua Mack & Ron Warren, Gillian McCain, Malcolm S. McDermid & Katie Windle, Mary & Malcolm McDermid, Sjur Midness & Briar Andresen, Maureen Millea Smith & Daniel Smith, Peter Nelson & Jennifer Swenson, Enrique & Jennifer Olivarez, Alan Polsky, Marc Porter & James Hennessy, Robin Preble, Alexis Scott, Ruth Stricker Dayton, Jeffrey Sugerman & Sarah Schultz, Nan G. & Stephen C. Swid, Kenneth Thorp in memory of Allan Kornblum & Rochelle Ratner, Patricia Tilton, Joanne Von Blon, Stu Wilson & Melissa Barker, Warren D. Woessner & Iris C. Freeman, Margaret Wurtele, and Wayne P. Zink & Christopher Schout.

For more information about the Publisher's Circle and other ways
to support Coffee House Press books, authors, and activities,
please visit www.coffeehousepress.org/pages/support or
contact us at info@coffeehousepress.org.

Since When was designed by Bookmobile Design & Digital Publisher Services. Text is set in Arno Pro, a face designed by Robert Slimbach and named after the river that runs through Florence.